ETERNAL

ETERNAL: ILya Kuvshinov Illustration Works

Author: **ILya Kuvshinov**
Editorial Design: **Tomoyuki Arima** (TATSDESIGN)
 Chiharu Tanaka
Translation: **Christian Traylor**
 Hiromi Ishii
 Brainwoods Corporation, Ltd.
Cooperator: **Fatima Dominguez**
 The Gamine Studios, Inc.
Editor: **Keiko Kinefuchi**

Publisher: **Hiromoto Miyoshi**

PIE International Inc.
2-32-4 Minami-Otsuka, Toshima-ku, Tokyo 170-0005 JAPAN
international@pie.co.jp
www.pie.co.jp/english

ISBN978-4-7562-5235-7 (Outside Japan)
Printed in Japan

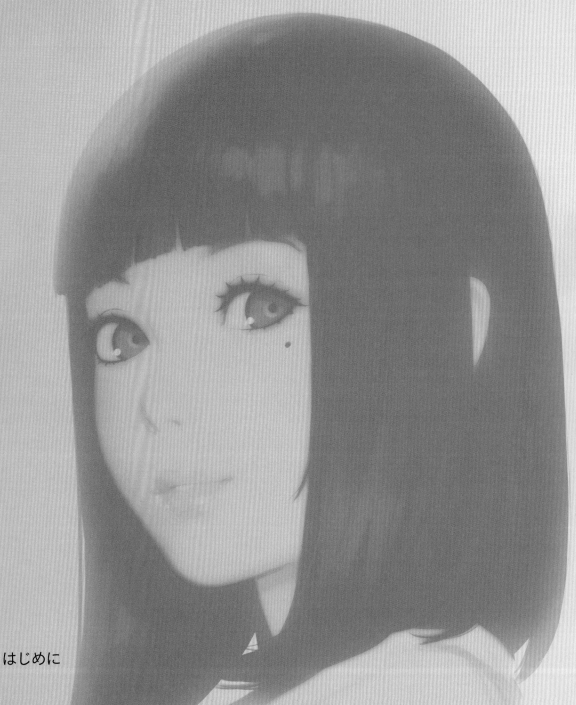

はじめに

『ETERNAL』を購入していただき、ありがとうございます！
皆さんが今、手にしているこの本は3年間の私の仕事の集大成です。商業作品として手が
けたもの、個人的な作品もありますが、すべて私が皆さんに見てもらいたいものを丁寧に
選びました。前作『MOMENTARY』とイメージが重なる部分もあるかもしれませんが、私の
中ではこの3年間でさまざまな変化がありました。

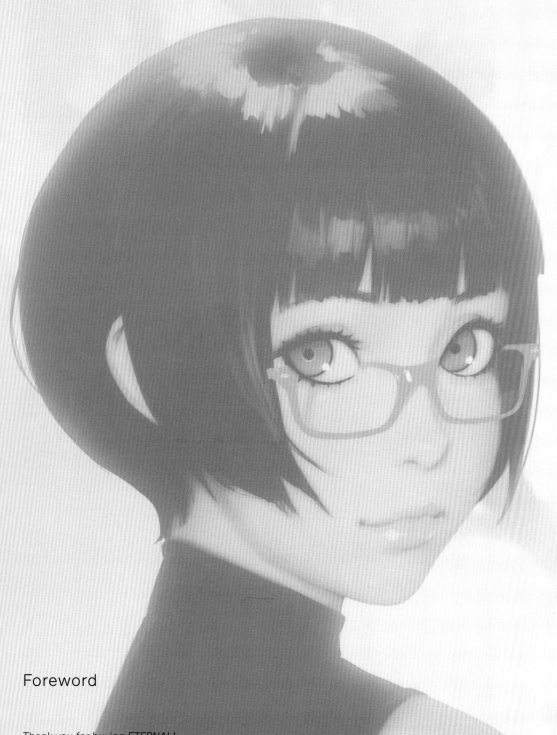

Foreword

Thank you for buying *ETERNAL*!

The book you now hold in your hands is the culmination of three years of my work—both commercial and personal—with the contents all carefully selected by me. It may well remind you of my previous book, *MOMENTARY*, but these past three years have seen a lot of changes.

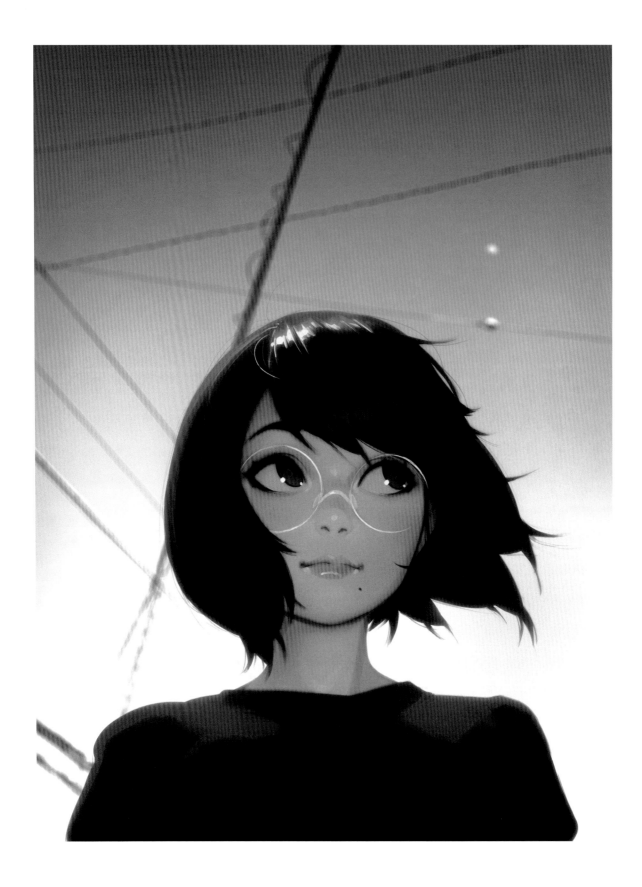

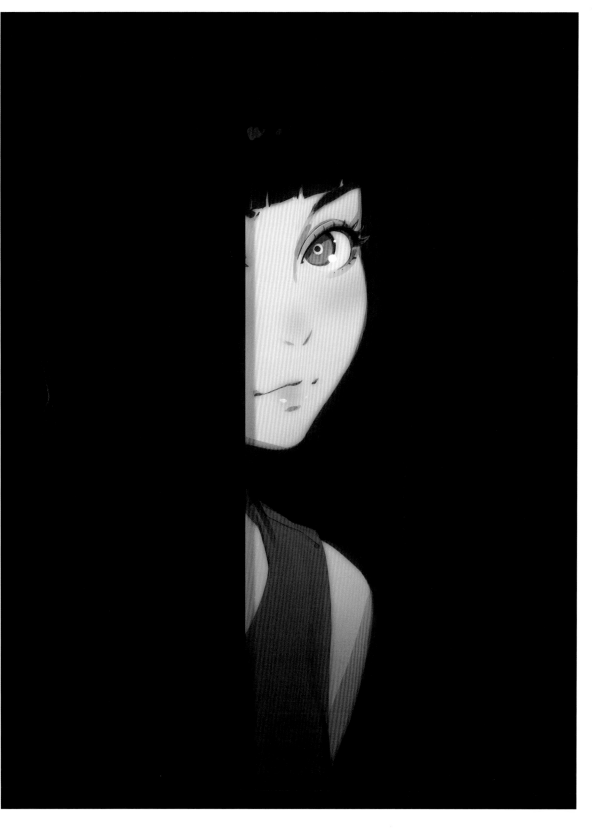

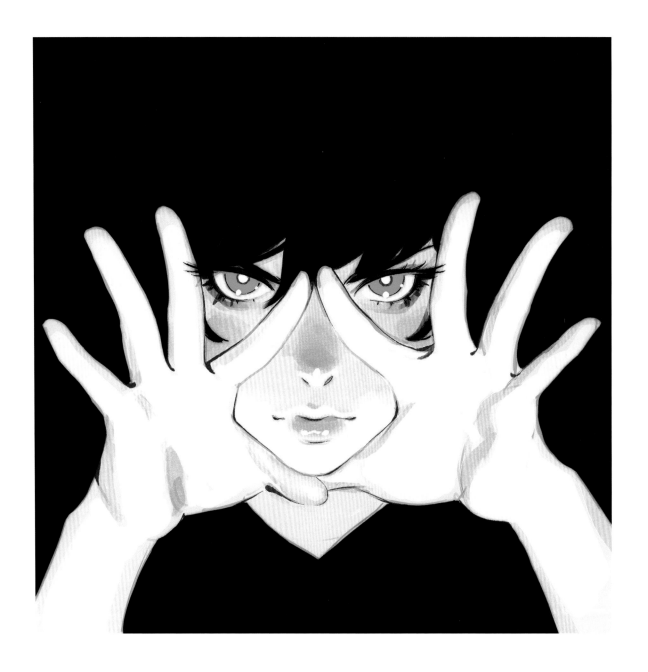

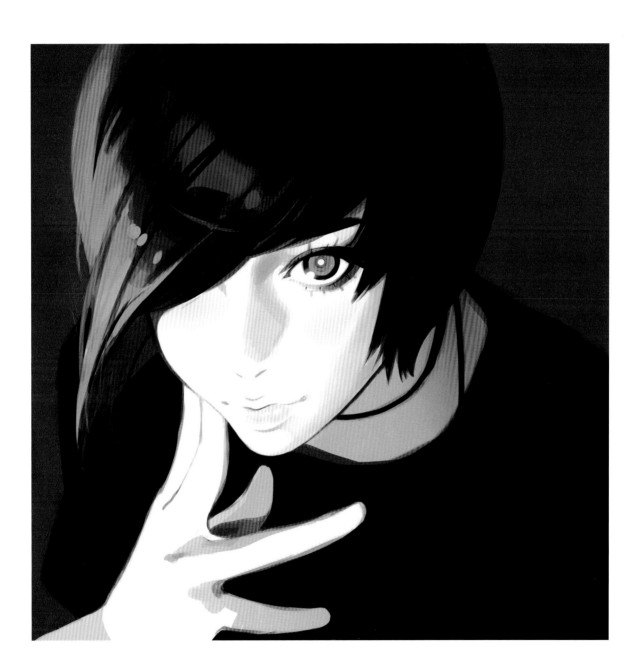

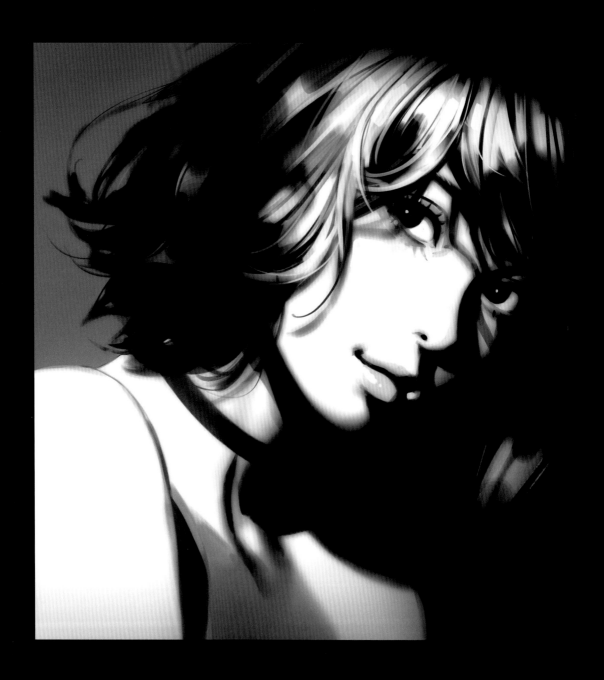

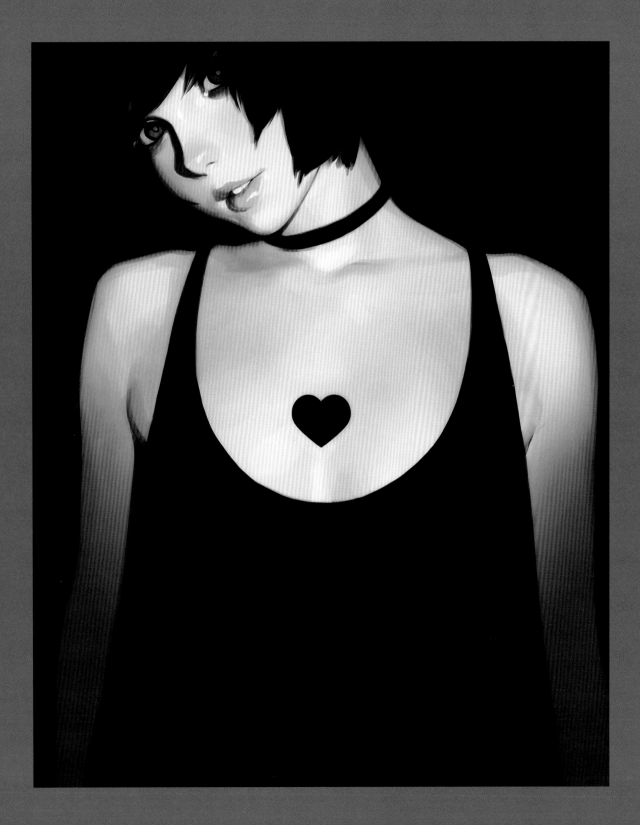

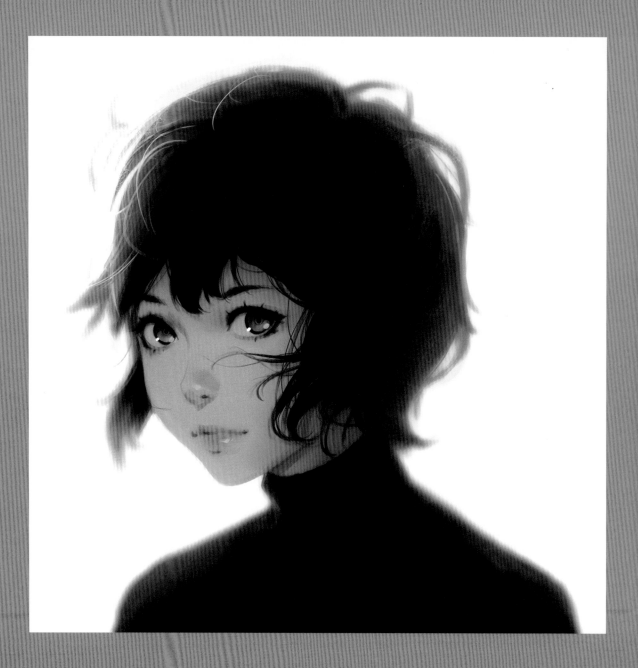

『イラストレーション 2017年12月号』(玄光社) 表紙イラスト
Cover illustration for the December 2017 edition of illustration (GENKOSHA)

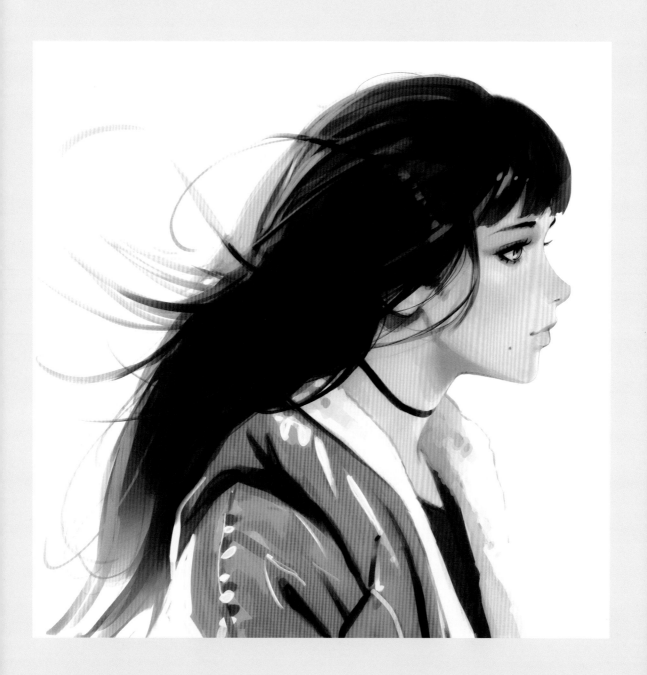

『イラストレーション 2017年12月号』(玄光社) 付録カレンダーイラスト
Illustration for included calendar in December 2017 edition of *illustration* (GENKOSHA)

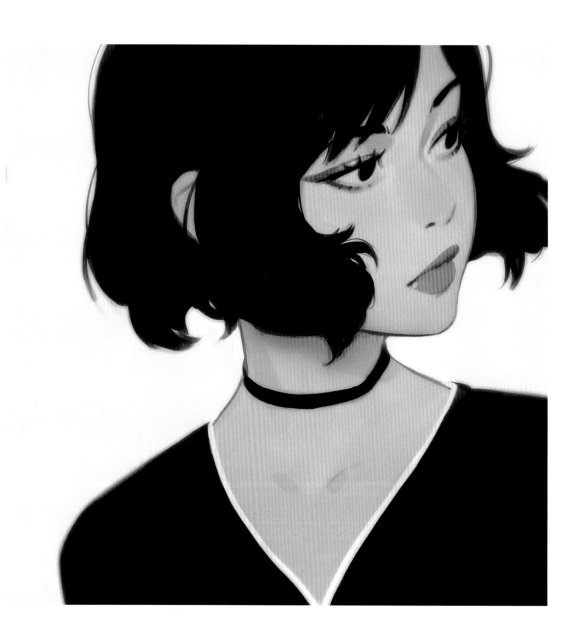

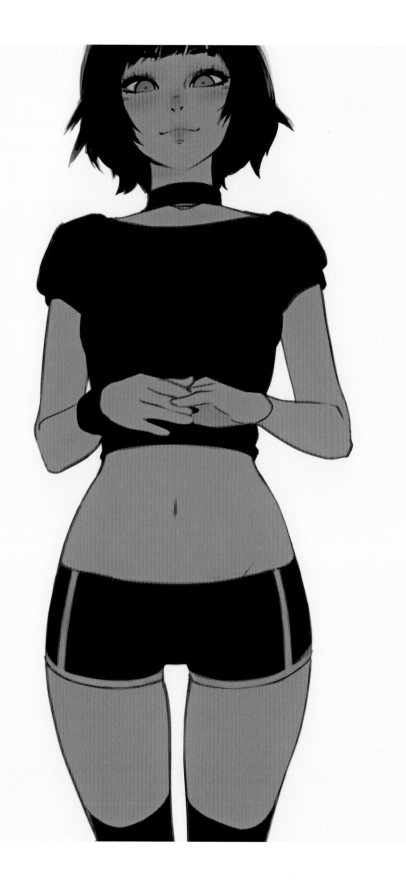

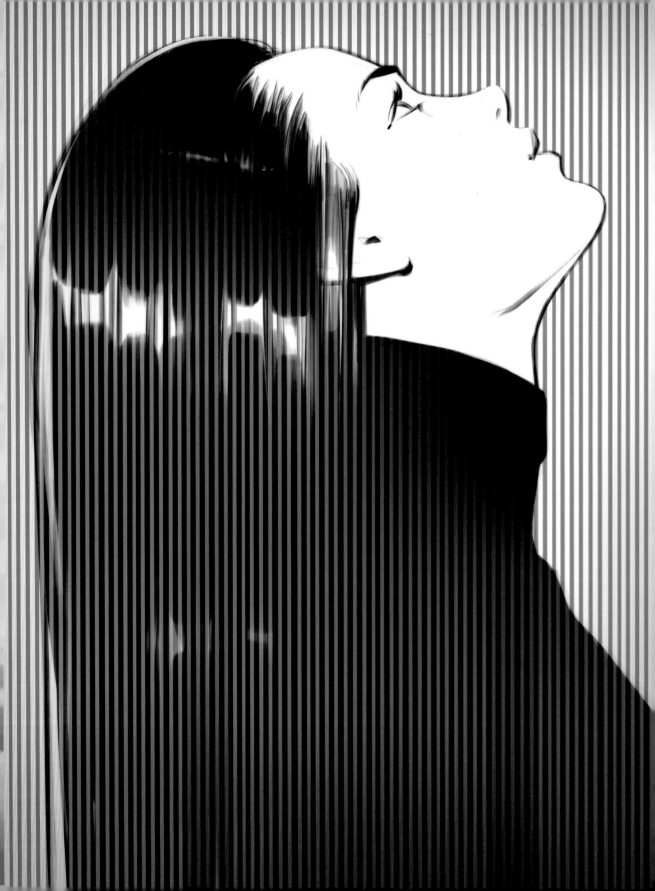

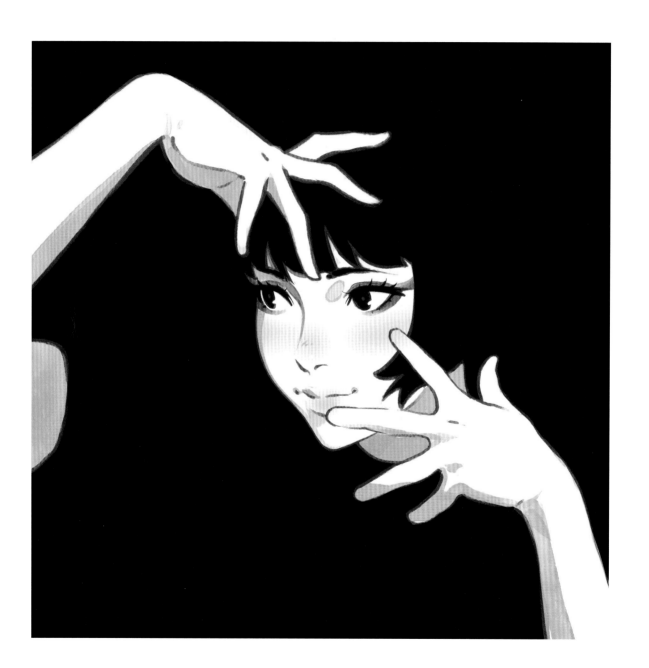

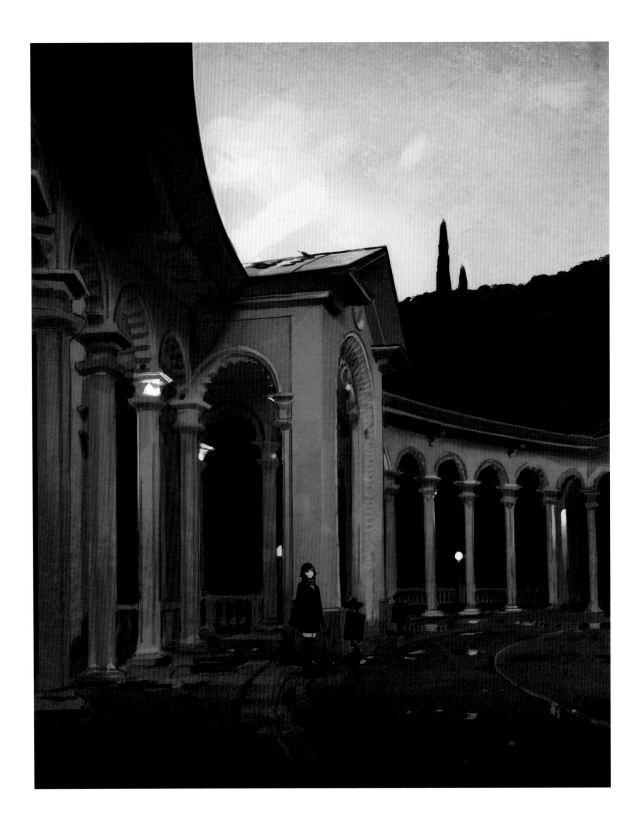

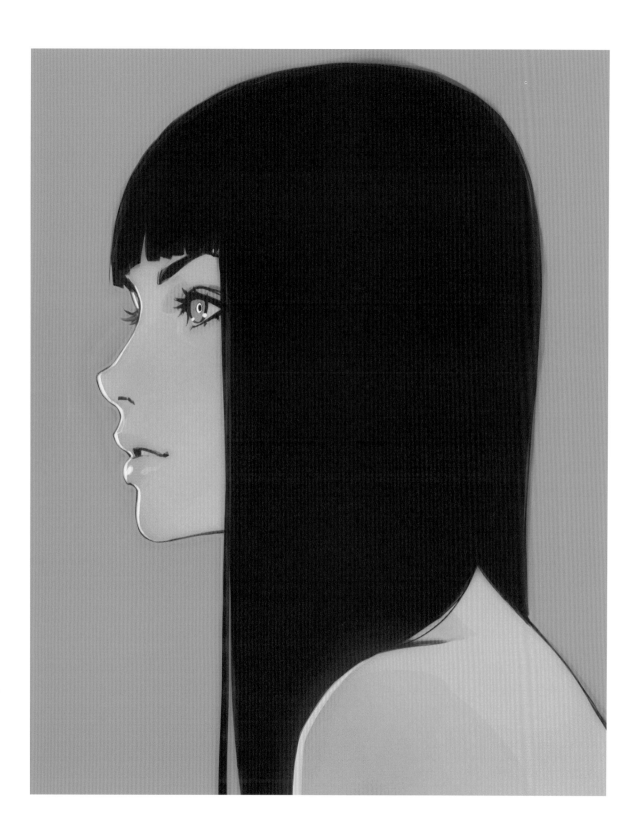

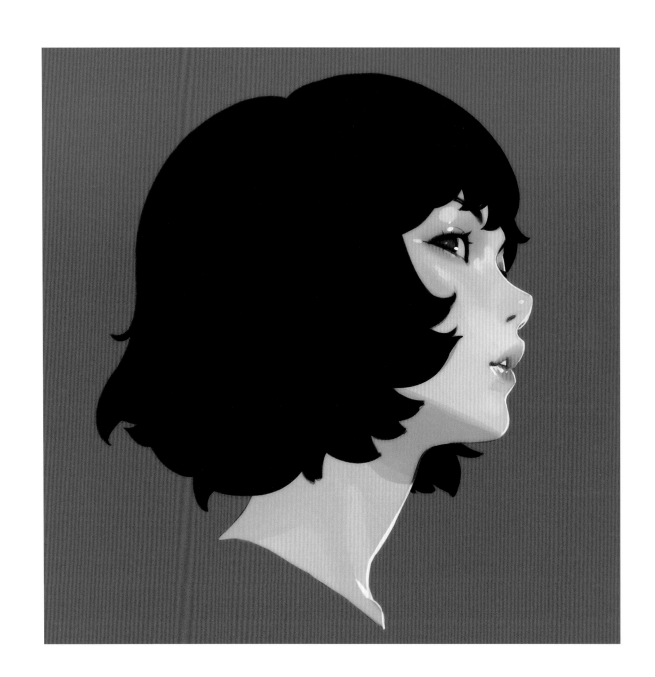

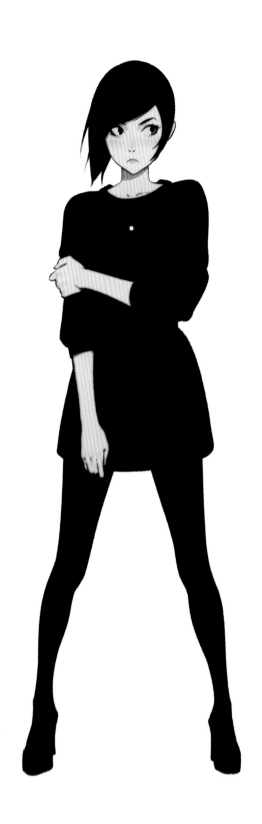

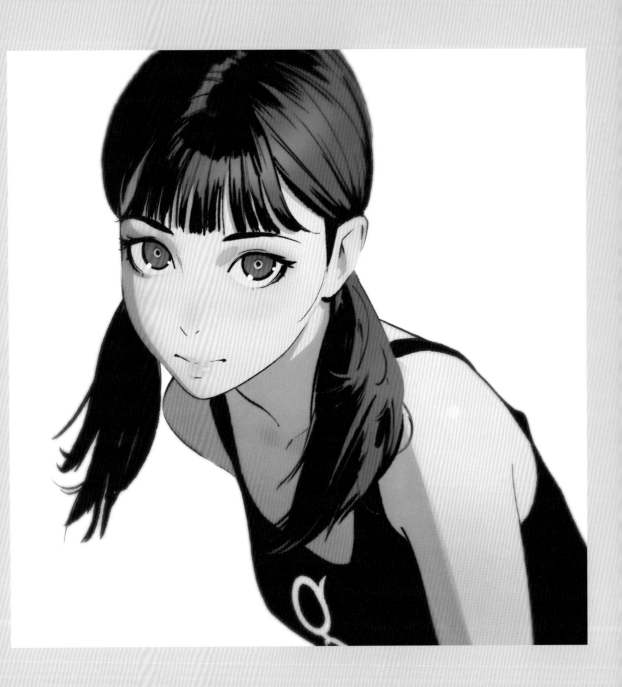

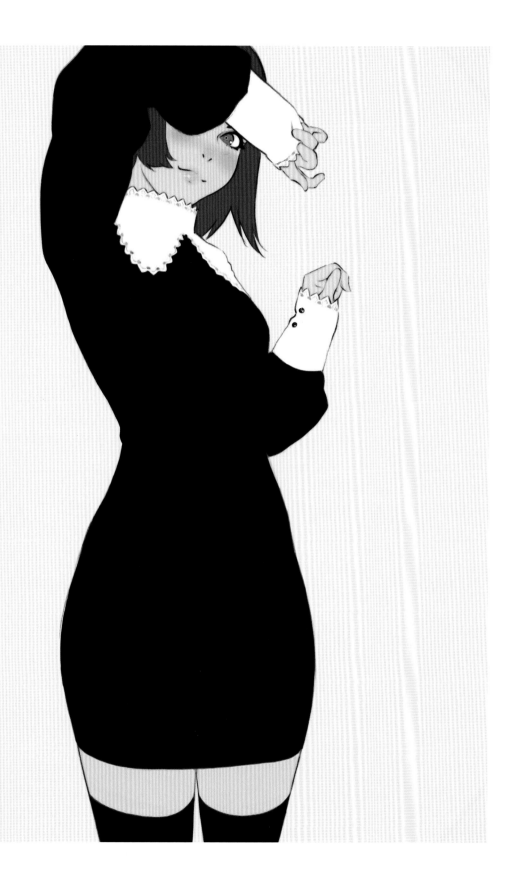

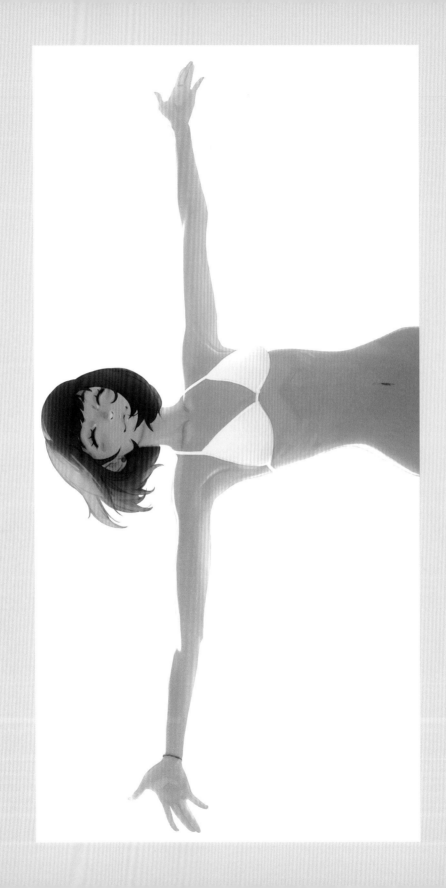

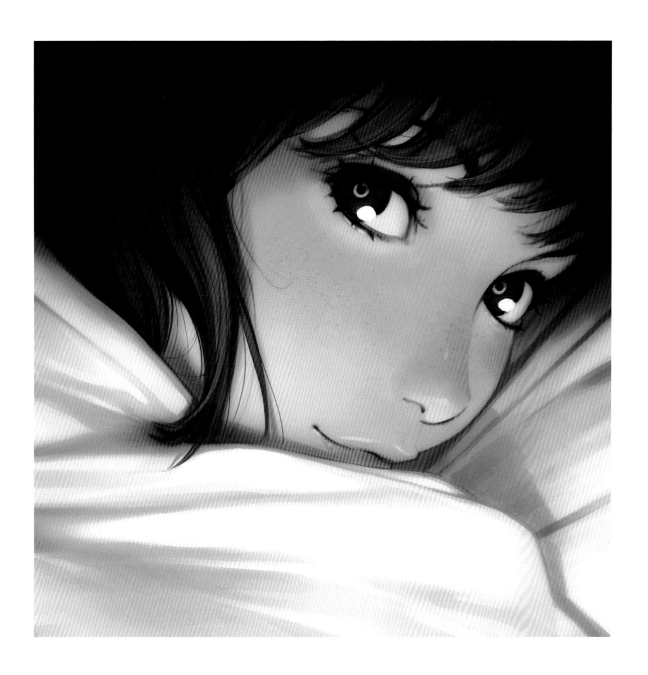

Procreate 作例イラスト (Savage Interactive)
Procreate example illustration (Savage Interactive)

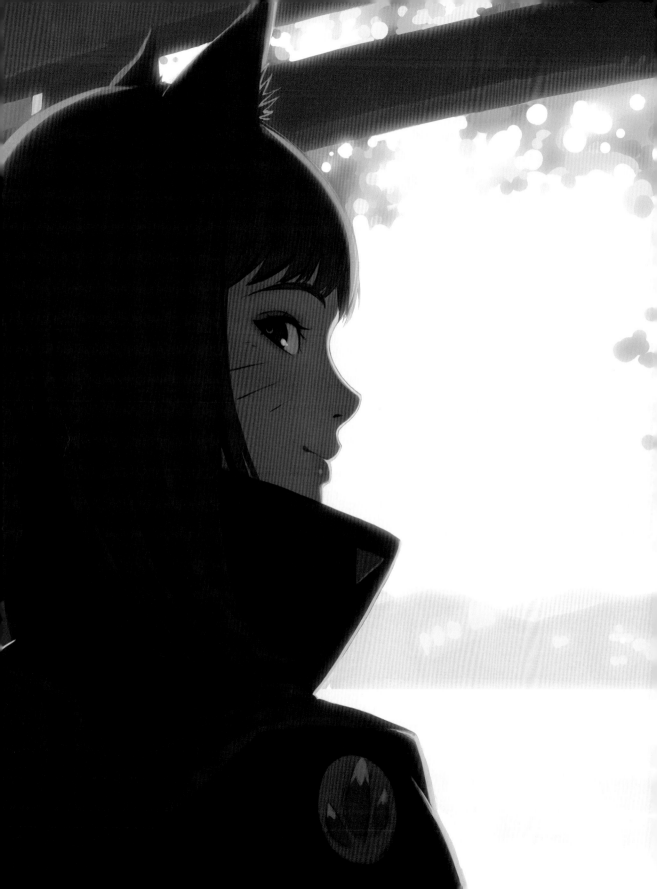

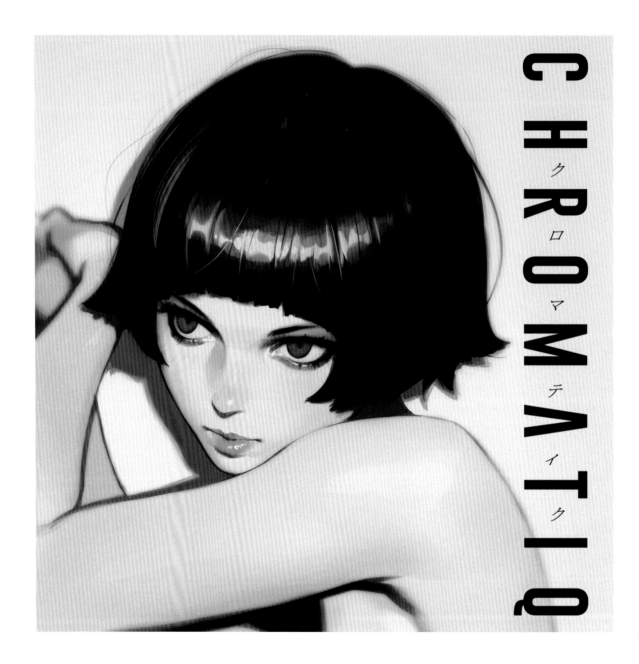

CHROMATIQ クロマティク

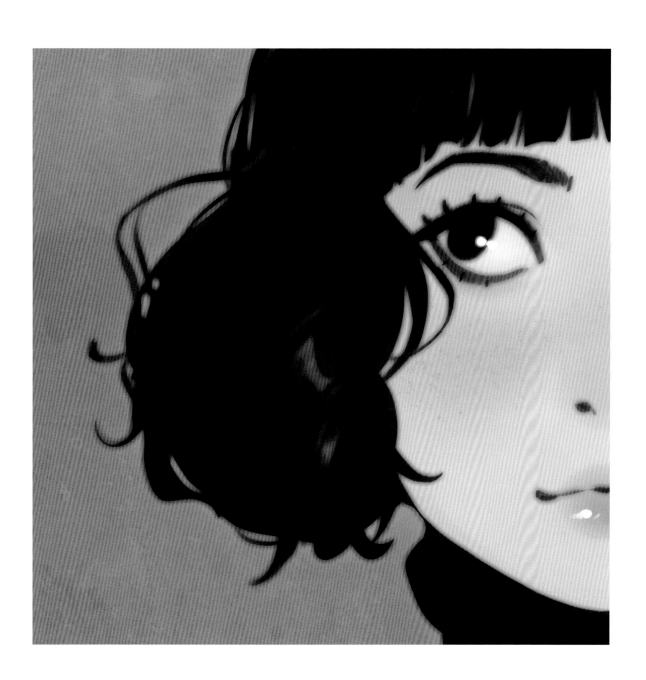

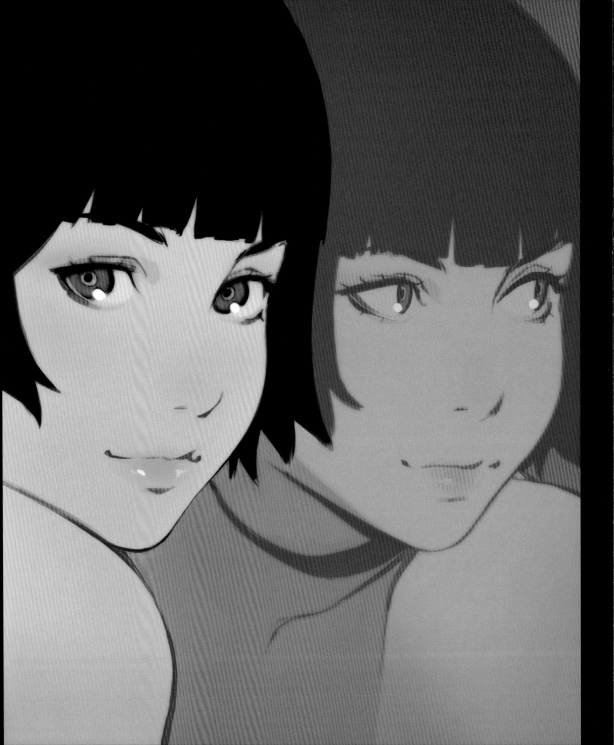

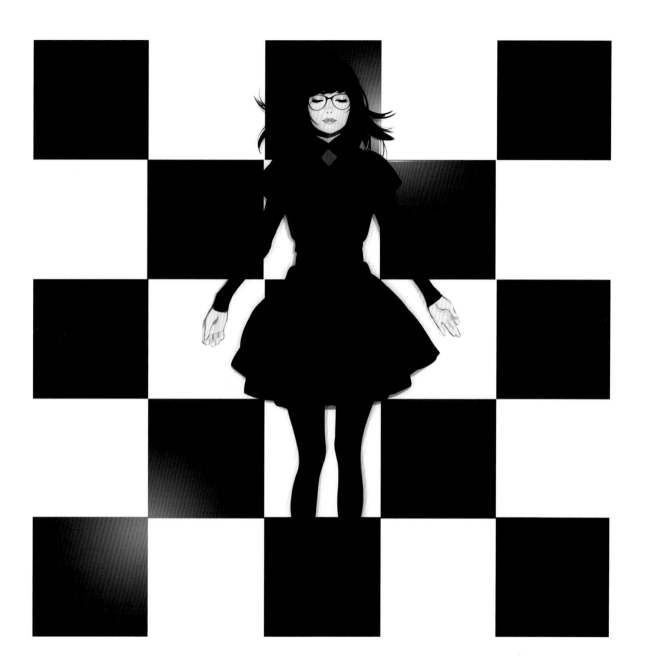

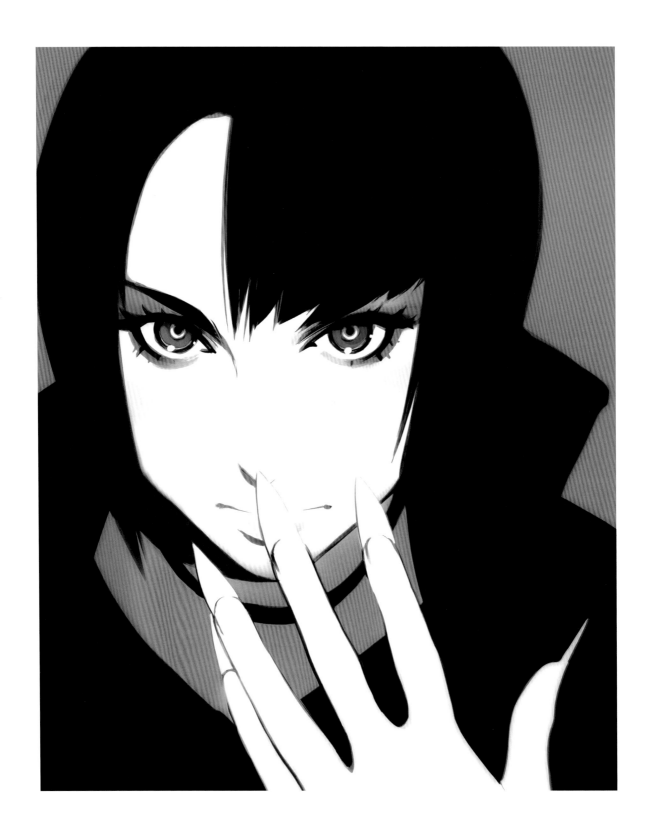

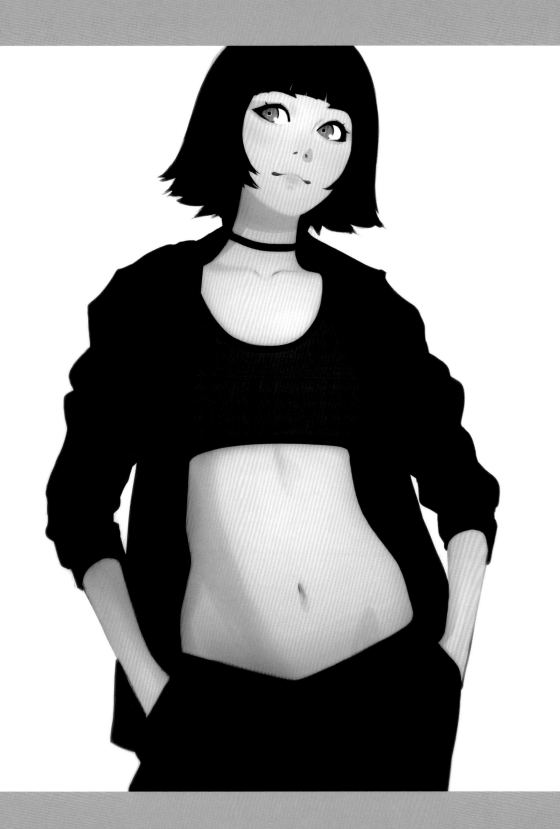

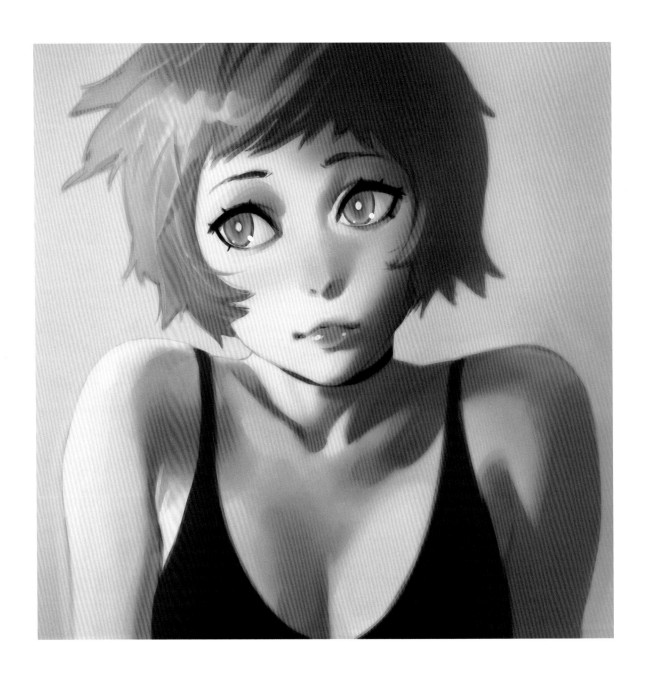

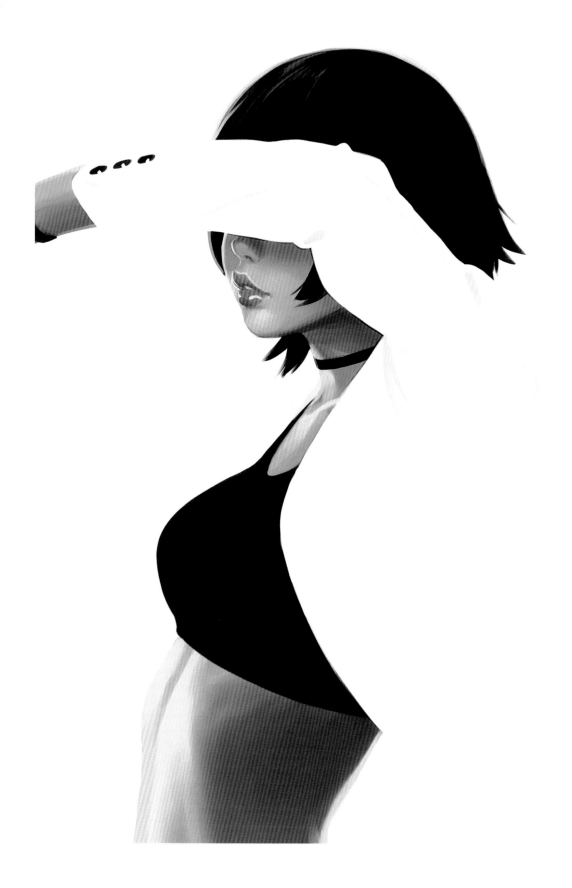

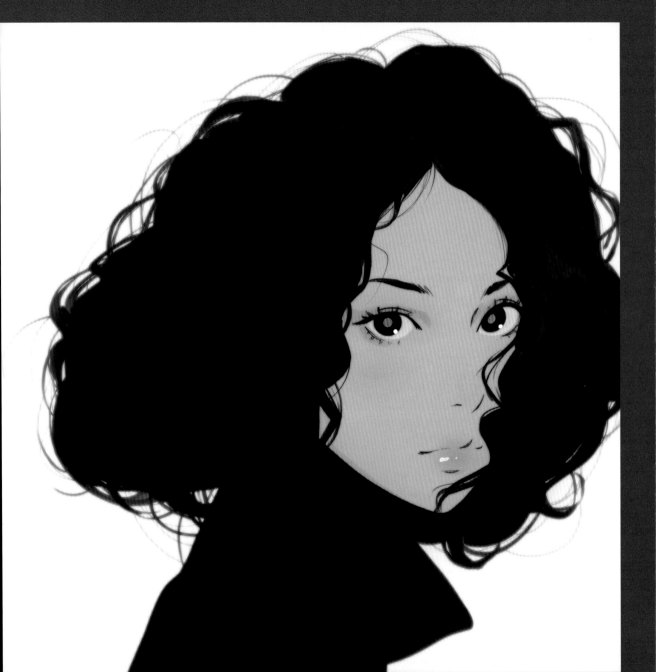

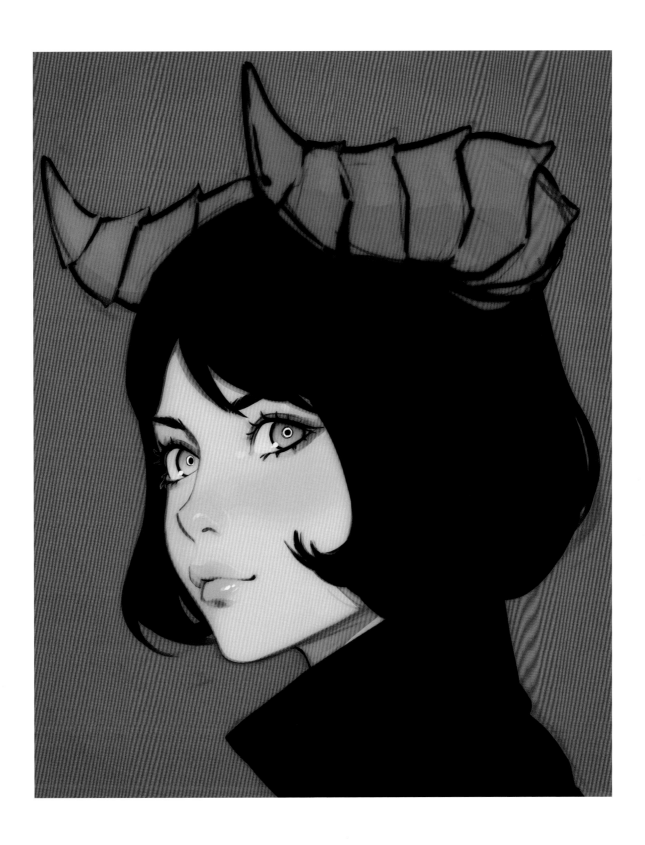

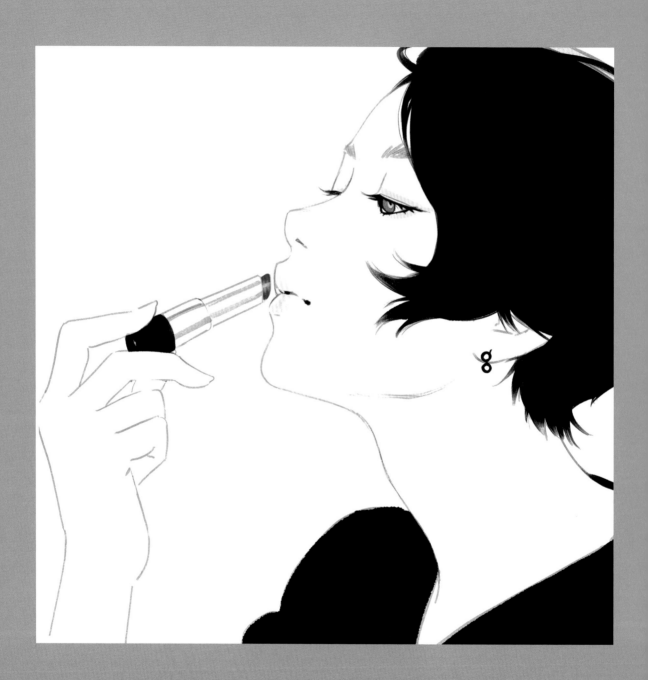

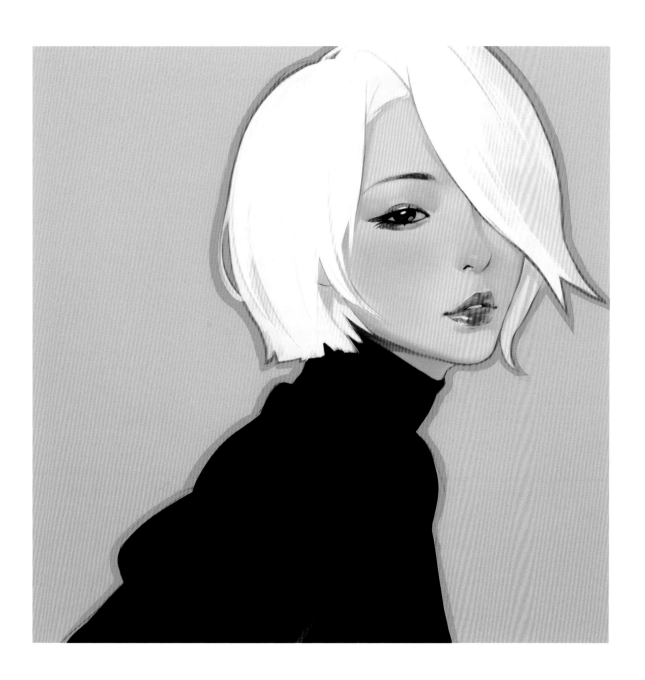

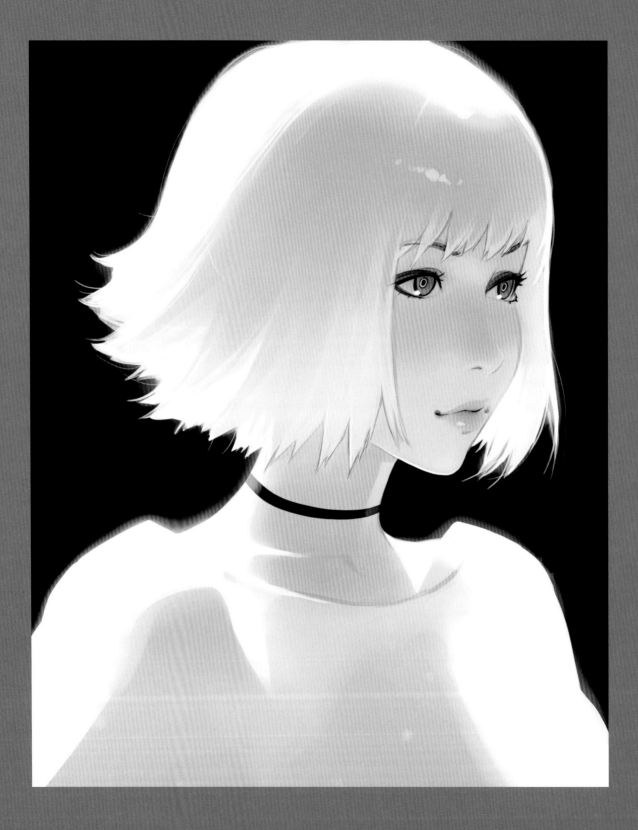

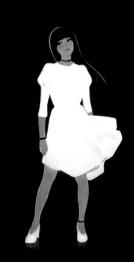

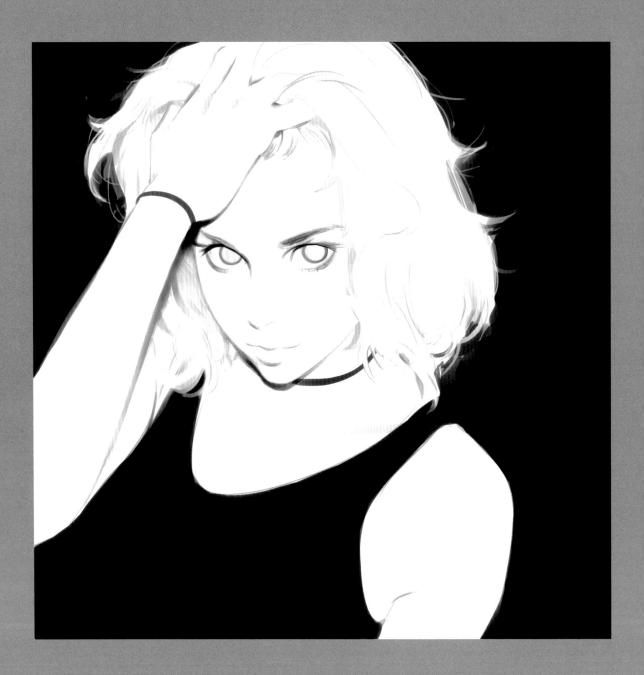

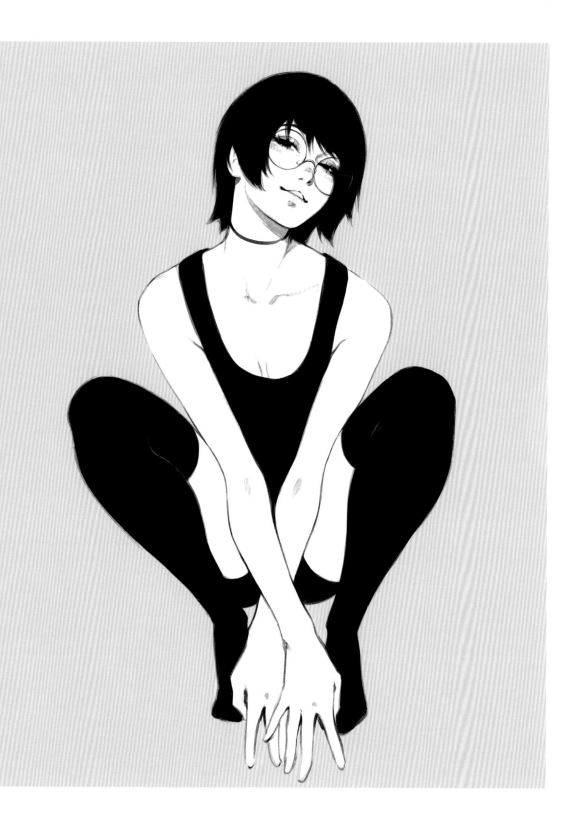

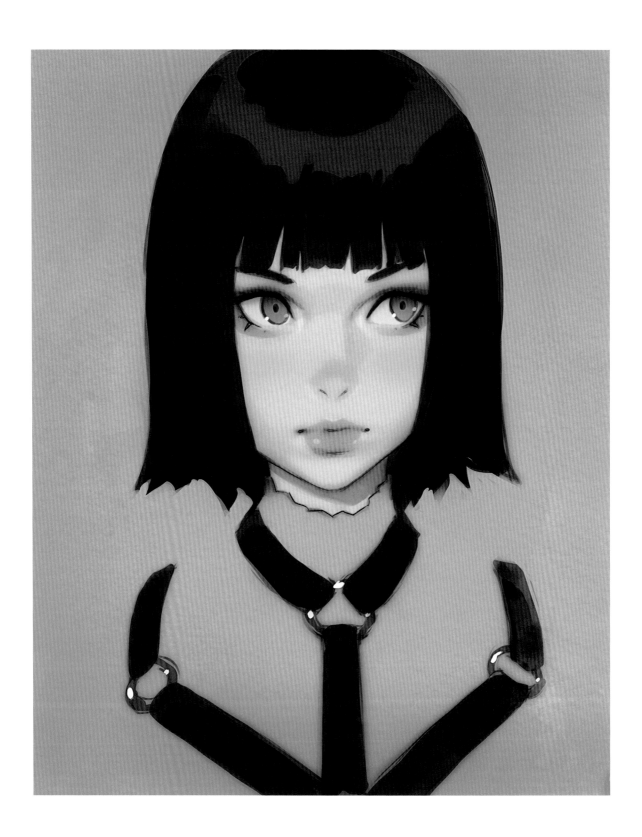

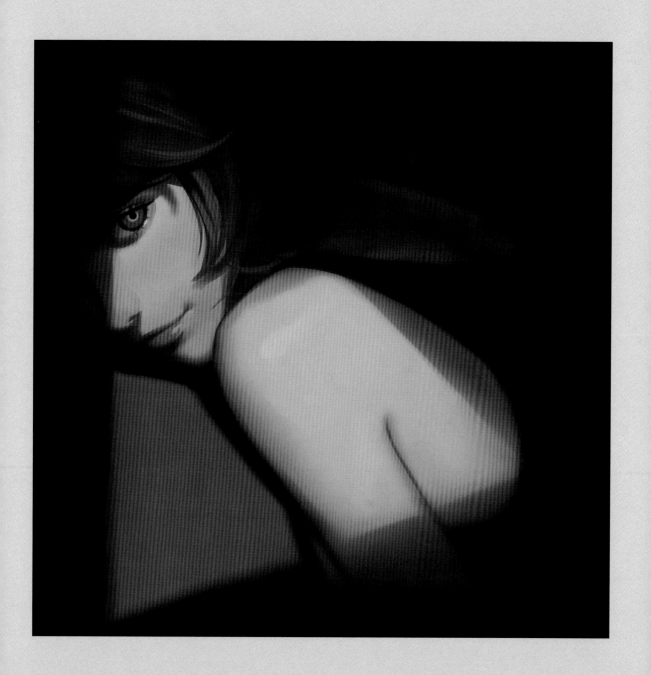

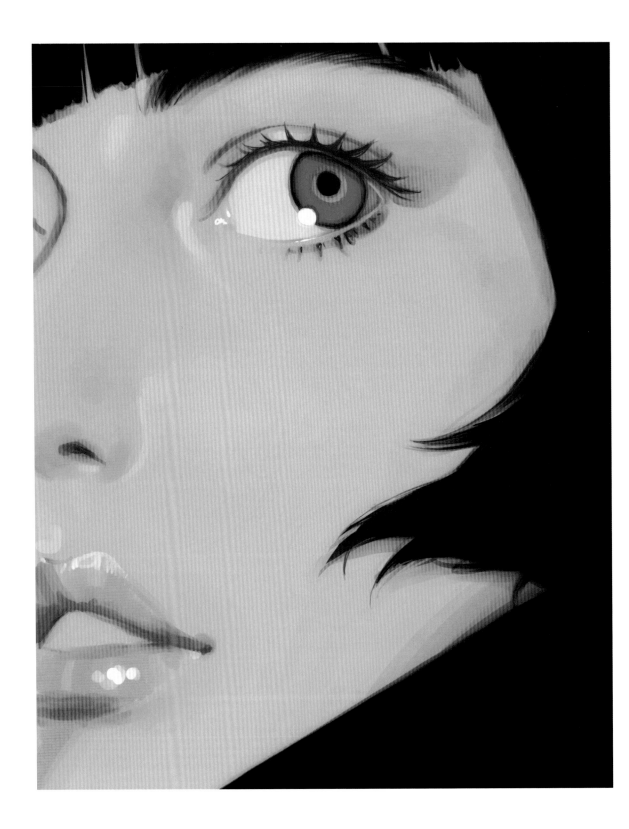

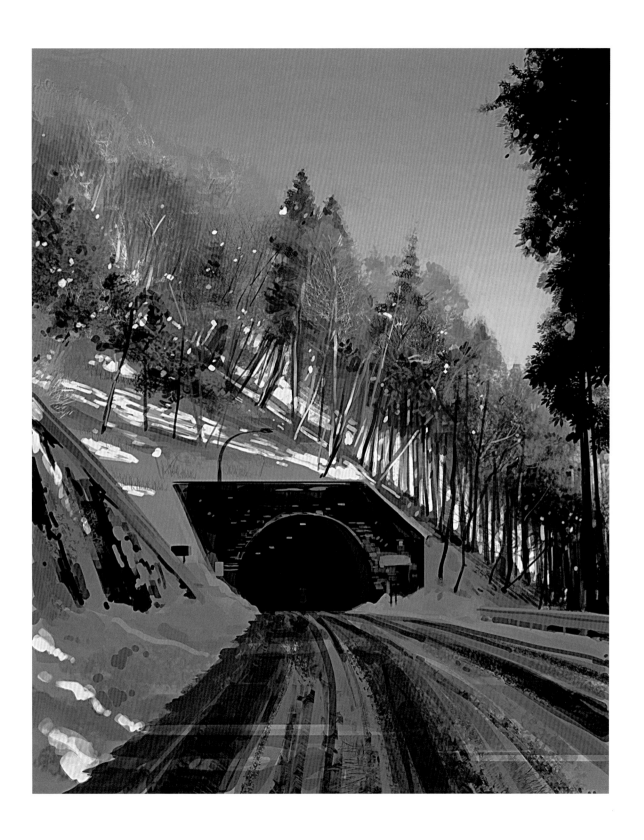

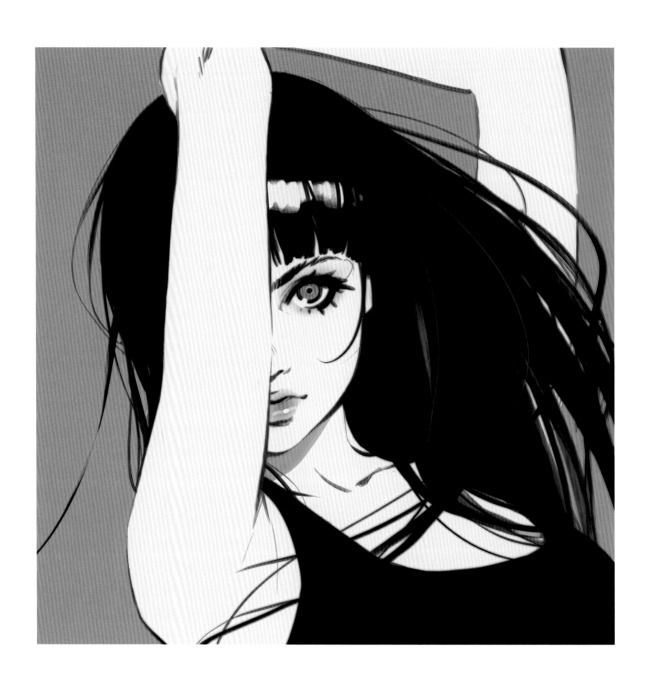

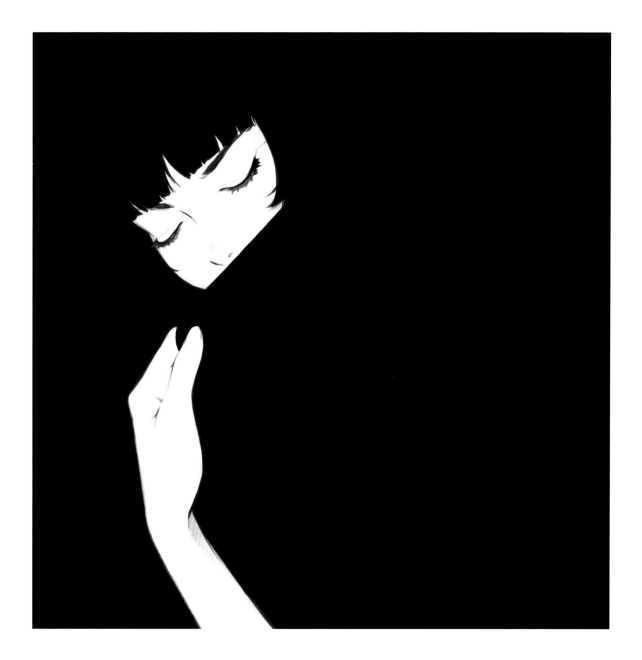

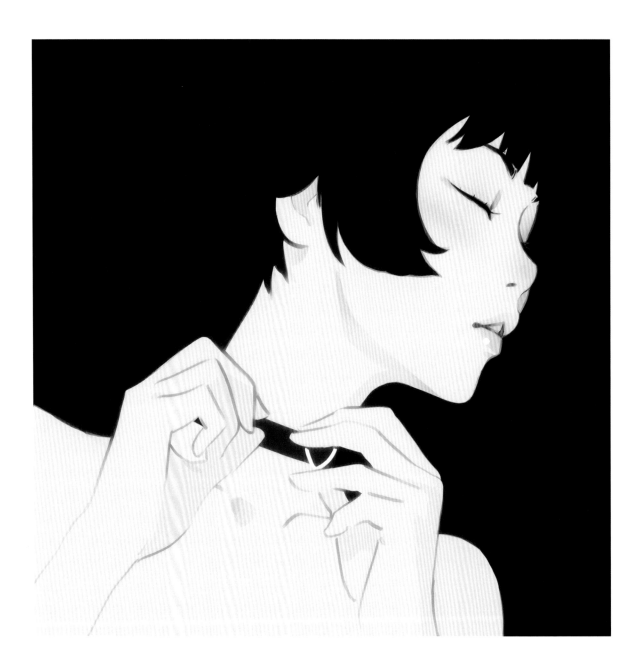

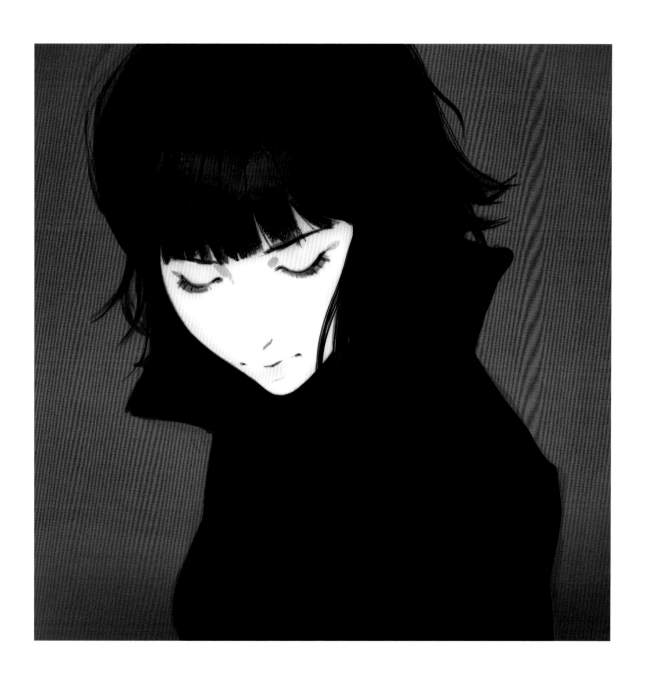

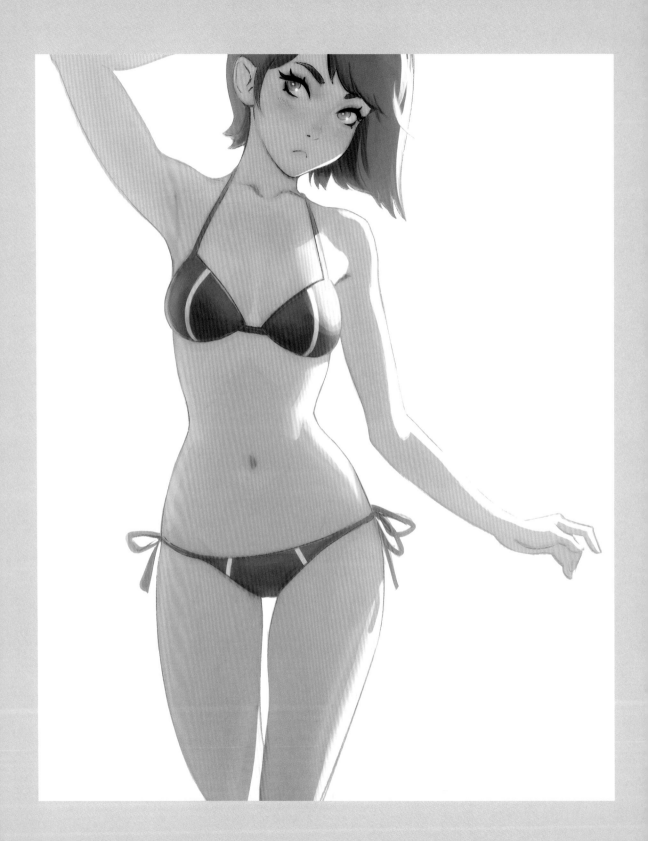

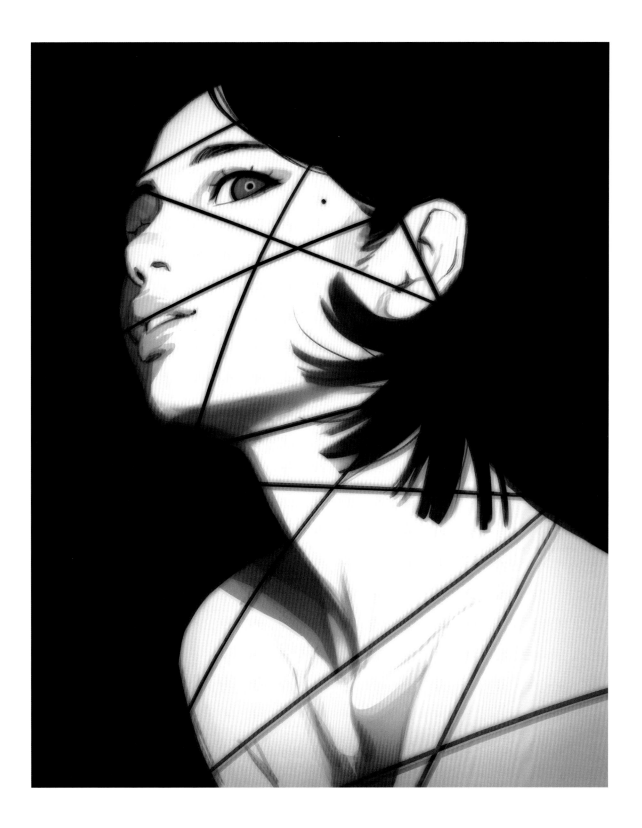

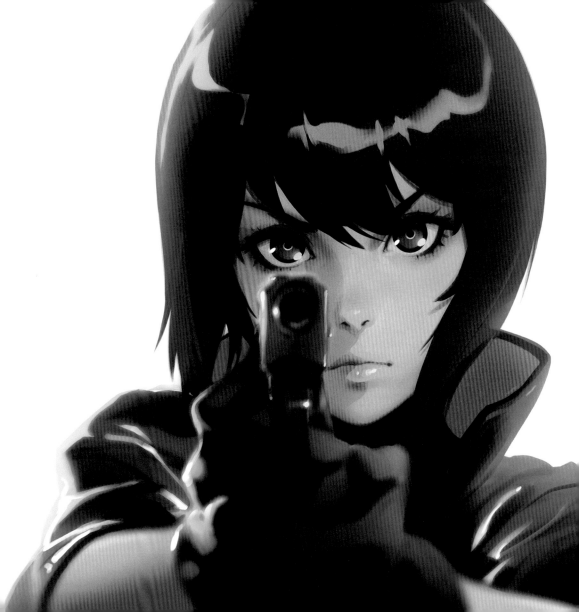

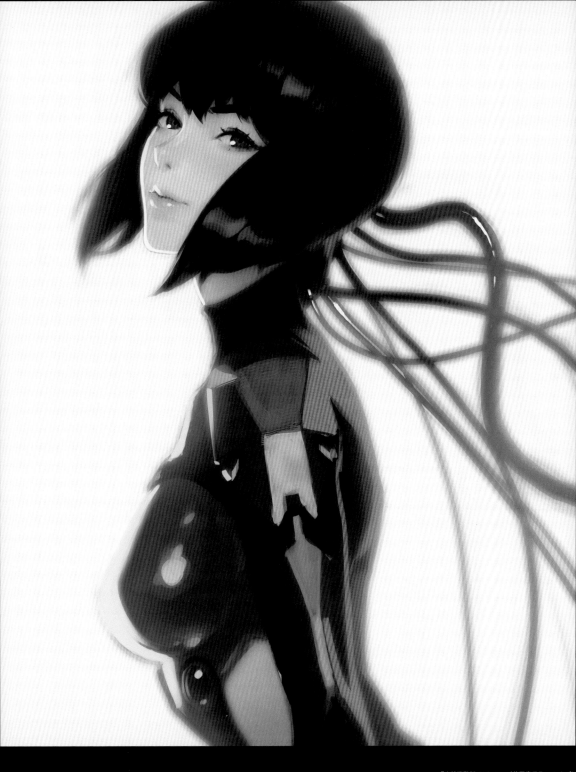

『攻殻機動隊 SAC_2045』草薙素子ラフコンセプト
Motoko Kusanagi rough concept art for *Ghost in the Shell: SAC_2045*

『MOMENTARY』の最後で、今後はマンガや映画、ゲームといったストーリー性を重視した作品に関わっていきたいという夢を書きました。当時は、まさか『MOMENTARY』がきっかけで夢が現実になるとは思ってもいませんでした。

『MOMENTARY』が発売されて書店に並び始めた頃、原 恵一さんという人が、その本をふと手に取りました。原さんは『河童のクゥと夏休み』、『カラフル』、『百日紅〜Miss HOKUSAI〜』などを手がけた映画監督でした。ちょうど次回作の構想を練り始めていた頃で、キャラクターデザインを誰に任せようかと考えていたときに、たまたま立ち寄った書店で私の本を見つけて連絡をしてきてくれたのです。そんな偶然が重なって、日本のアニメーション業界で仕事をするきっかけをいただきました。

すべては偶然から始まったと思うと、少し怖くなります。もし、原さんがその日、書店に行かなかったら？ 私の本が原さんの目に留まらなかったら？ 中ページを確認できる見本が置かれていなかったら？ 発売日が1カ月ずれていたら？ さまざまな要素が完璧なタイミングで完璧に揃わなかったら、その後に起きたことは何ひとつ現実になりませんでした。

原 恵一という偉大な監督とともに映画を制作したこの2年間は、私にとって波乱万丈の冒険でした。コンセプトアーティストからキャラクターデザイナー、メカニックデザイナー、プロップデザイナー、イメージボードアーティストのようなさまざまな仕事を担当させてもらいました。いくつかのシーンでは原画も描きました。ある1分間のシーンでは原画から撮影までを1人でやりました。

その上、原さんのおかげで『攻殻機動隊 SAC_2045』のキャラクターデザインを担当させてもらえることにもなりました。子どものときに見て感動し、一生の仕事を選ぶきっかけになったシリーズの最新作に取り組んでいるなんて、今でも夢のようです。あの幸運すぎる偶然がなかったら、こうしたことは一切起こらなかったに違いありません。夢だったらさめないでほしいと願うばかりです。

これまで私を信頼し、助けてくれた人たちには、どれほど感謝してもしきれません。たくさんの小さな出来事が重なって、夢だった仕事をスタートさせることができました。その一つ一つの出会いや偶然にとても感謝しています。

『MOMENTARY』は、数えきれないほど多くのチャンスを私の人生にもたらしてくれました。そして、そこからもらったエネルギーやインスピレーションが花開き、この『ETERNAL』が生まれました。そうした魔法が、この本を通して皆さんにも届きますように。

In the last pages of *MOMENTARY*, I expressed my desire to work on story-driven mediums such as manga, movies and video games. I had never dreamt that *MOMENTARY* would somehow turn my dream into a reality.

The very first month *MOMENTARY* hit the store shelves, Keiichi Hara happened to stumble upon a copy. He also happened to be the director of *Summer Days with Coo, Colorful* and *Miss Hokusai*. At the time, he was in the early stages of developing his next movie and in search of someone who could create character designs for it. Thanks to this fortuitous visit to a bookstore, he decided to contact me after browsing through my work. This opened the door to my first job in Japan's animation industry.

It's kind of scary when I realize this was just blind luck. What if he hadn't gone to the bookstore that day? What if he didn't see my book, or if an unsealed copy hadn't been available for browsing? What if my book had gone on sale just a month later, or a month earlier? All of what has come to pass would never have done so if it weren't for each element aligning perfectly at the perfect time.

My two-year-long journey of working together with the truly awesome Keiichi Hara on his movie was an eventful one. I've worn many hats: working as a concept artist, character designer, mecha designer, props artist and image board artist, and I even got a chance to animate some scenes of the movie myself.

And also thanks to Keiichi Hara, I was gifted with the opportunity to do character designs for the next *Ghost in the Shell* series. I am currently working on the latest installment of the very IP that so impressed me as a kid it made me decide that this was what I wanted to do for life! I still can hardly believe it. None of these things would be a reality now if it weren't for that ridiculous stroke of luck. The thought truly scares me.

To all the awesome people who believed in me and helped me along the way, I cannot thank you enough. So many small events came together to kickstart my dream career, I am grateful for every single one.

MOMENTARY brought so many gifts of opportunity into my life. *ETERNAL* is the flower of its energy and inspiration. I hope that magic can reach you through these pages.

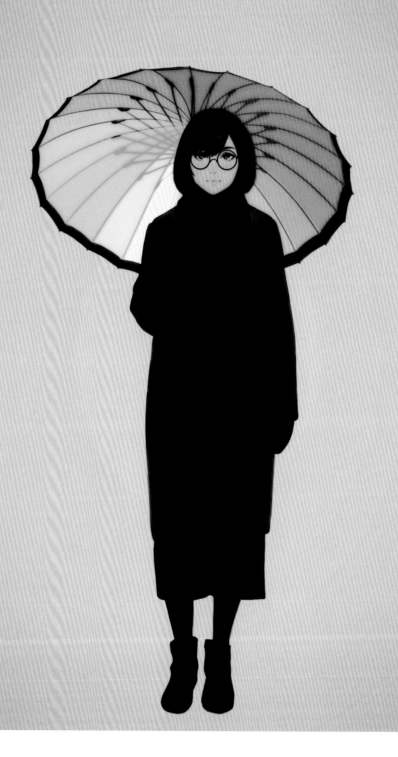

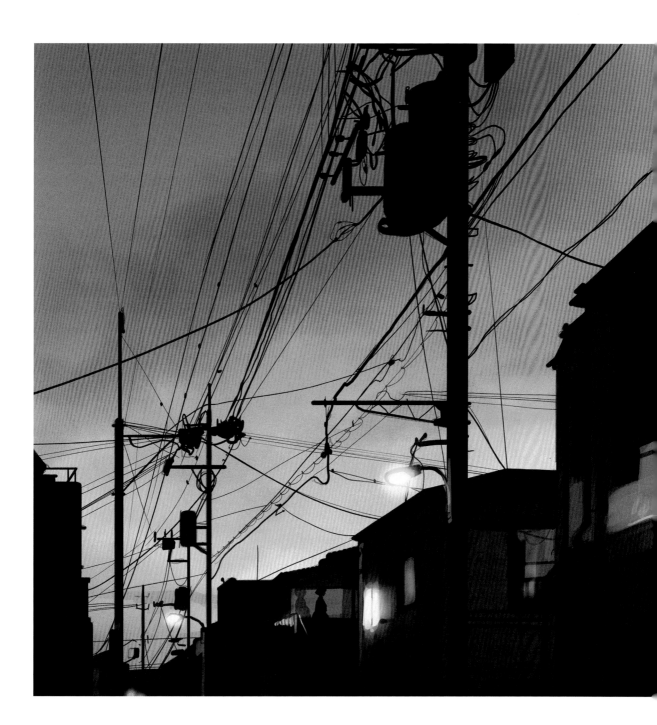

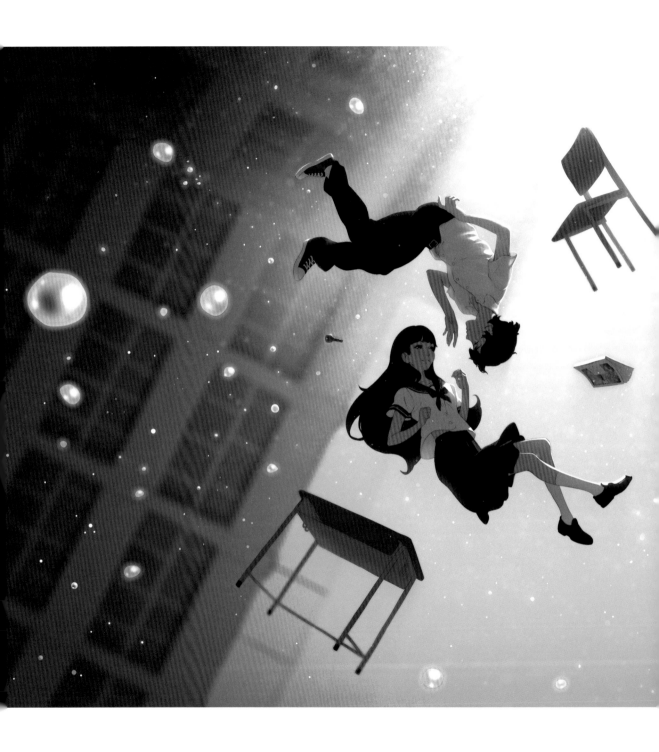

『パドルの子』(虻川 枕 著 / ポプラ社)カバーイラスト
Cover illustration for *The Summer Puddle With You* (by Abukawa Makura, published by POPLAR Publishing)

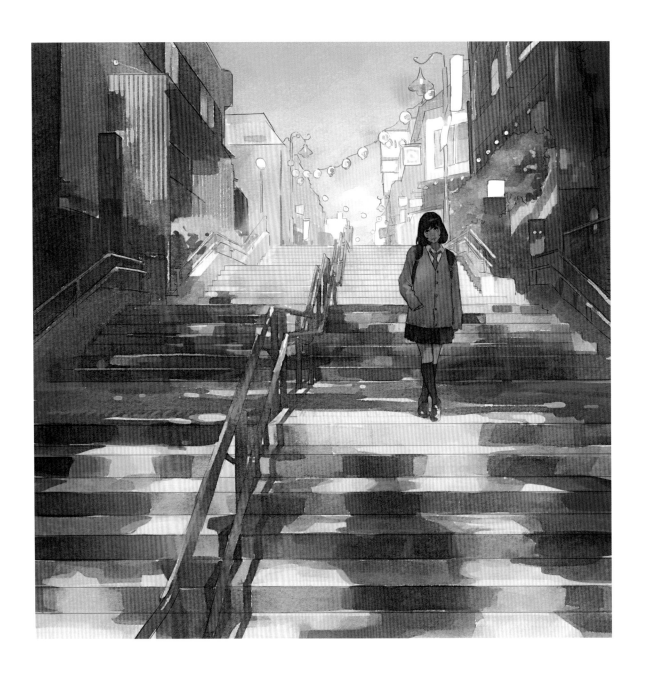

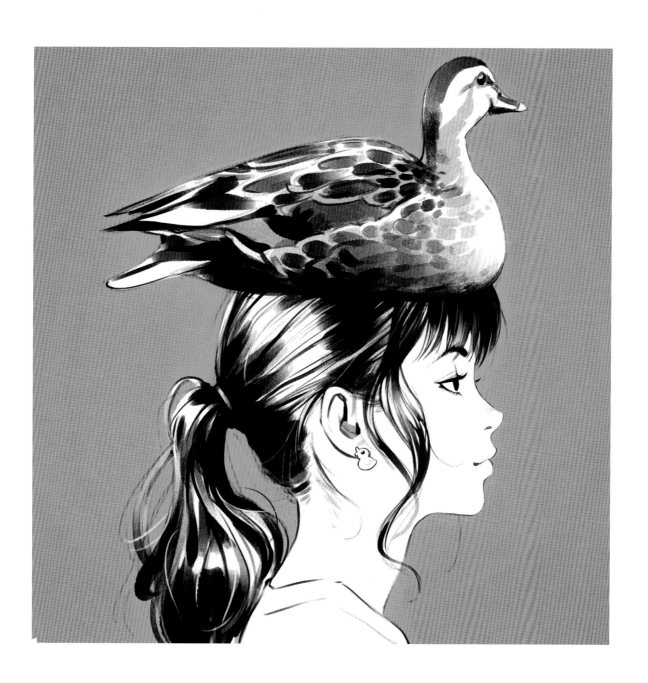

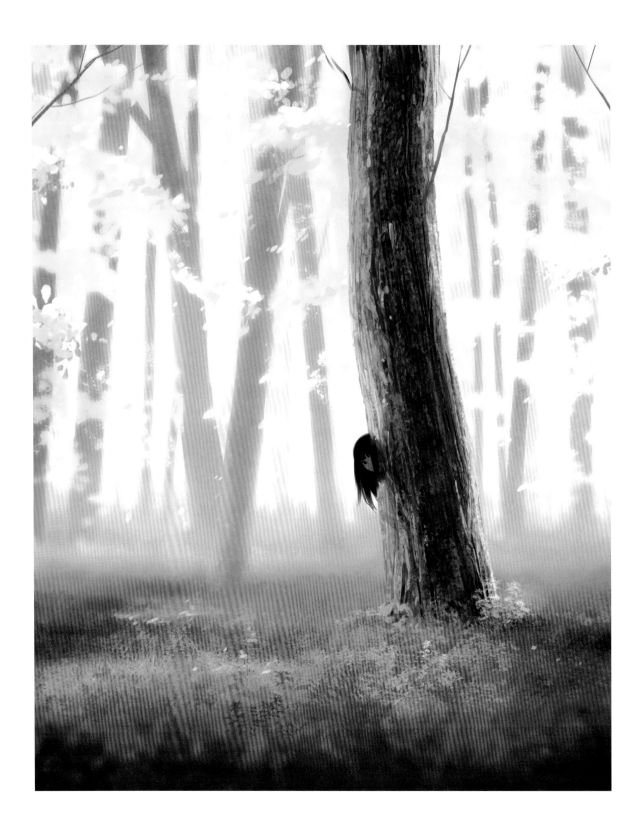

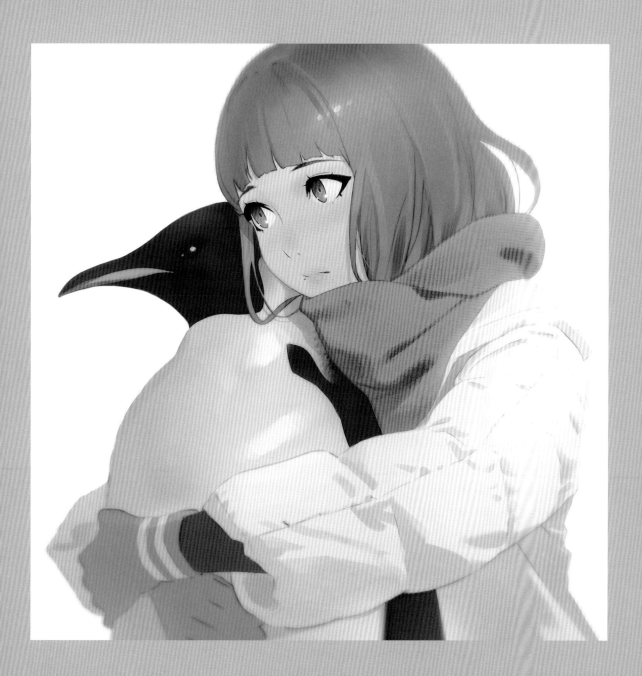

ARTivismチャリティーイラスト
Commission for Pangeaseed Foundation's ARTivism program to save the oceans

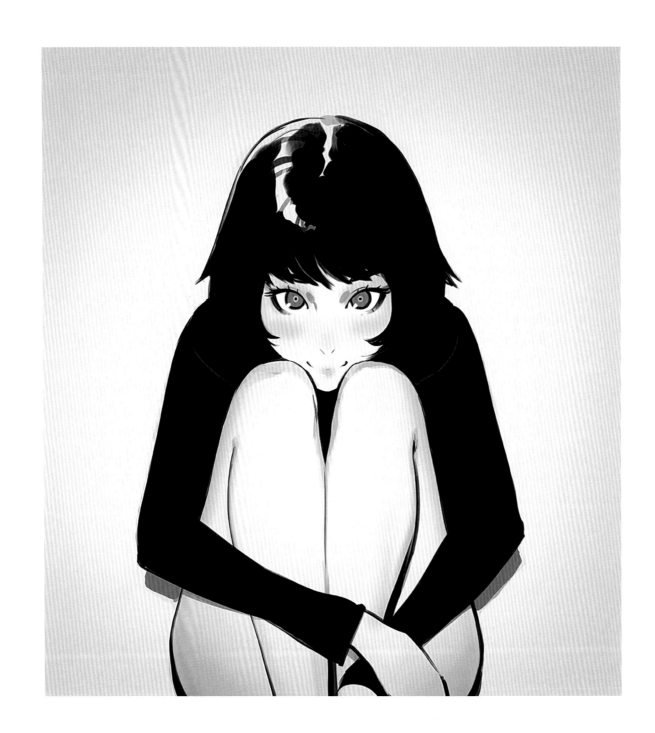

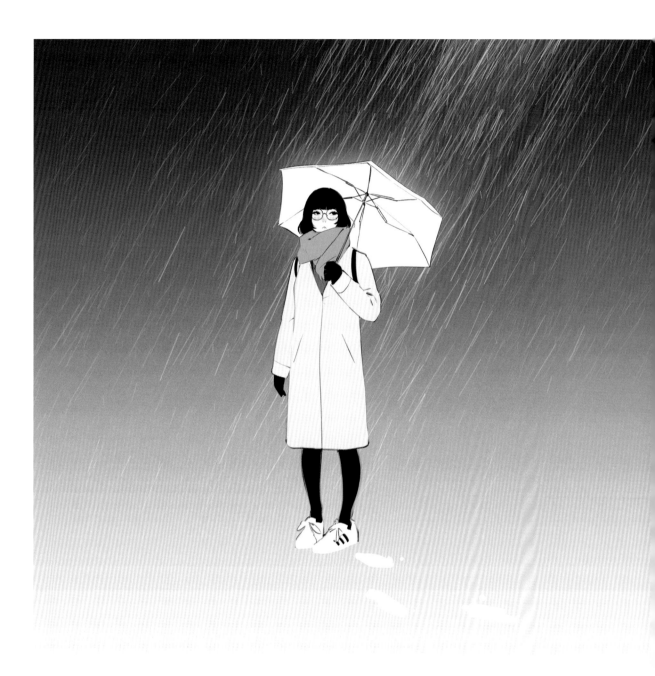

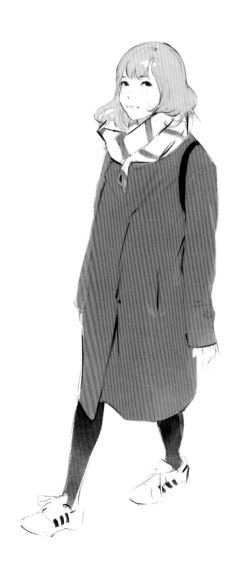

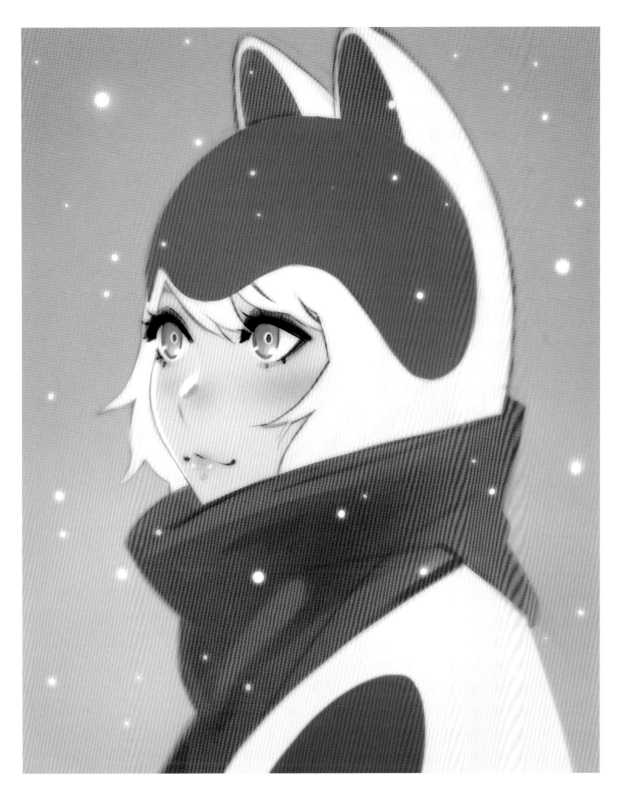

ライブドローイング「pixiv ONE」描き下ろしイラスト
Illustration drawn for pixiv ONE live drawing event

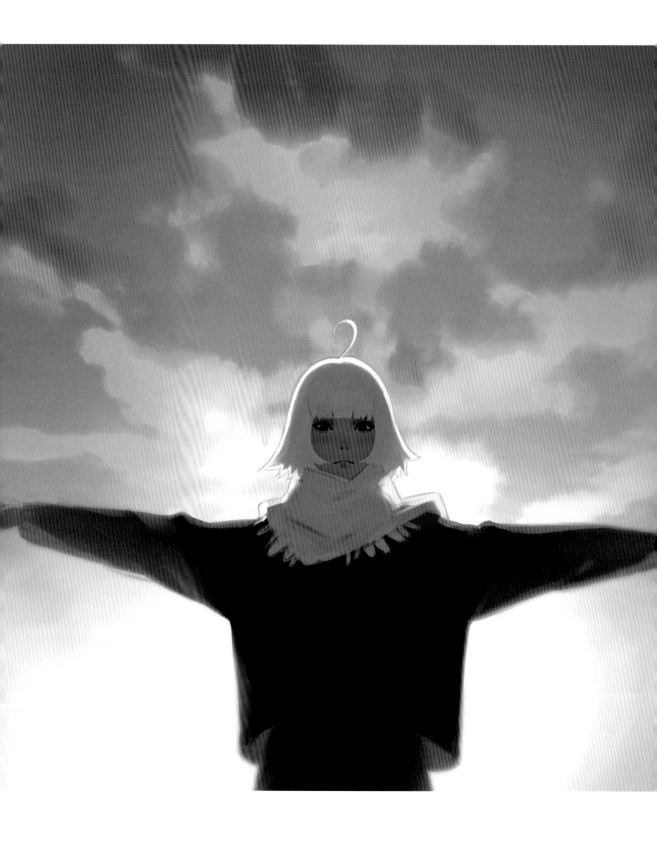

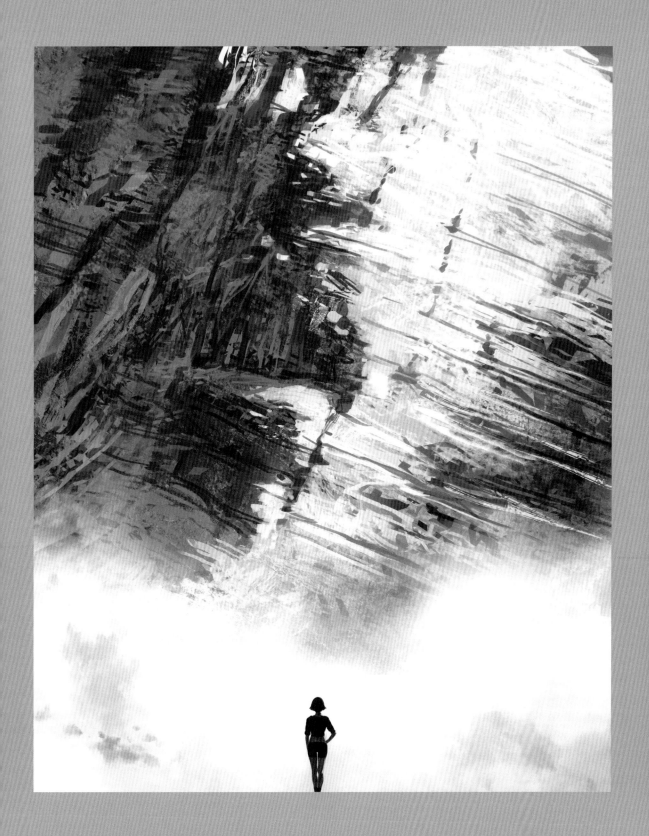

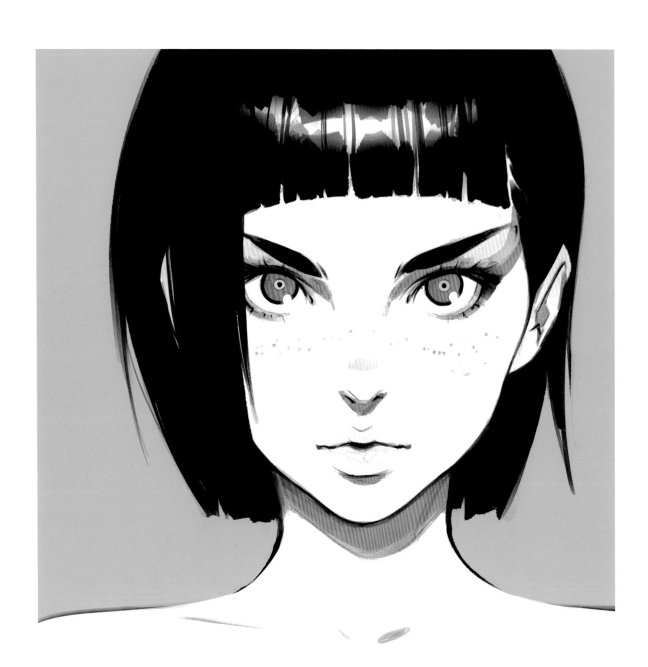

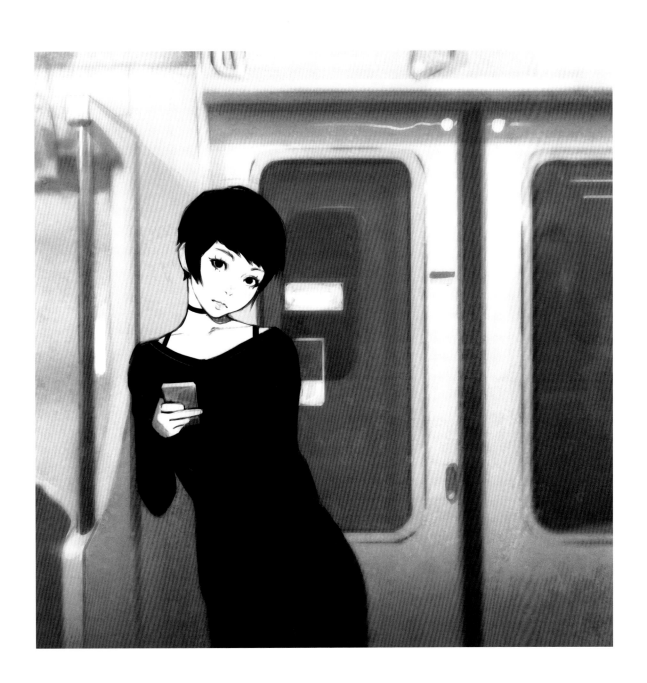

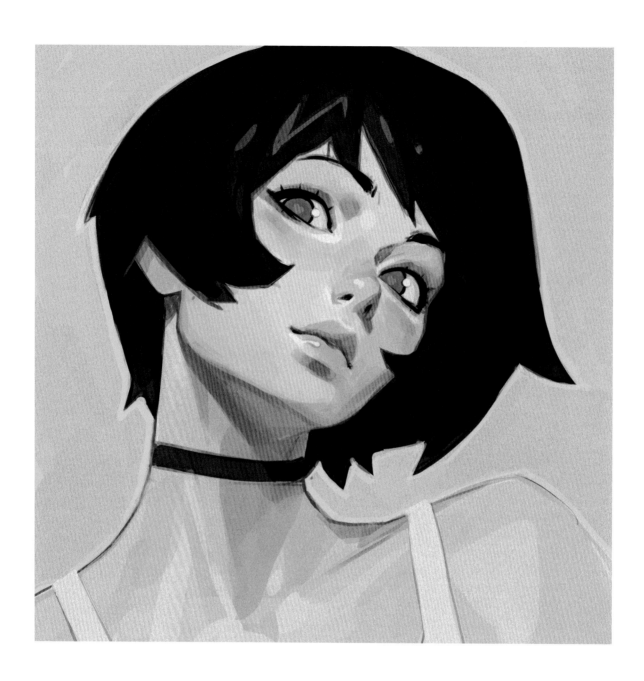

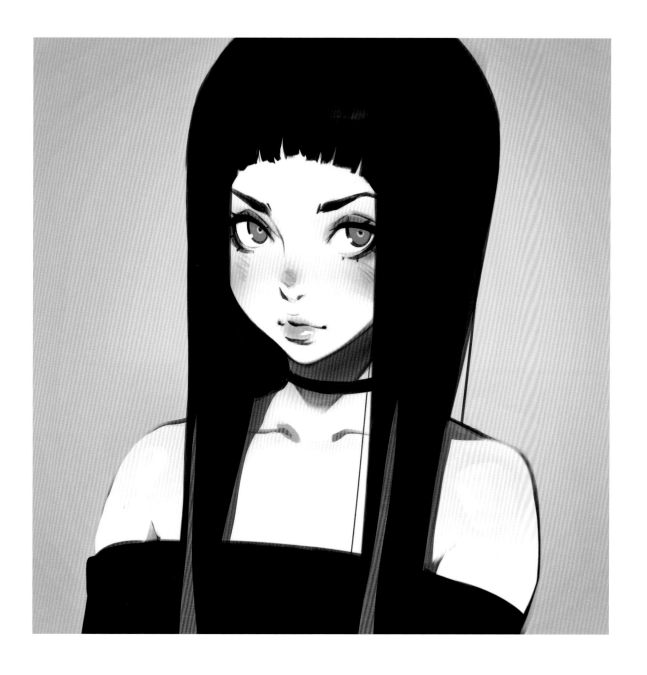

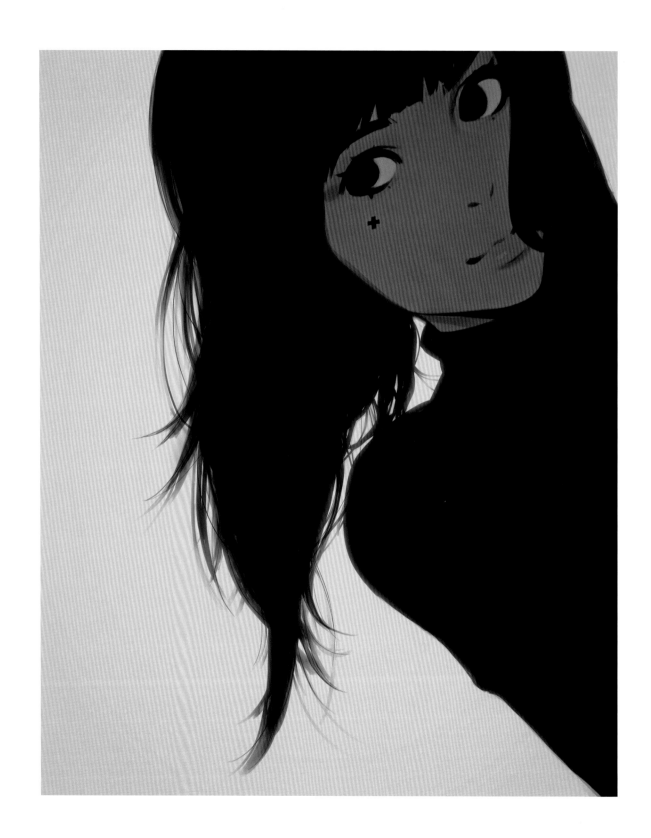

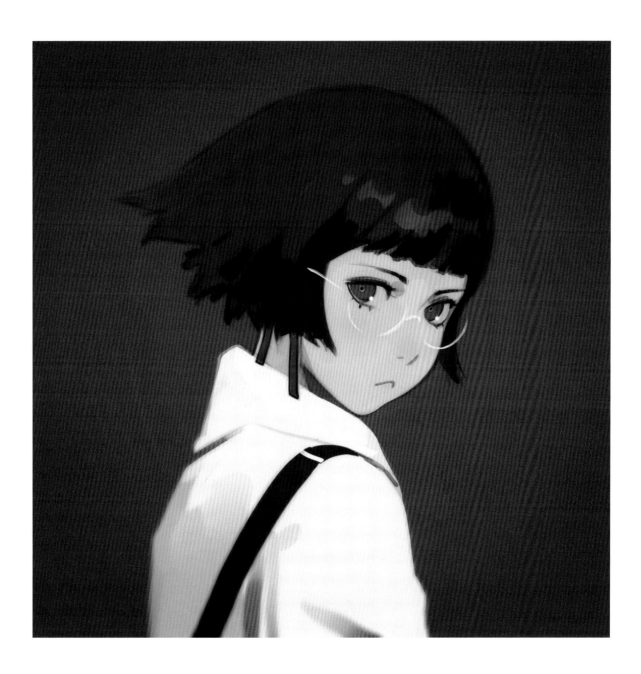

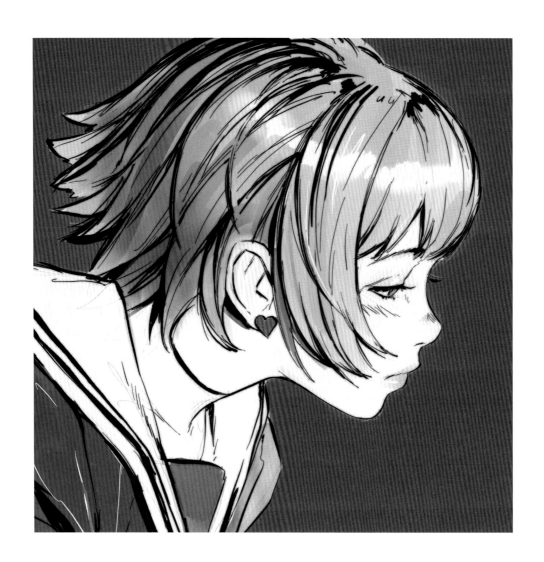

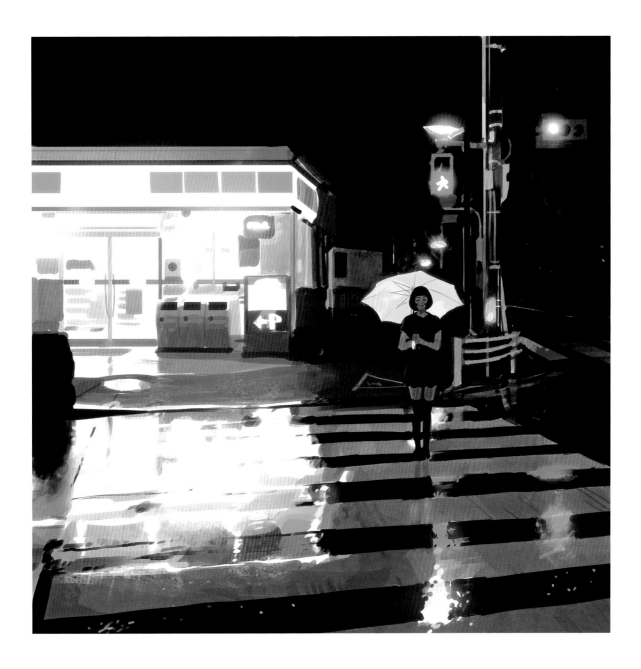

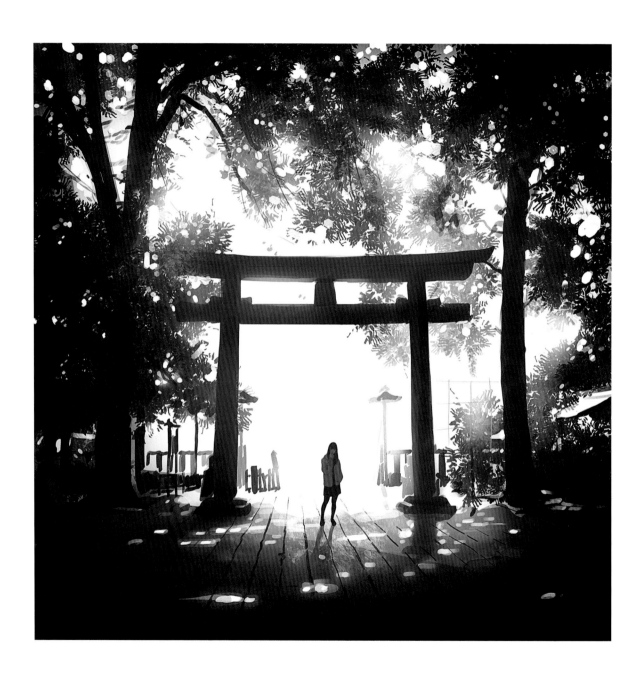

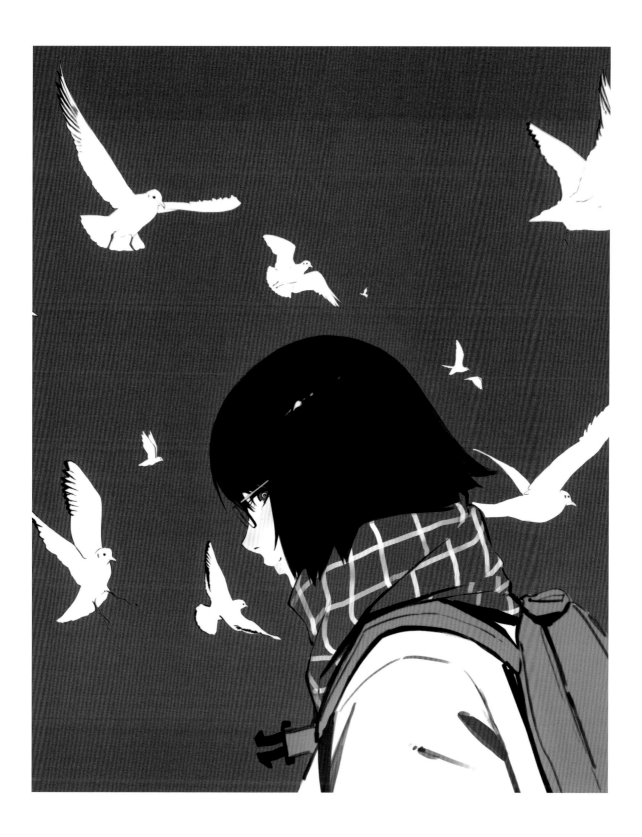

日本のアニメーション業界で3年間働いたことは素晴らしい経験でした。才能あふれるたくさんの方々と仕事ができて本当に楽しかったし、アニメーションを制作する工程、その膨大な量の作業のすべてから、アーティストとしてだけでなく、人間としても成長するきっかけをもらいました。自分の「安全地帯」から足を踏み出さざるを得なくなり、感情を伝え、アイデアを引き出すために、作品制作のアプローチをがらりと変えたこともありました。

この本をつくることになったとき、グラフィックっぽい、シルエット重視のスタイルで、シンプルな構図の作品を基調にしようと思いました。作品のエッセンスに関係のない余分なディテールを省いてシンプルにすることで、さらに心地良い作品になります。コンセプトや感情もはっきりします。

実を言うと、こうしたミニマルなスタイルの方が今はしっくりくる気がしています。もちろん、大勢の人に私の名前を覚えてもらえるきっかけとなった、レンダリングされたリアリスティックなスタイルも気に入っていますし、『MOMENTARY』ほどではないけれど、この画集にはそういった作品もいくつも含まれています。でも、私にとってイラストで重要なのは技術的な要素ではありません。見る人にどんな感情を持ってもらえるかです。この本のページを通して、そんなつながりを皆さんとの間に生み出せることを願っています。

Working in the Japanese animation industry for three years was an awesome experience that I felt left me empowered and enlightened. I treasure all the wonderful people with whom I worked. From technical animation production through to the enormous amount of other work, it all helped me grow both as an artist and person. I was forced out of my comfort zone, sometimes drastically changing my illustration approach to communicate emotions and inspire ideas.

As you can see, the vision I had for this book was graphical, silhouette-heavy and refined in composition. When I eliminate unnecessary details that don't contribute to the essence of the piece, the simplified result is more pleasant. Beyond this, the concept and emotion is clearer, as well.

If truth be told, I enjoy this minimalistic style a bit more than the semi-realistic, camera-and-lens heavy rendered pieces by which you may have come to know me. While there were more of the latter in *MOMENTARY*, there are also a number of them to enjoy in this book. I like both styles, but what matters to me in any illustration is not the technical aspects, but what feelings it evokes in the viewer. I hope you can feel the connection I want to create through the inks that grace these pages.

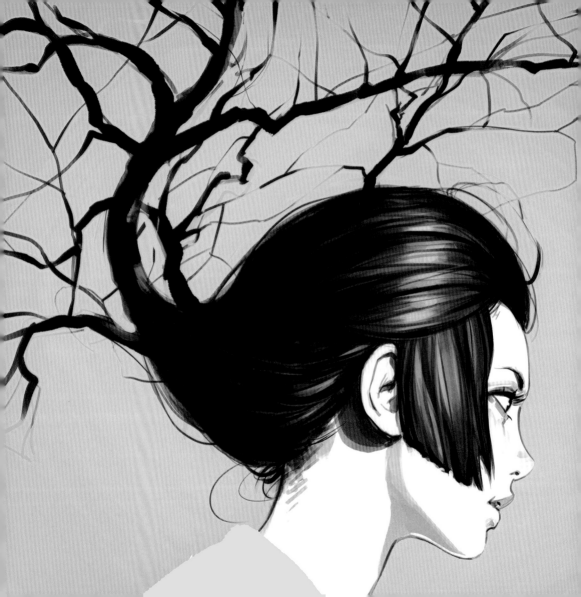

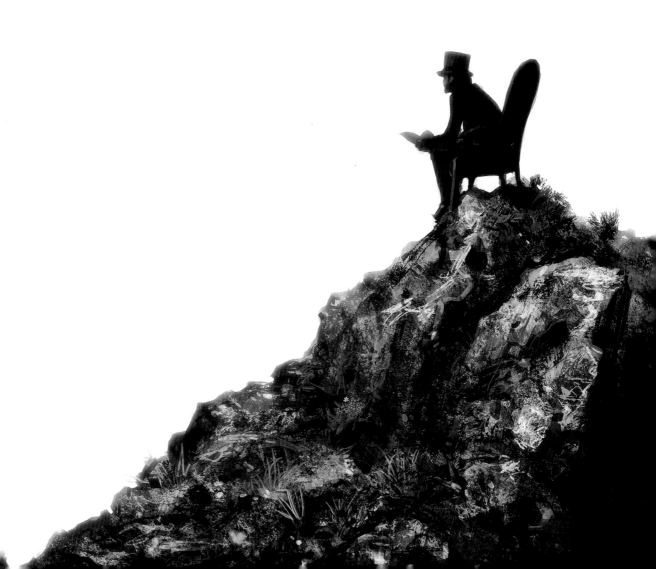

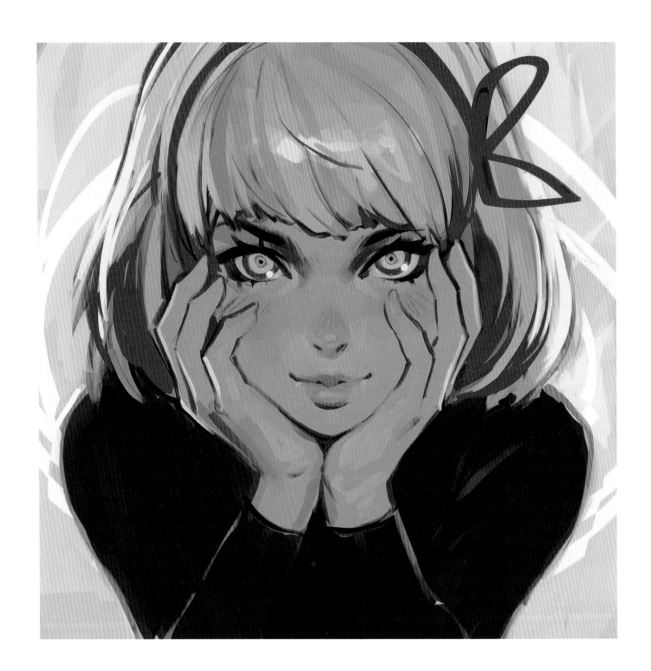

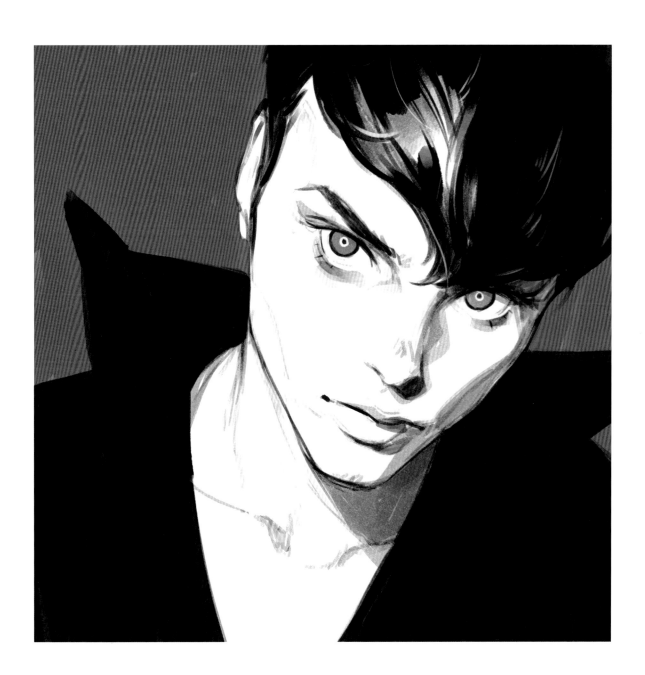

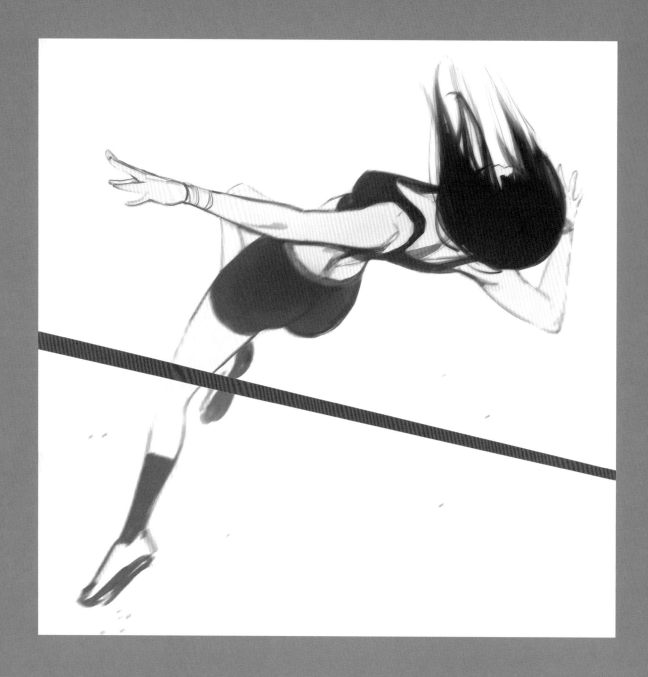

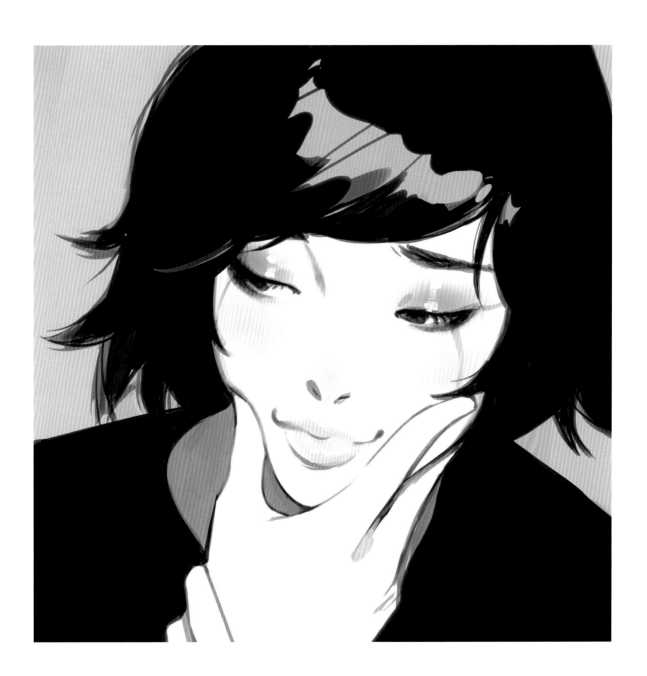

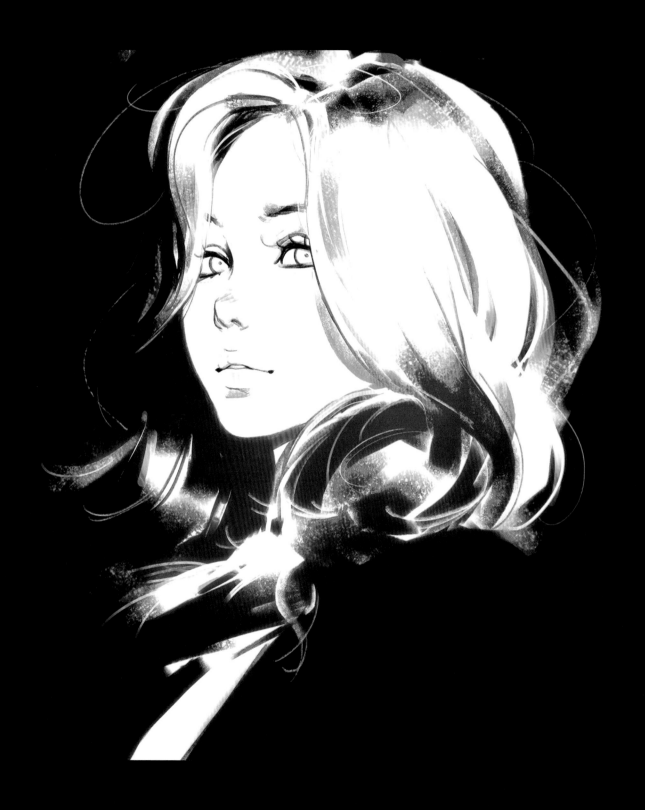

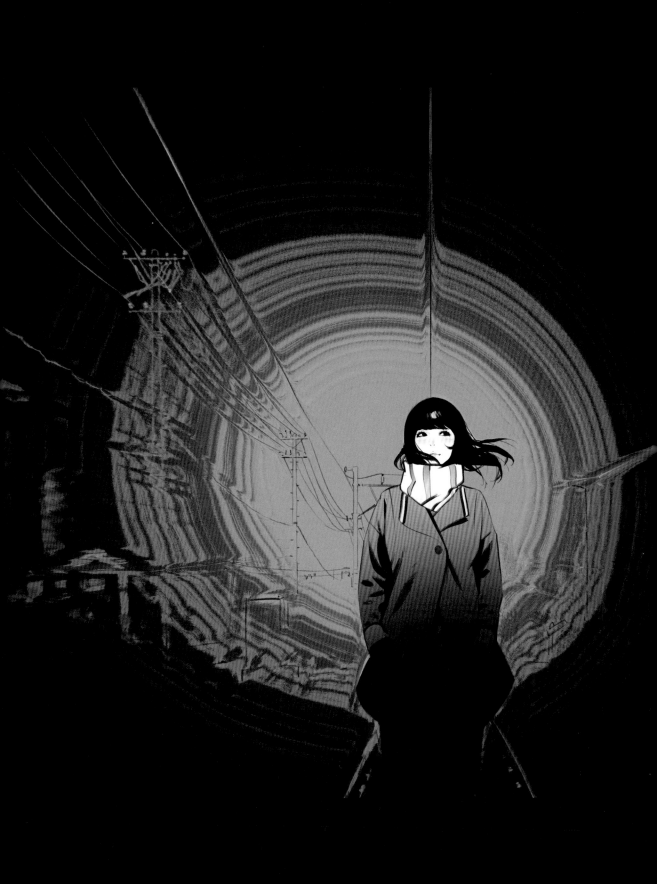

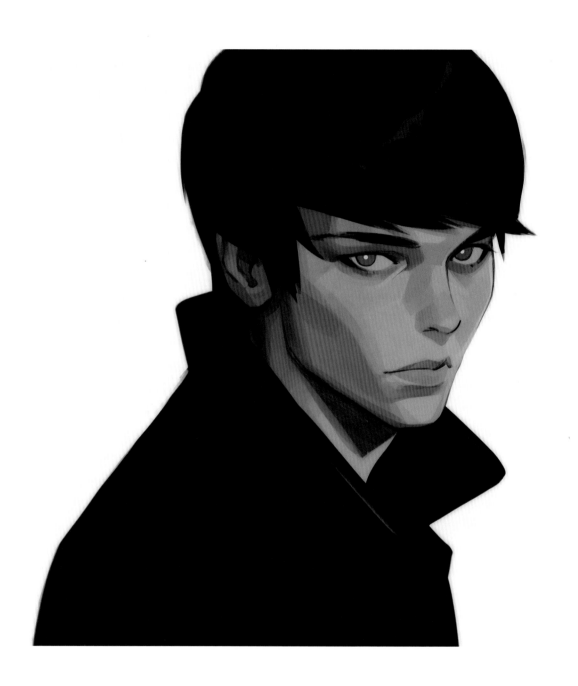

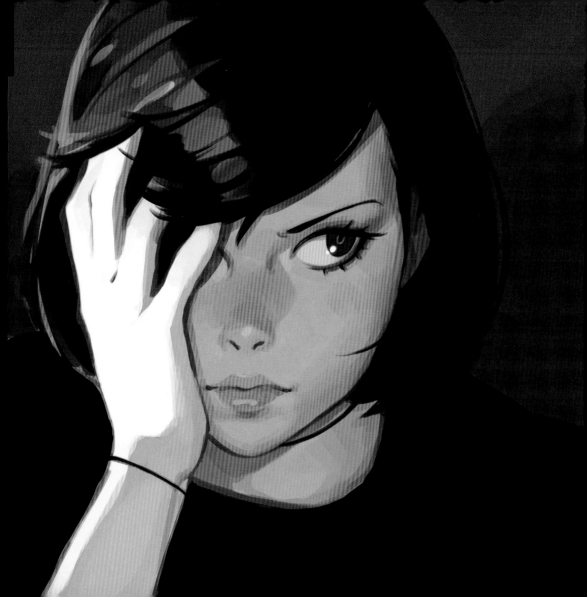

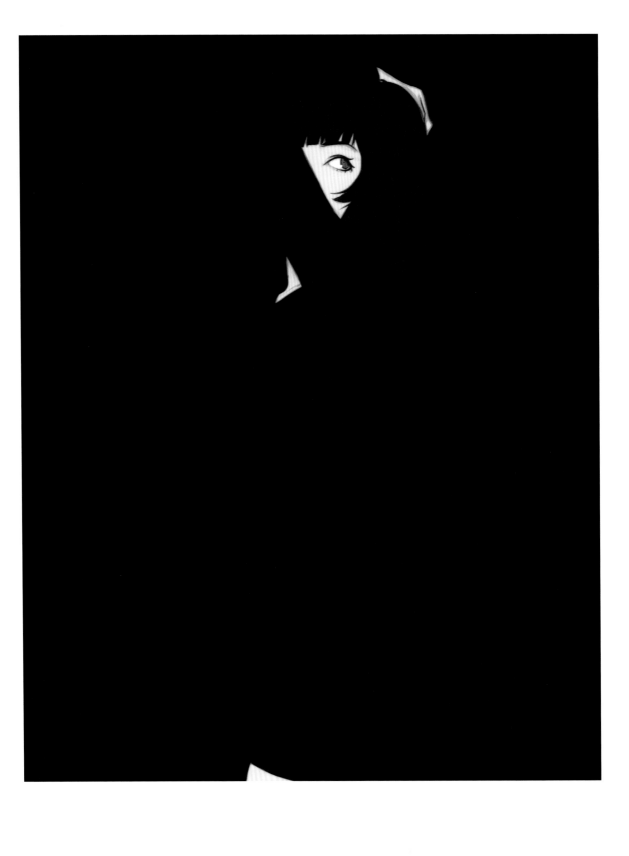

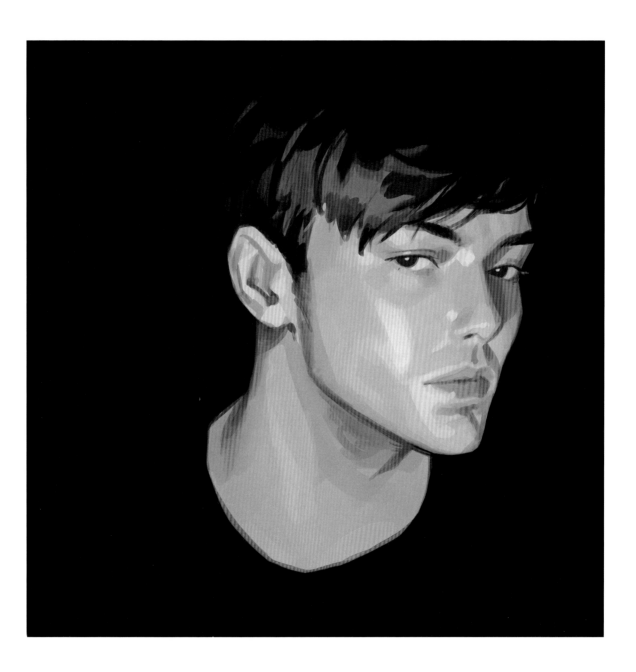

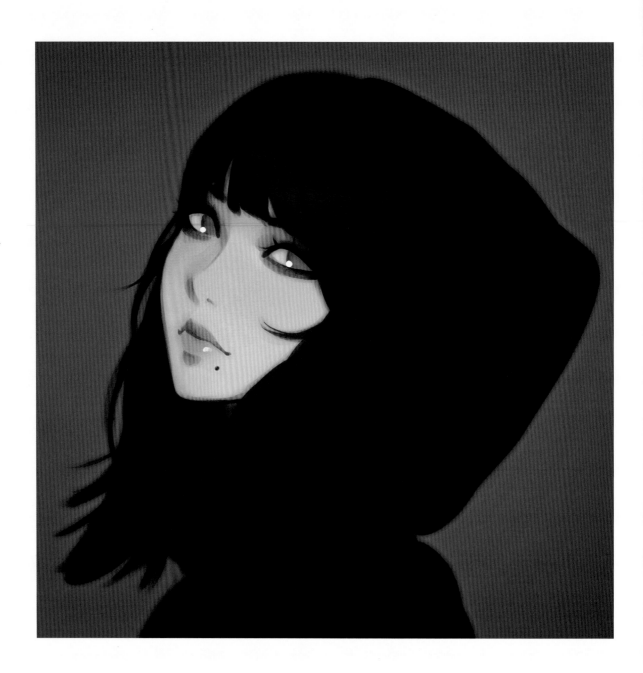

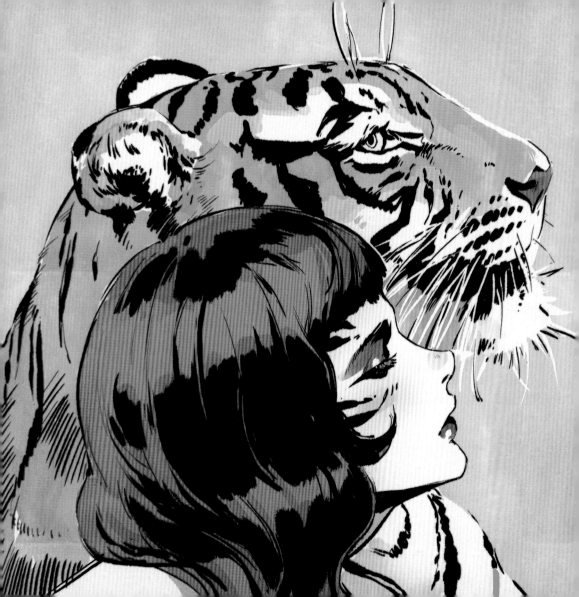

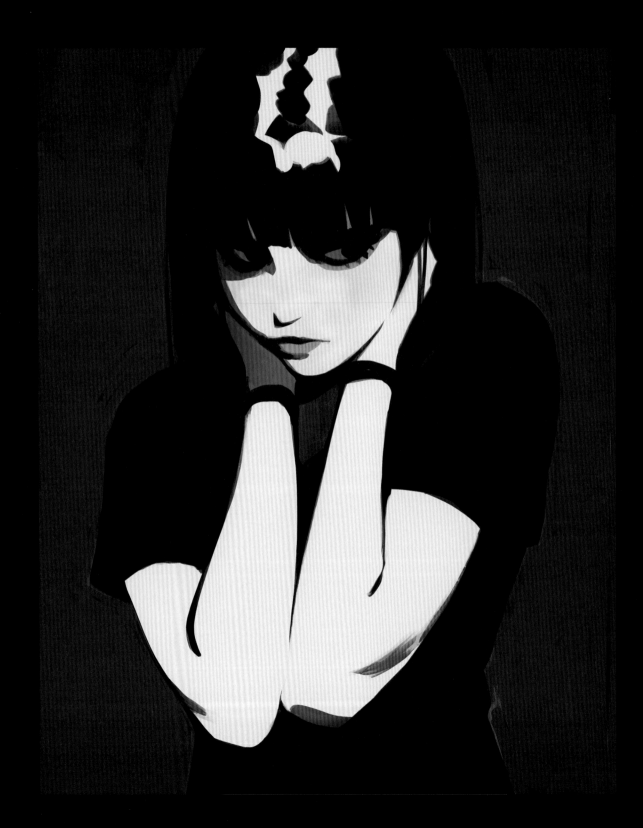

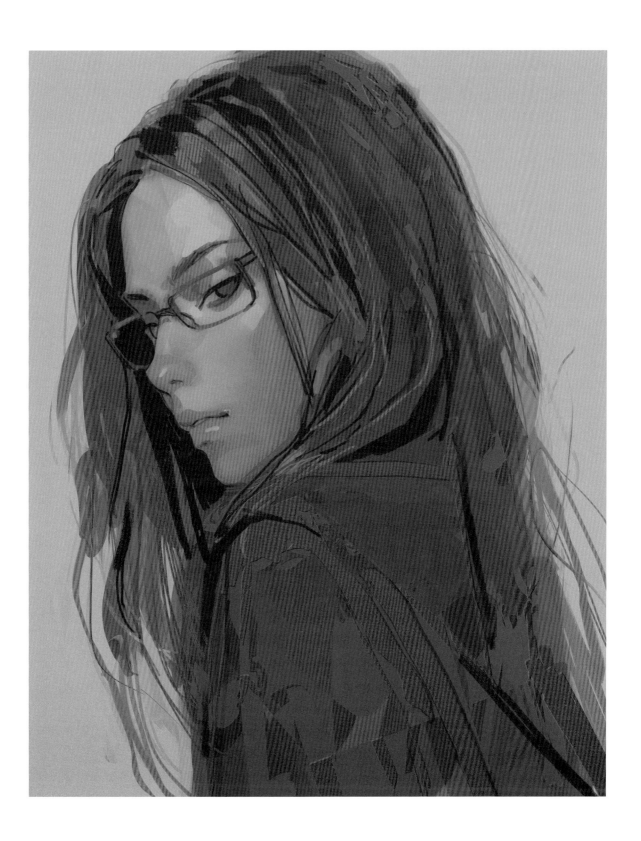

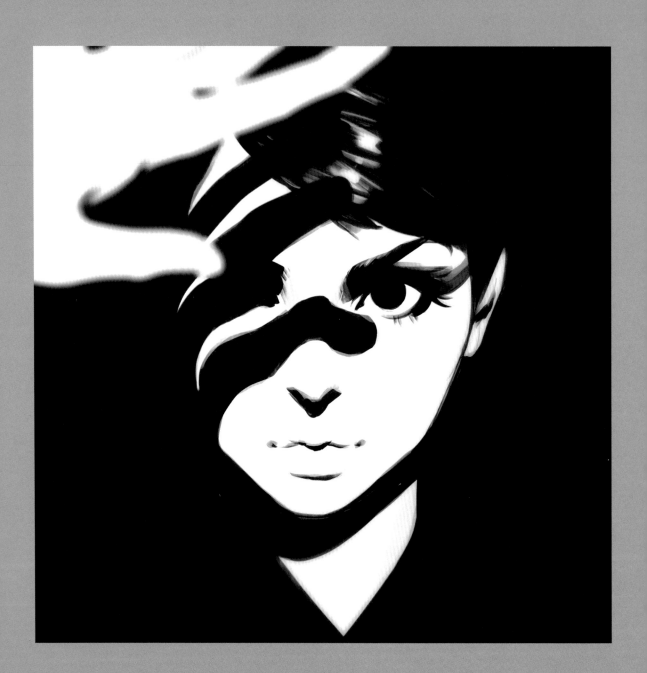

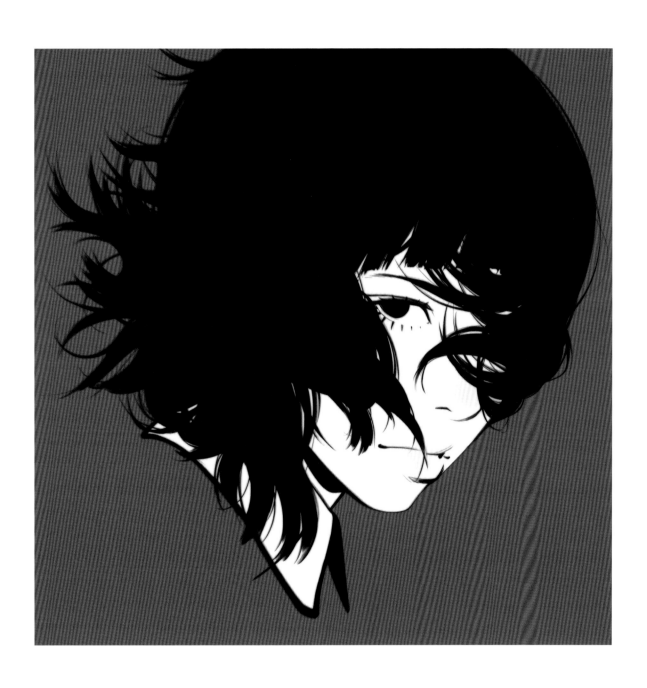

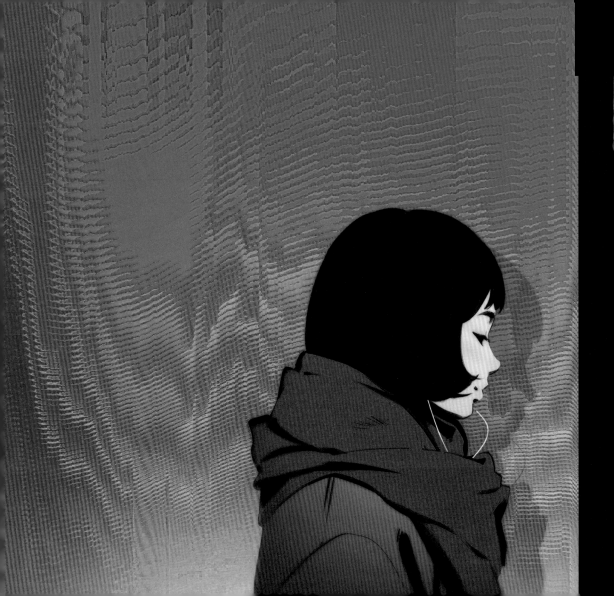

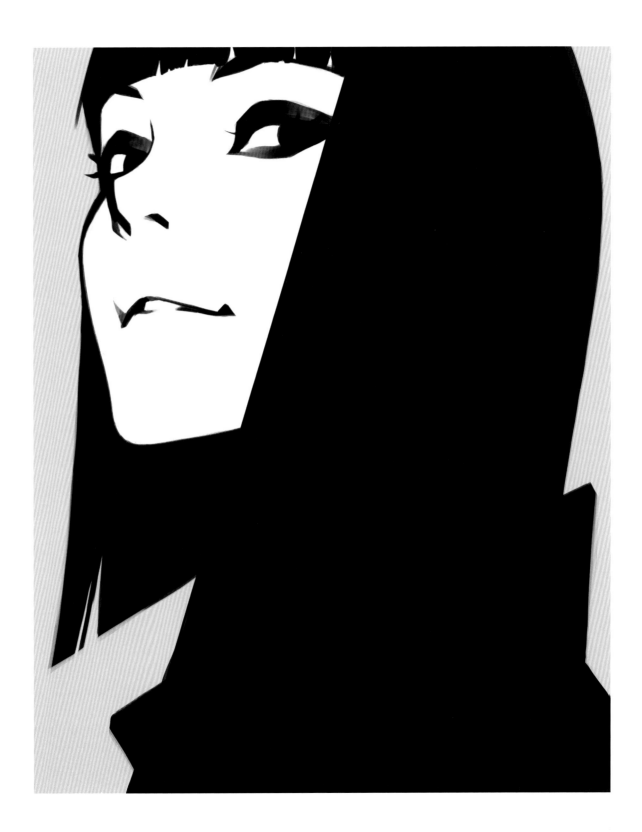

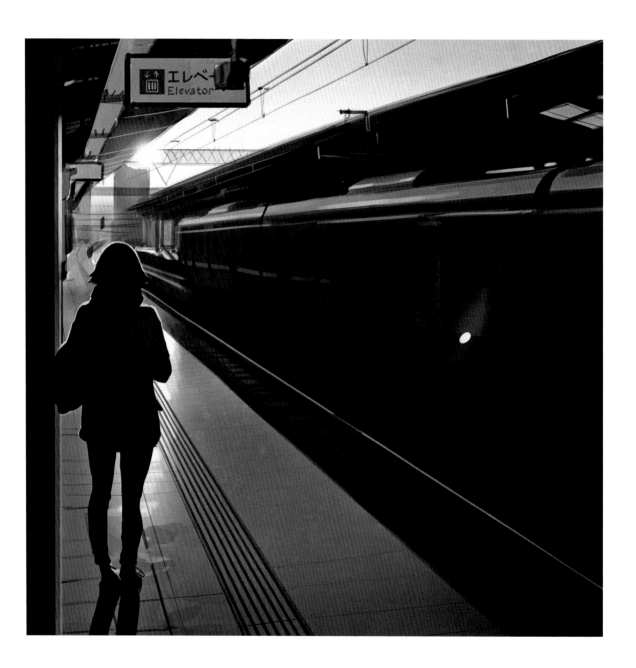

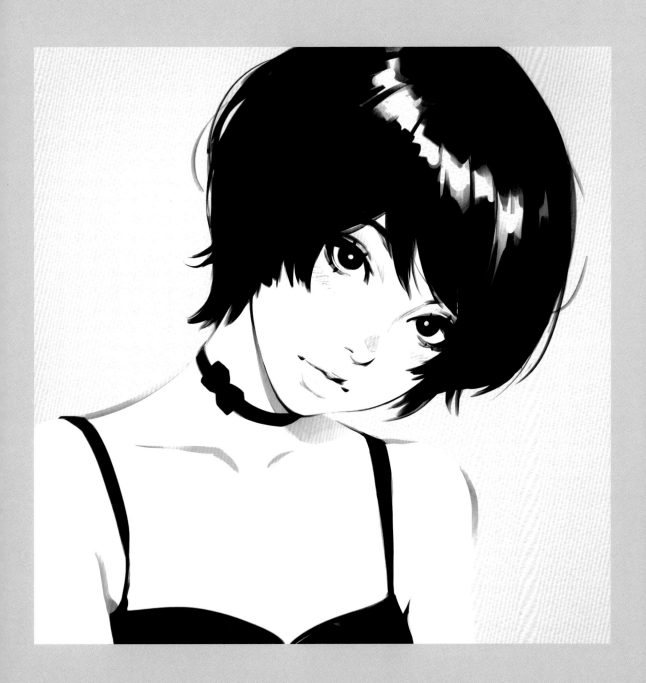

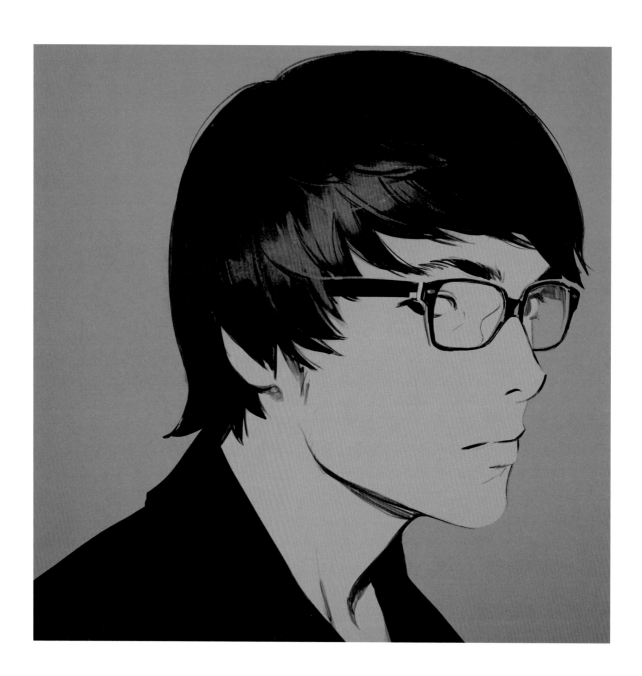

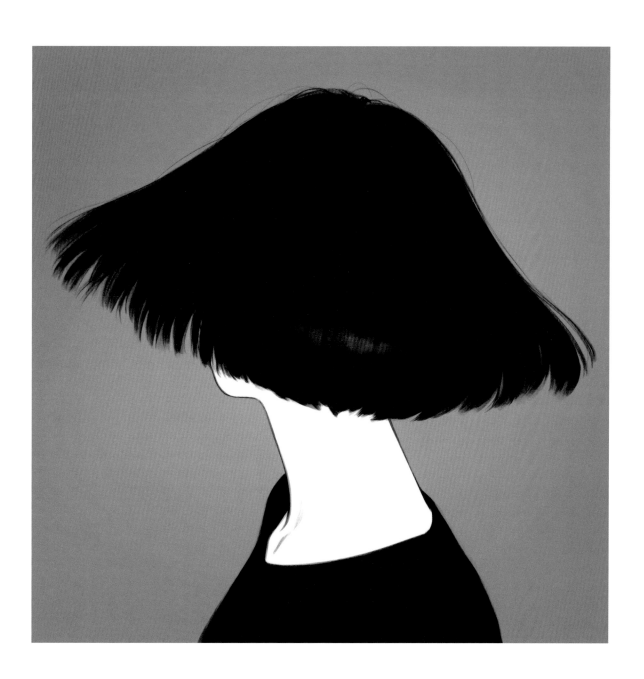

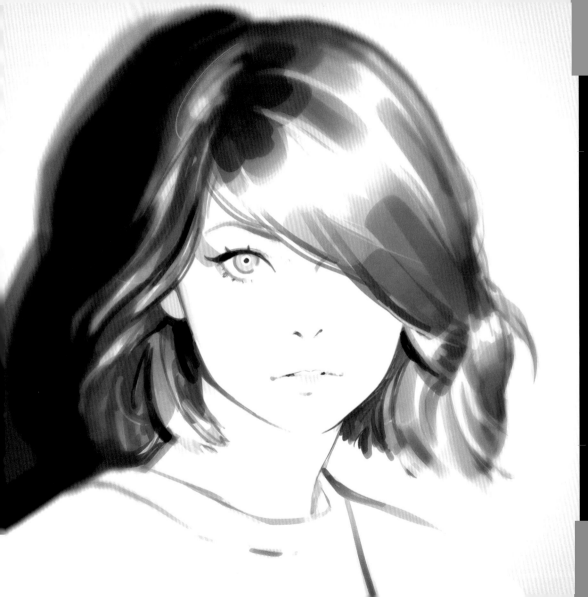

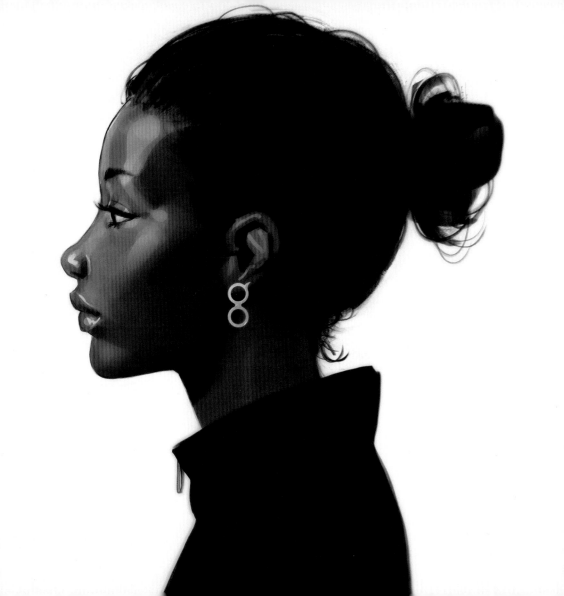

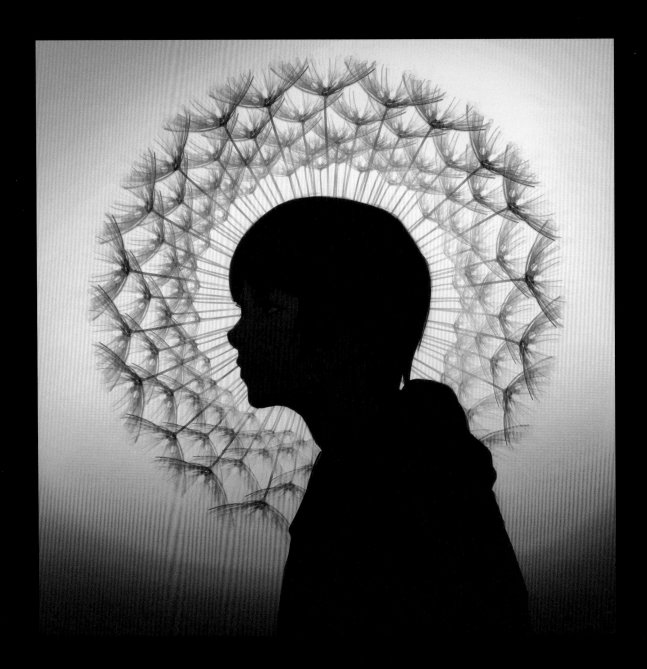

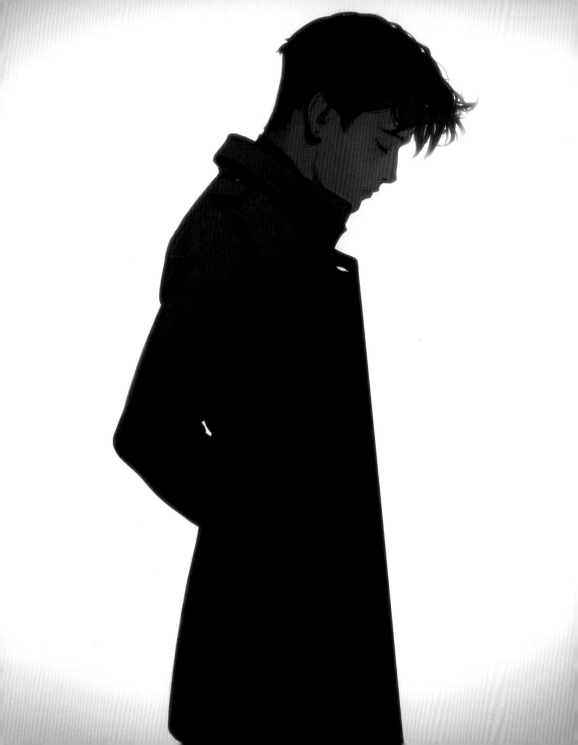

『バースデー・ワンダーランド』の制作中は、ラッシュチェックが頻繁にありました。制作チームで集まって、完成したアニメーションにミスがないかを1シーンずつ確認する作業です。ミスが見つかると、どう修正するかを話し合って決め、必要であればシーンを丸ごと作り直すこともあります。しかし、締め切りが近づき、残された制作時間が少なくなるにつれ、リテイクの数をかなり減らさないといけなくなりました。そんなとき、一生忘れられない言葉に出会ったんです。

とあるミスを私が見つけたときのことでした。そのミスは5秒間のシーンに影響を及ぼすと思ったのですが、時間がないことは分かっていました。だから皆に知らせるときにも「こういうミスがあるけど、大きなミスじゃないから、そのままでもいいかも」という感じで伝えました。そしたら、撮影監督の田中宏侍さんが、こんな意味のことをおっしゃったんです。「時間は押しているけど、直しましょう。この映画は僕たちがこれで完成、と決めた状態で永遠に残りますから。ベストを尽くしておかないと——作品をなるべく完璧にするよう、できることを全部やっておかないと——ずっと後悔しますから」

その言葉を聞いたとき、頭をぶんなぐられたような気分になりました。おかげでそれ以来、ポストプロダクション段階のカオスのまっただなかで「もう限界だ、見なかったことにしたい……」と思うときですら、正しい方向に進めるようになりました。ベストを尽くすにせよ、諦めてしまうにせよ、選んだ結果はずっと自分についてまわります。結果は残ります。修正しなかったミスからは、永遠に逃れられないんです。

私たちの行動はすべて、そのときの自分の決断と、それによってどのようなことが起こるかと、予想することに影響されると思います。それならベストを尽くした方が後悔しないし、今この瞬間を永遠に残ることのために役立てた方が良いでしょう。その責任を負うかどうか、それは自分でコントロールできます。私の話を聞いた皆さんが、いつも、どんなときでも主体的に行動し、自分を永遠に輝かせようと思ってくれれば、とても光栄です。

While working on *The Wonderland*, we were constantly having Rush Check meetings. Our production team would review finished animated scenes one by one in search of any mistakes.

A decision would then be made as to how to fix a mistake or, if it was required, to entirely remake a scene. As the deadline approached and production was coming to a close, we were forced to greatly minimize the number of retakes. During this time I heard words I will never forget.

I had found a mistake that I felt really affected a five-second scene. With hesitation due to our time constraints I pointed it out, "Here's the mistake, but it's not so big, so maybe we should just ignore it," and Kouji Tanaka, the director of photography of the movie, replied: "We don't have much time, but let's fix it anyway. This movie will remain in the state upon which we decide for eternity. And if we don't give it our best, don't do everything we can to create a product as close to perfect as we could, we will regret it forever."

These words hit me hard. Since then, even in the chaos of post-production stages when I feel I'd hit my limit and would just let it go, these words power me through things. This is because choosing to give up or to give my best will be the choice I'll have to live with. The result will be eternal. Any mistakes I didn't fix would forever haunt me.

I feel that everything we do is influenced by our decision at that moment and the wave of consequences or regrets that may follow. Will we be grateful that we have given our all? Making this moment significant for all eternity? That responsibility is in our control and I hope that after sharing my story, you'll be inspired to take charge of your present moment, and make it shine brightly for all eternity.

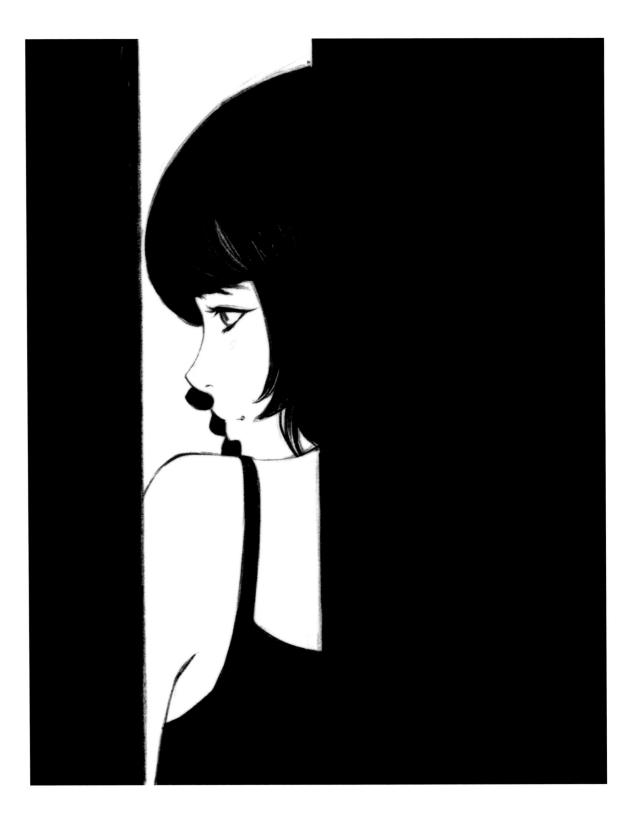

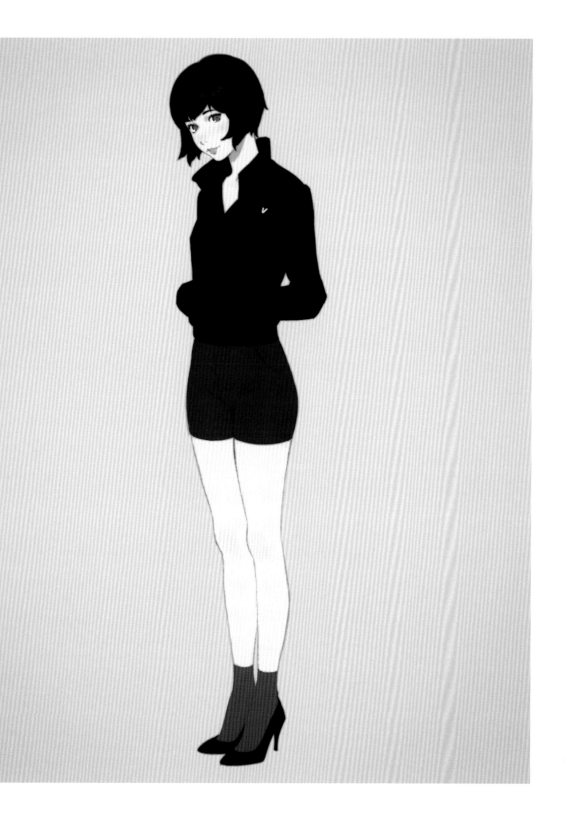

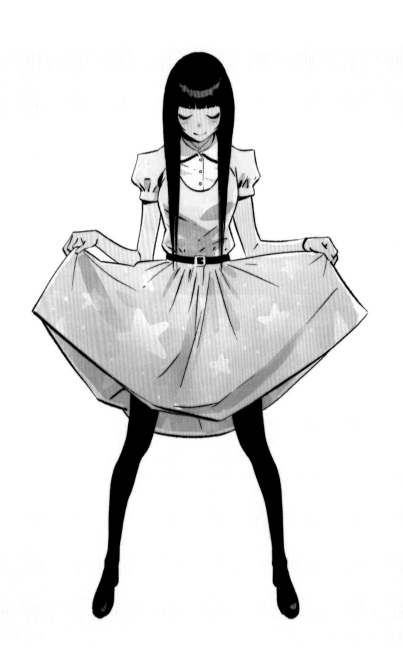

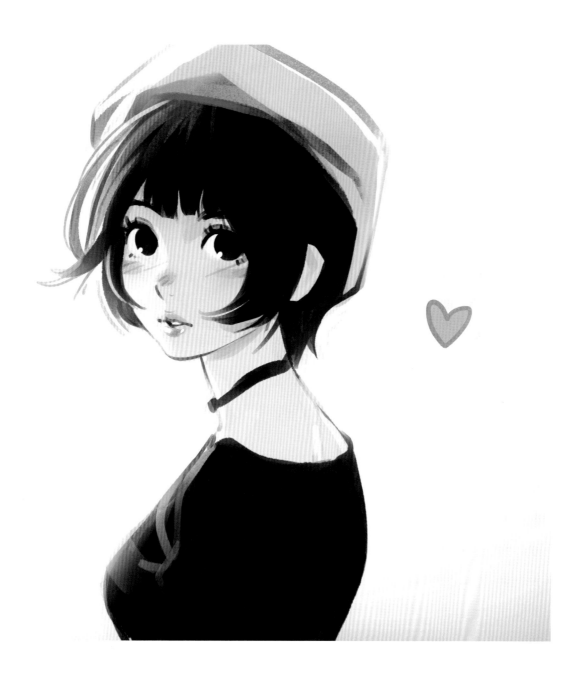

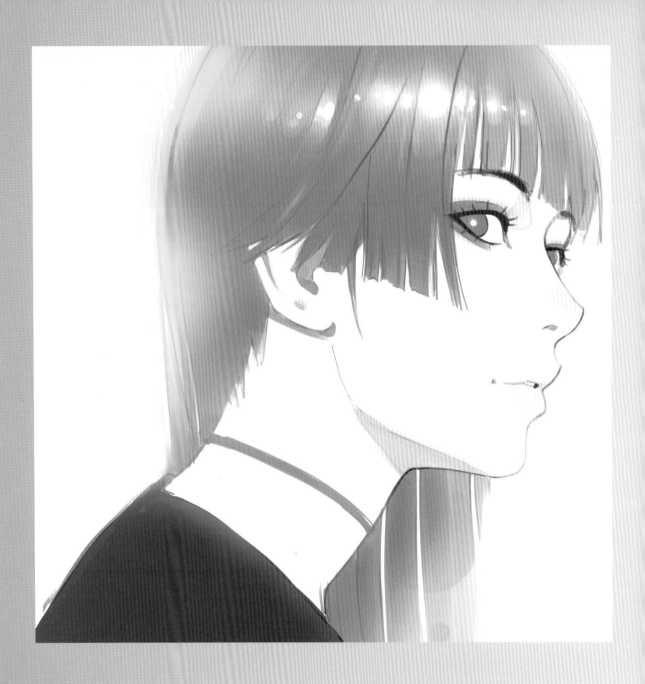

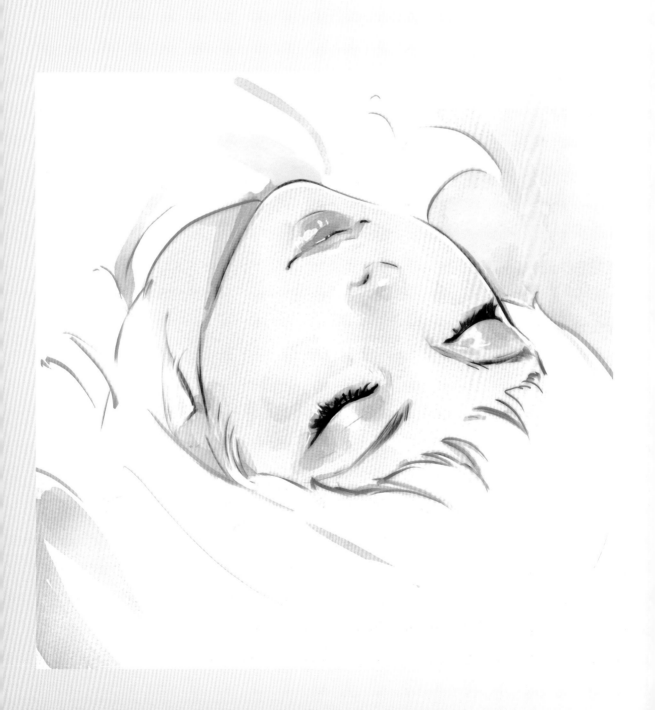

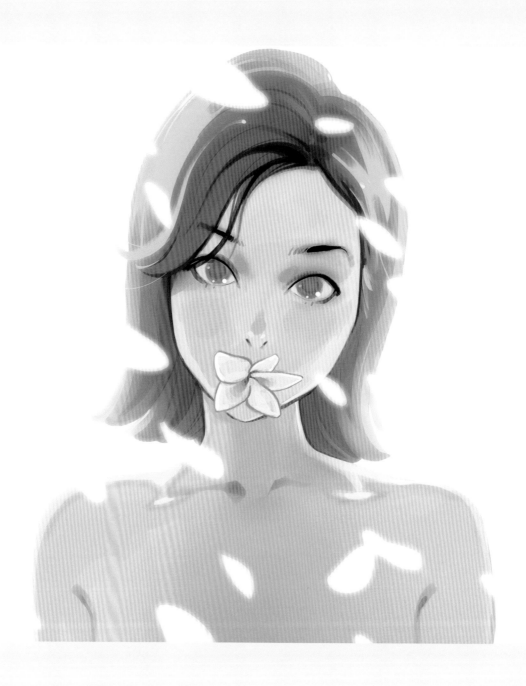

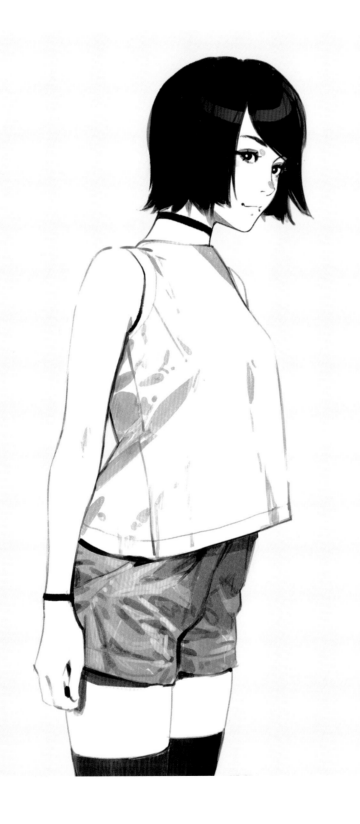

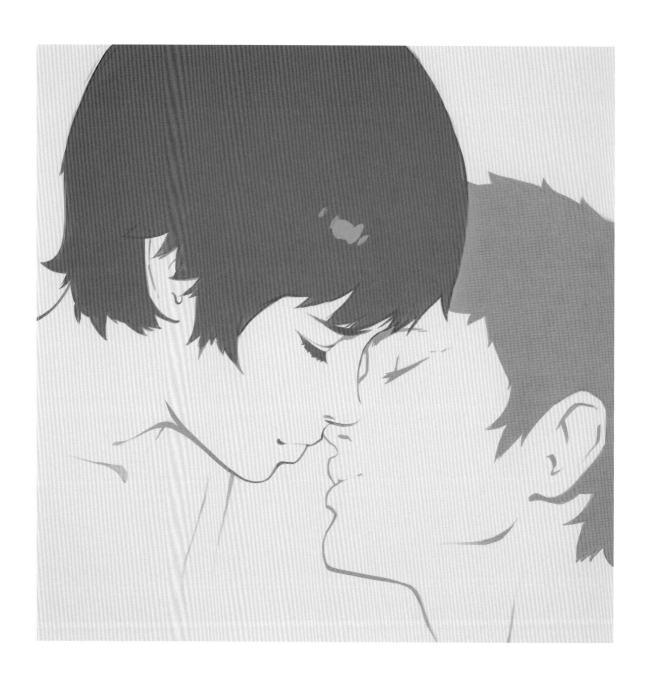

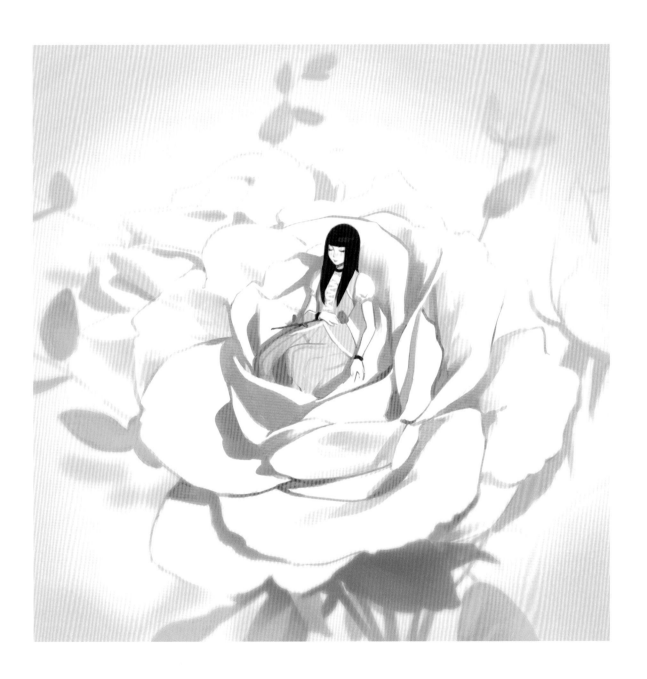

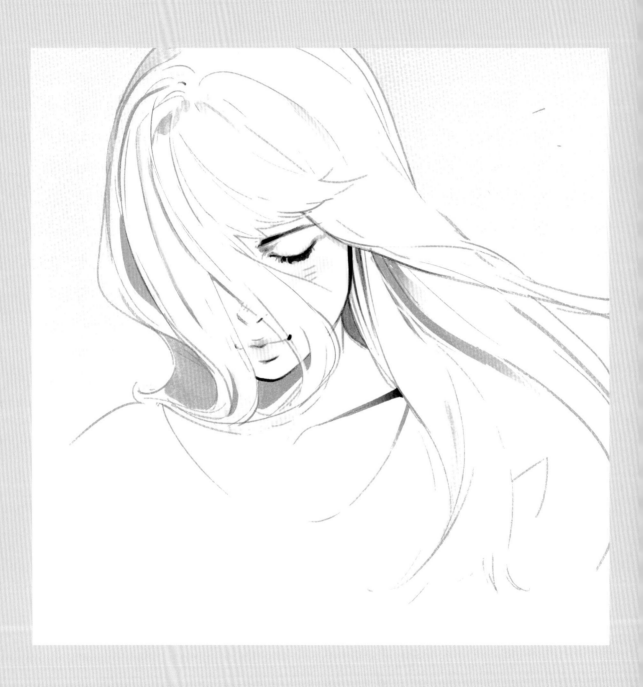

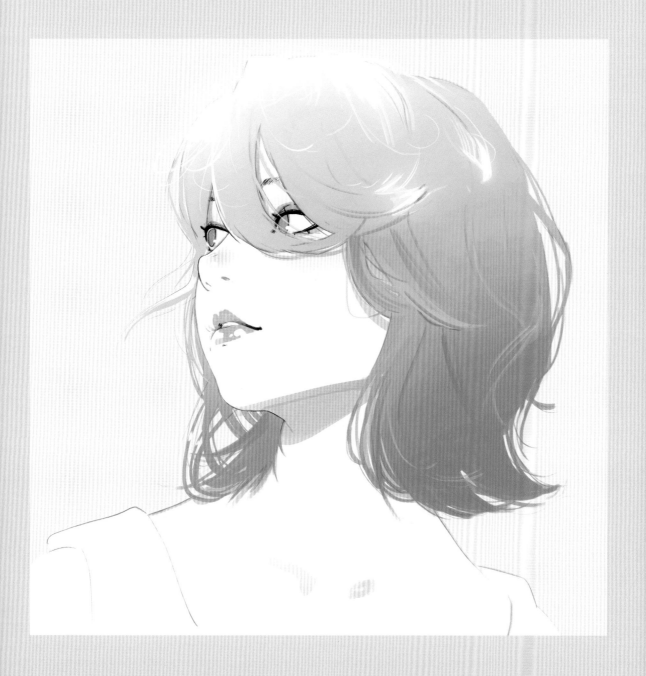

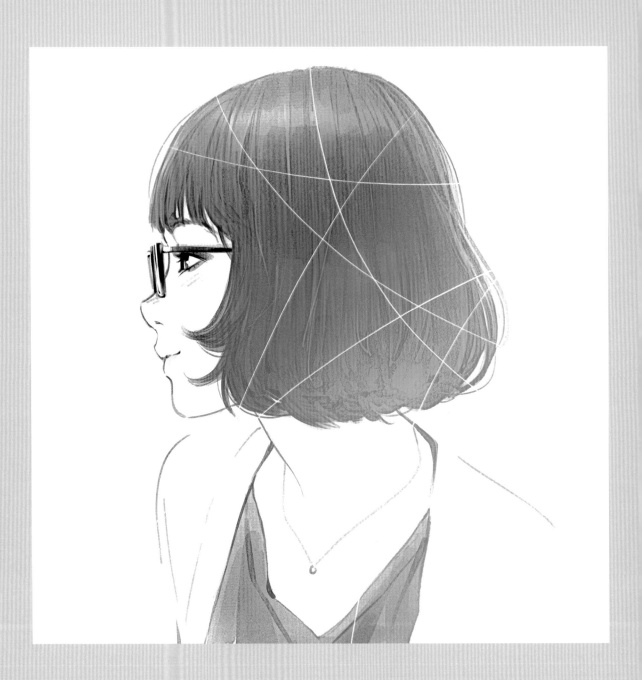

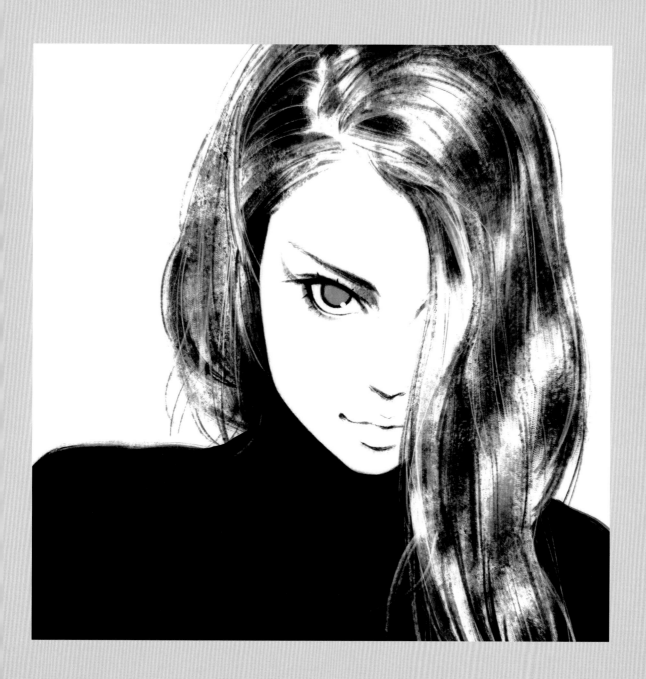

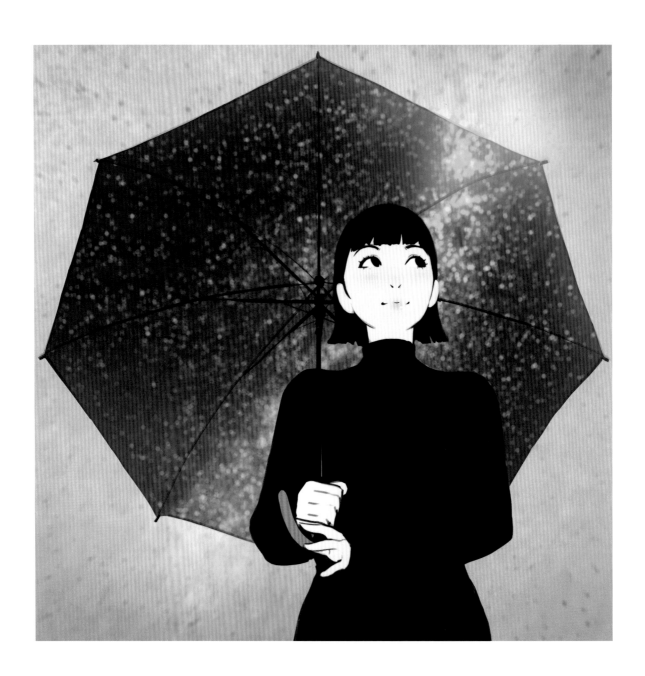

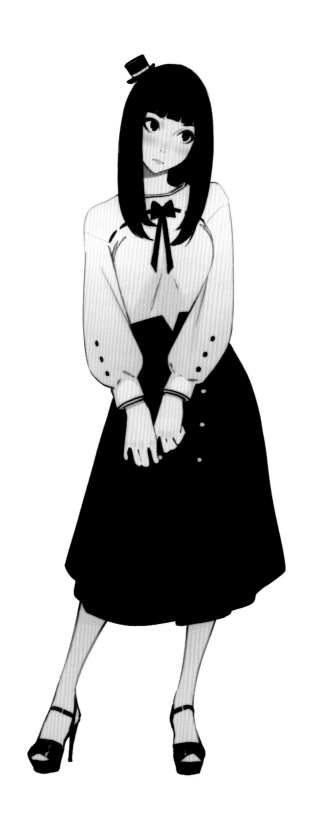

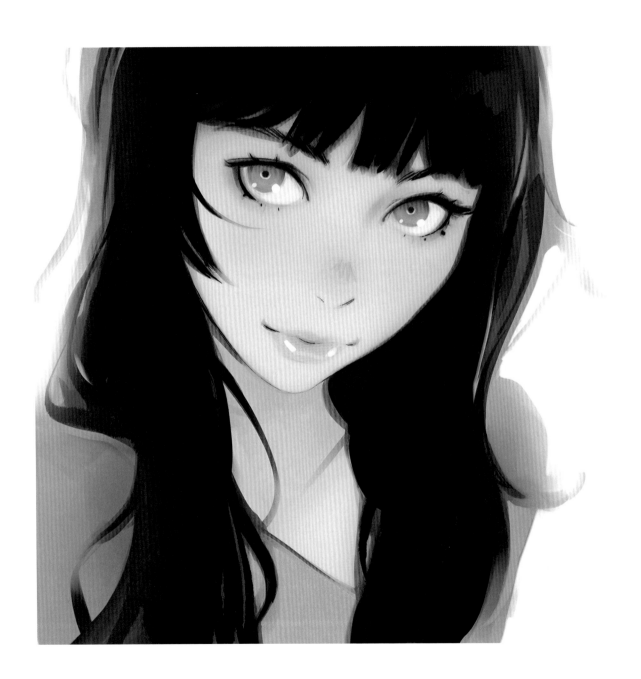

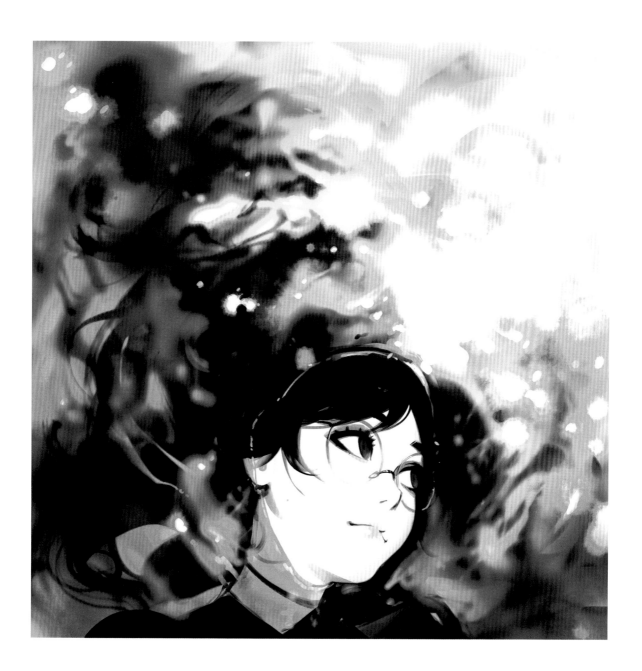

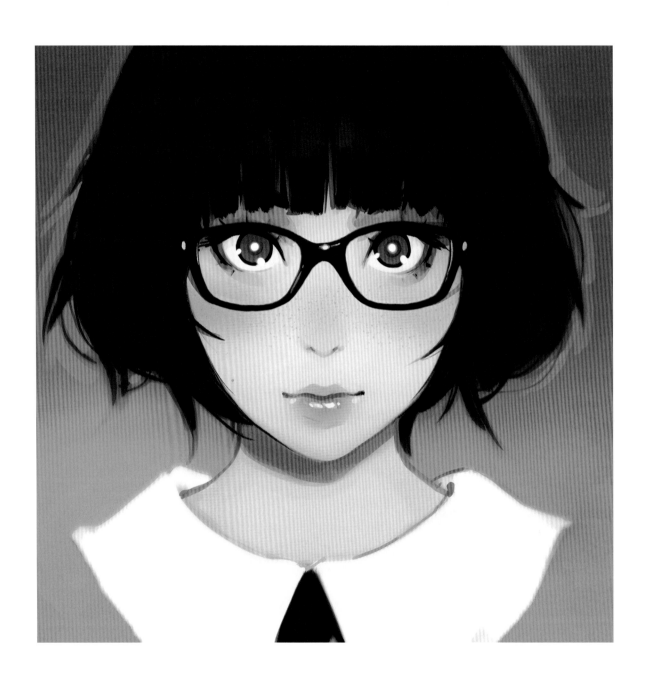

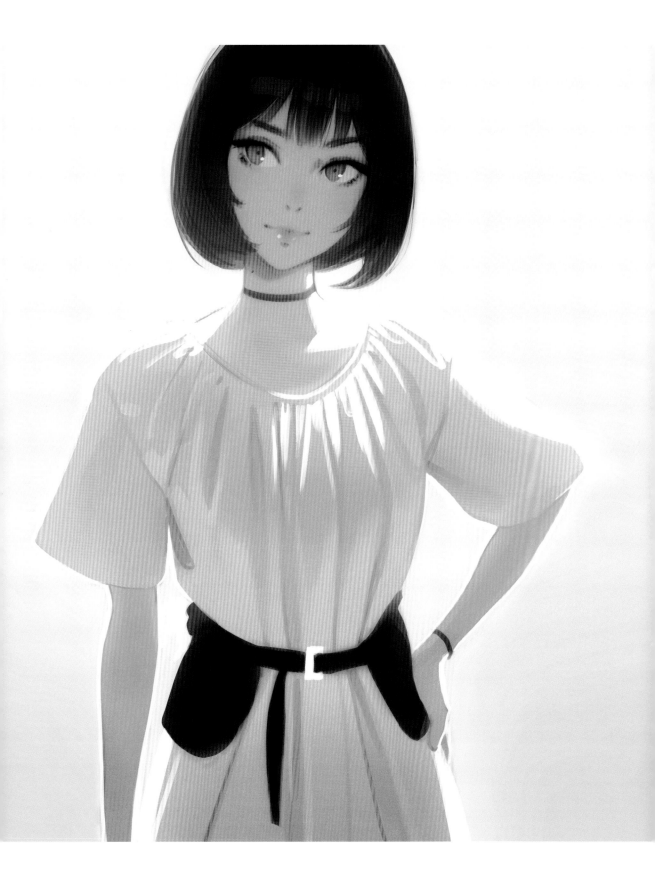

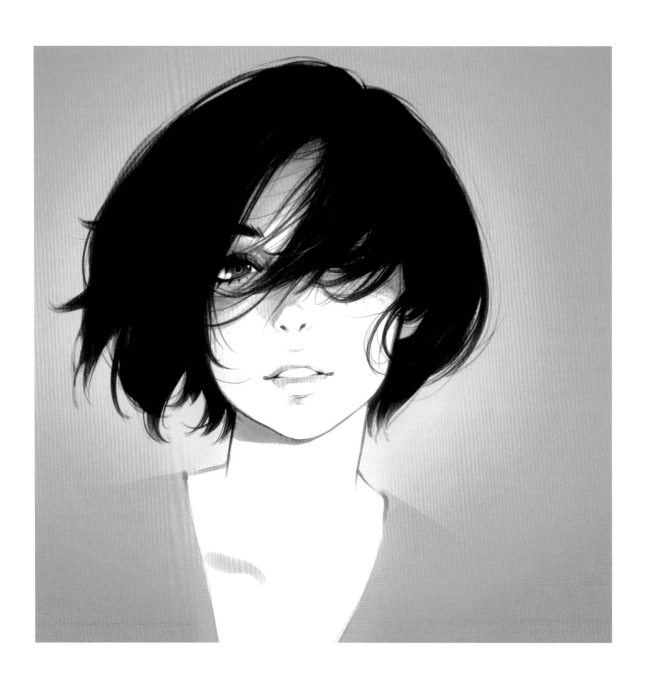

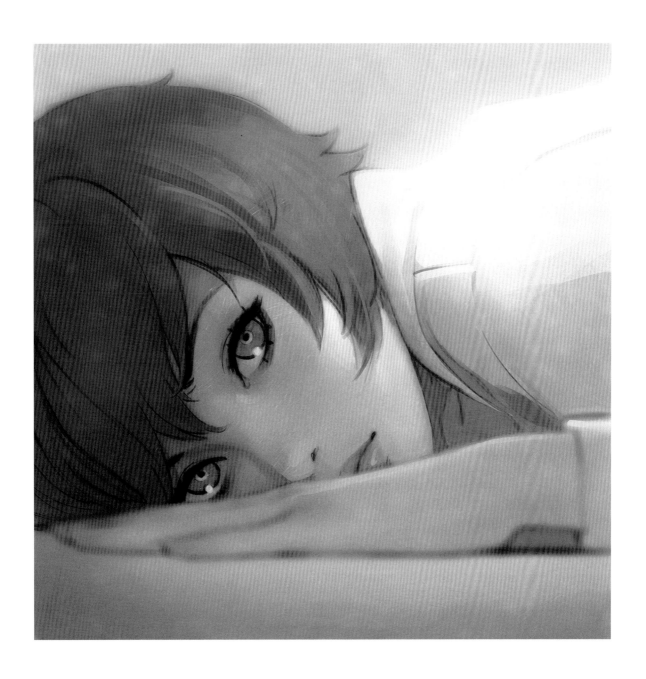

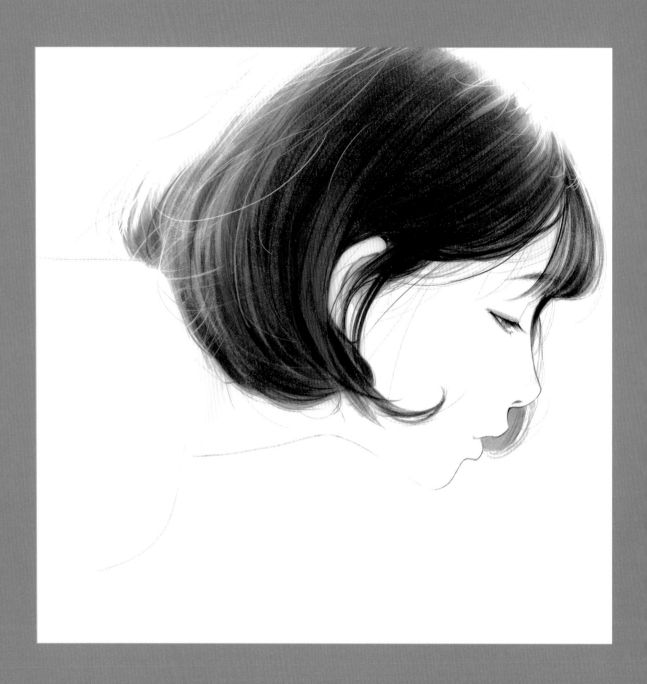

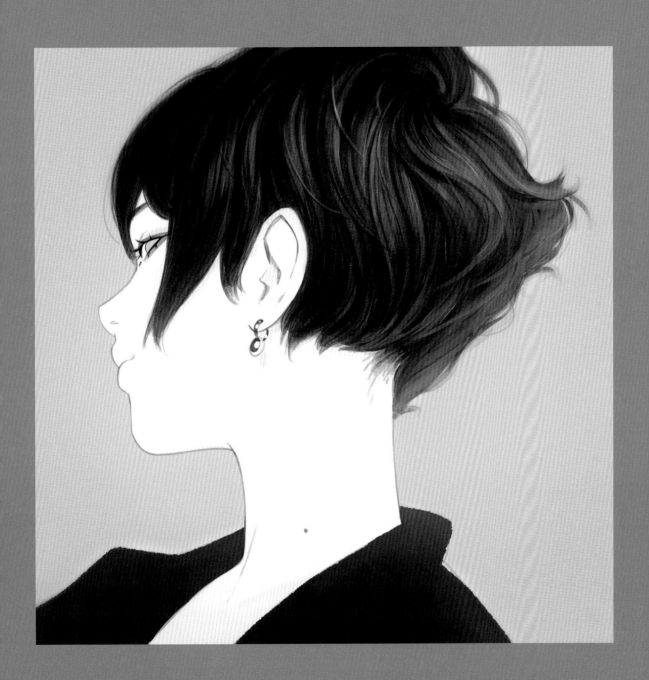

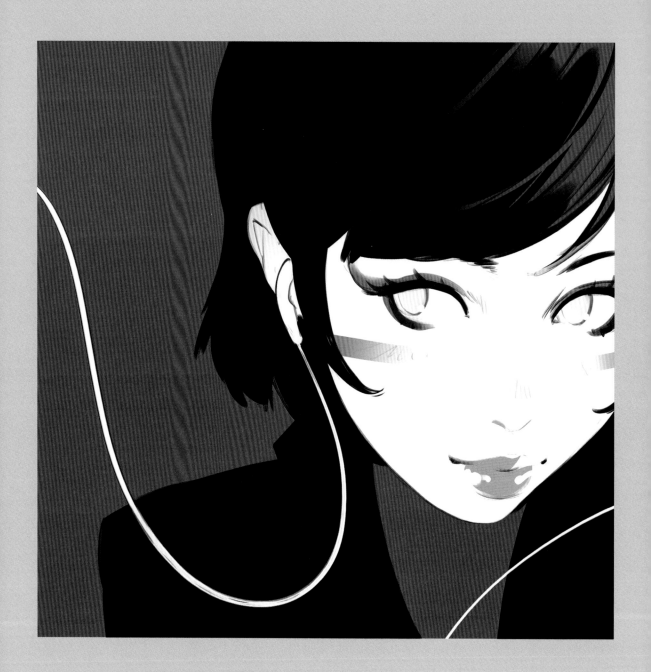

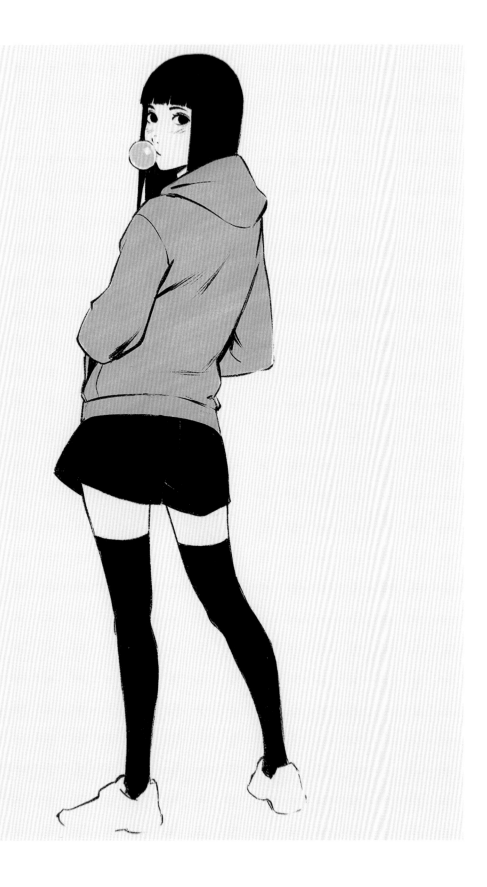

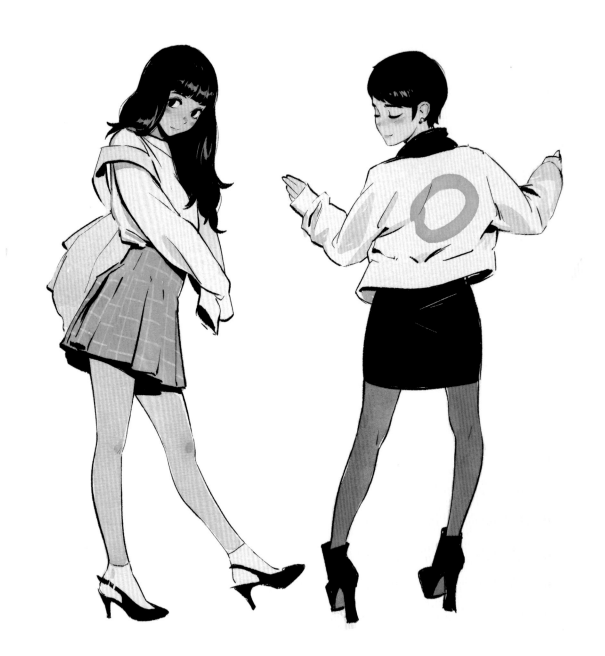

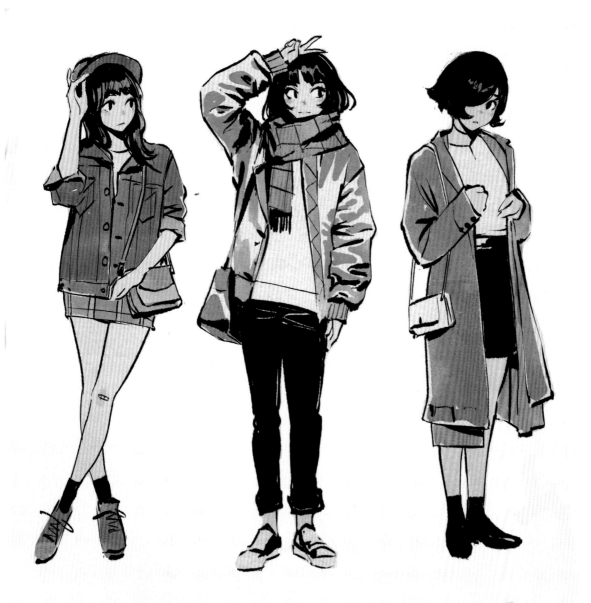

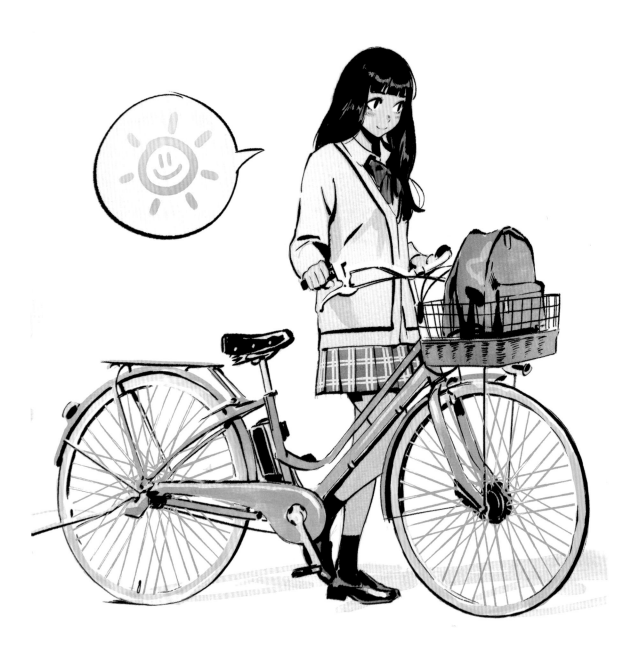

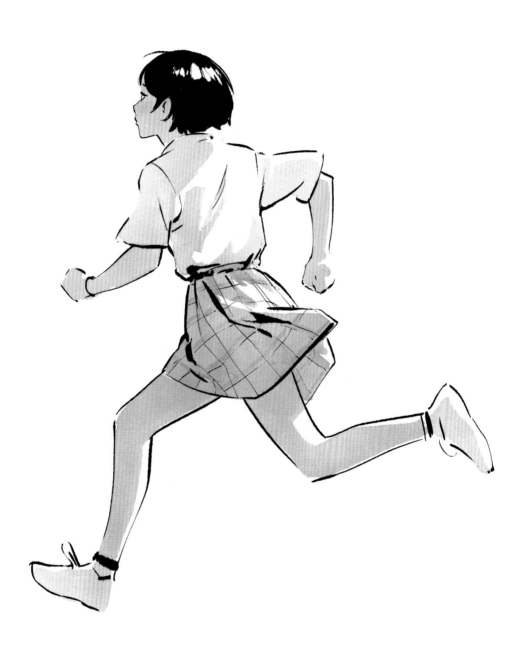

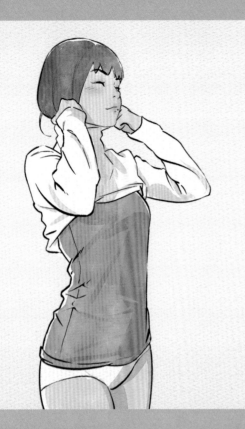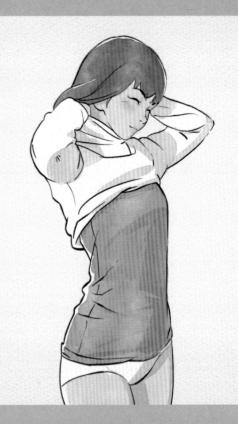

1OOOOOO thanks!

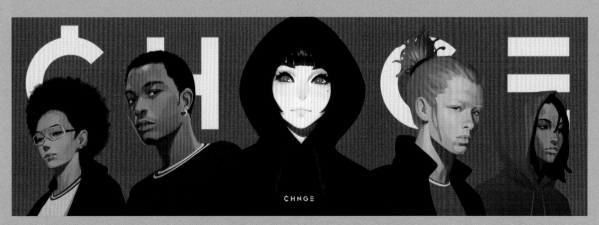

売上の50％をNGOに寄付しているファッションブランド「CHNGE」のイメージイラスト
Commission illustration for CHNGE, fashion brand donating 50% of profit to NGOs

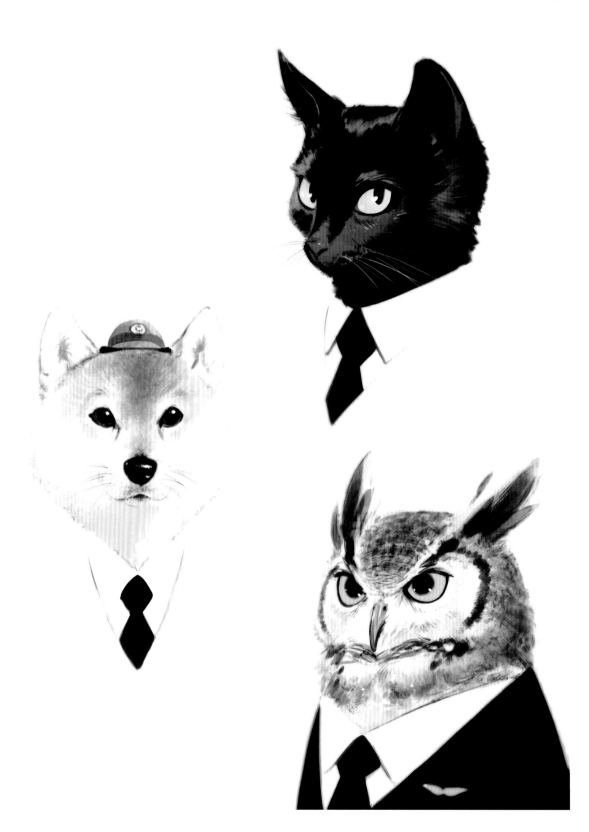

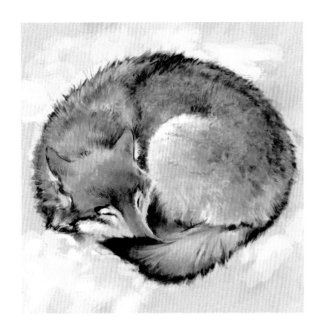

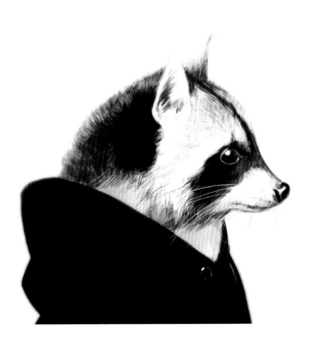

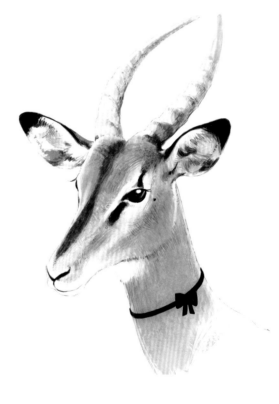

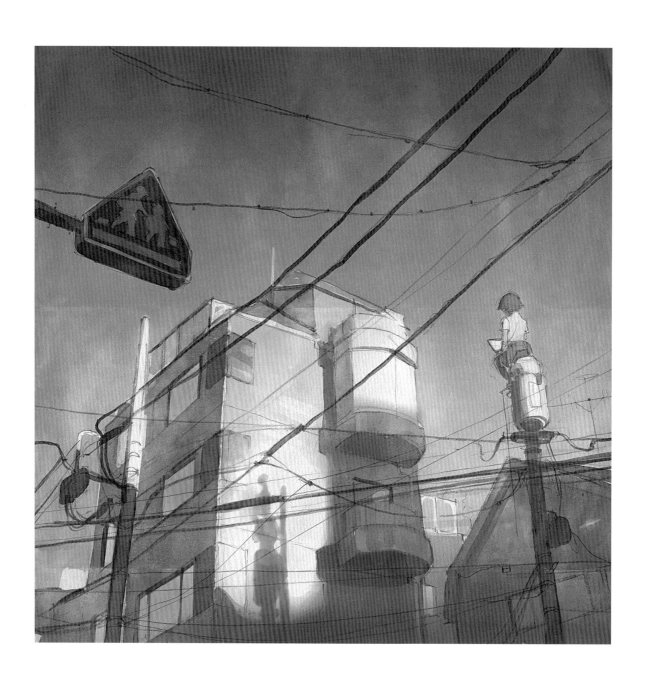

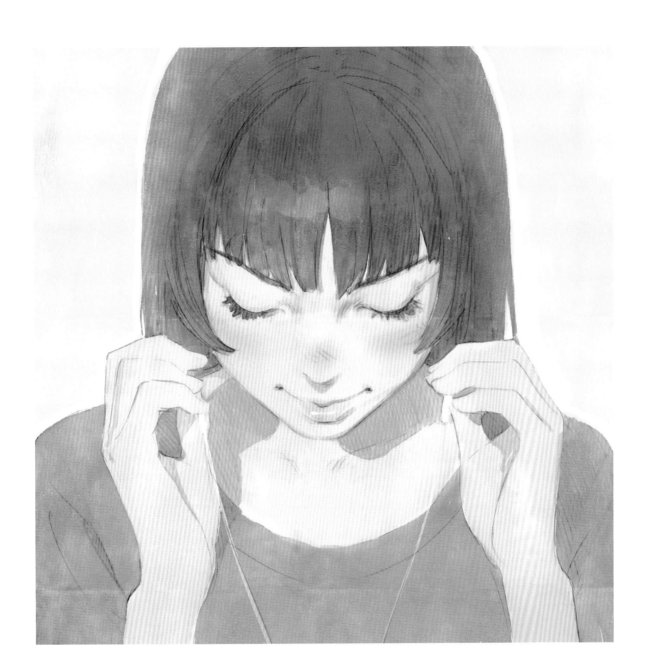

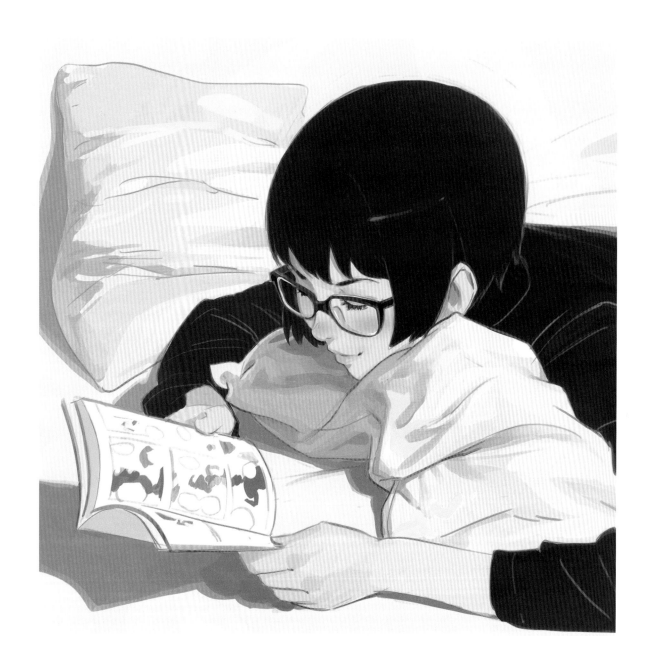

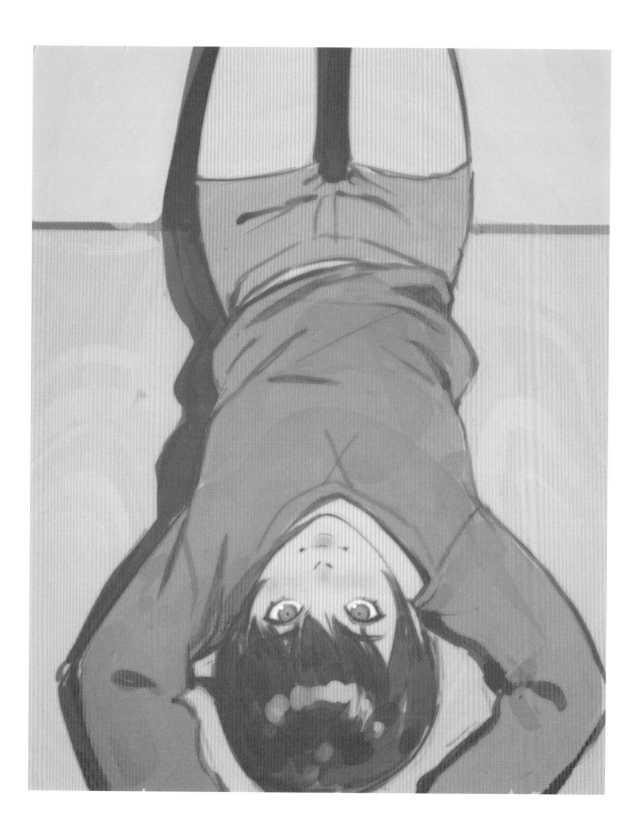

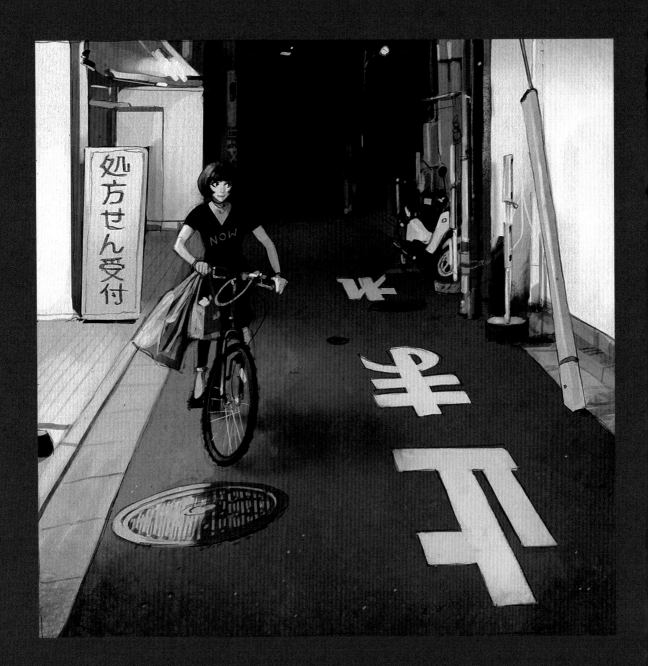

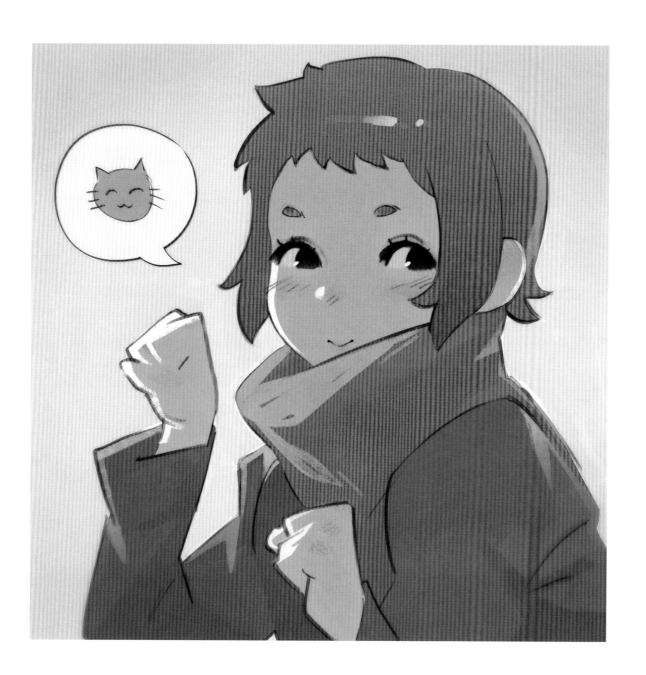

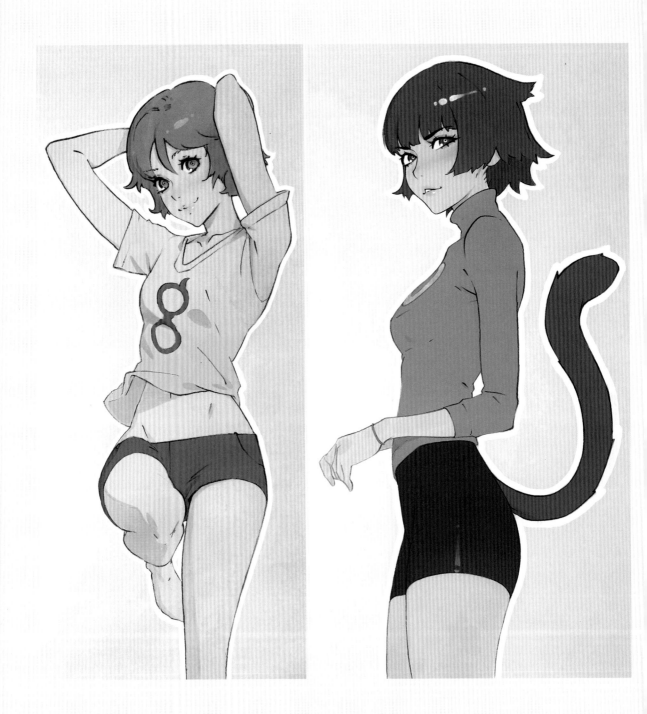

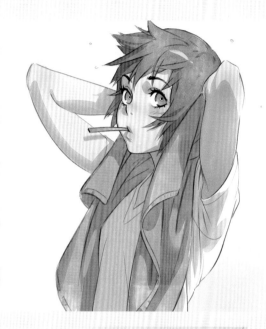

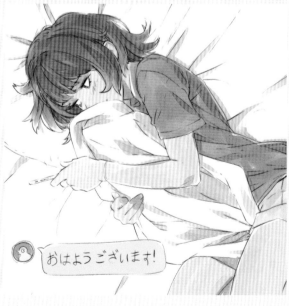

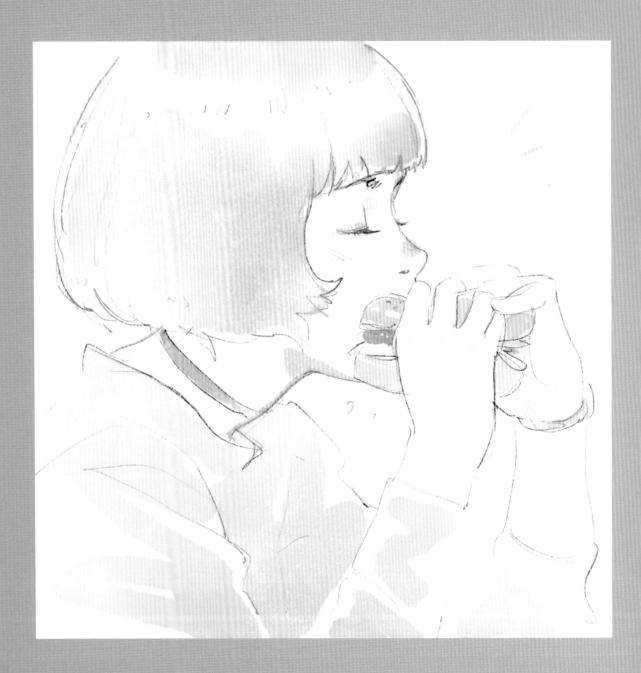

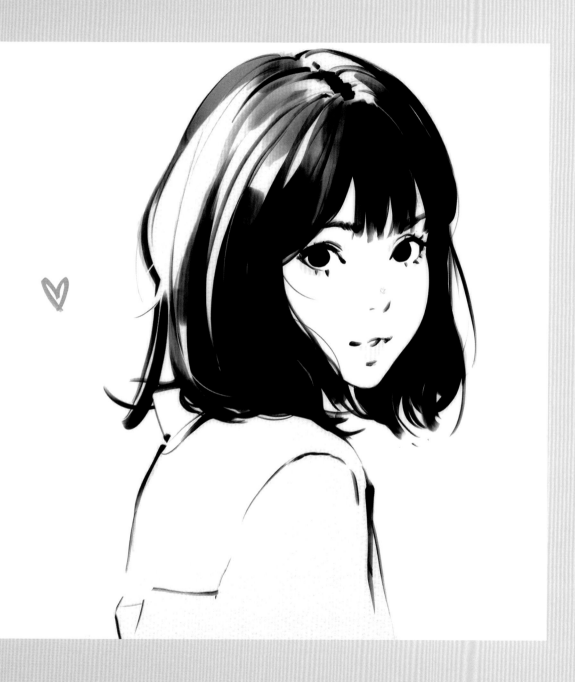

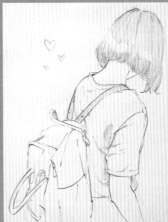
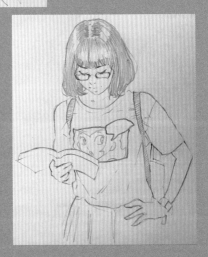

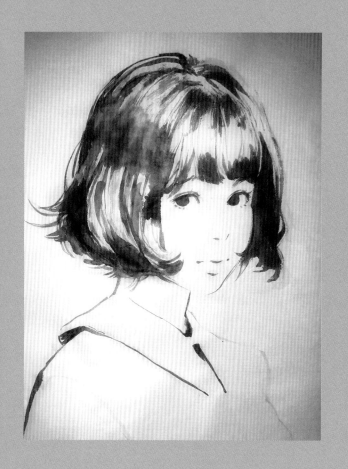

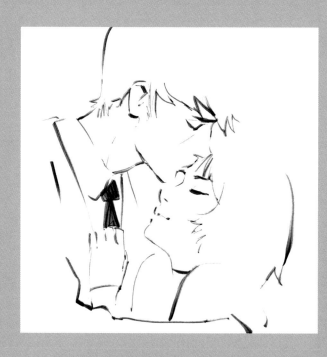

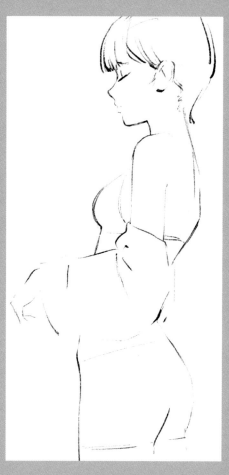

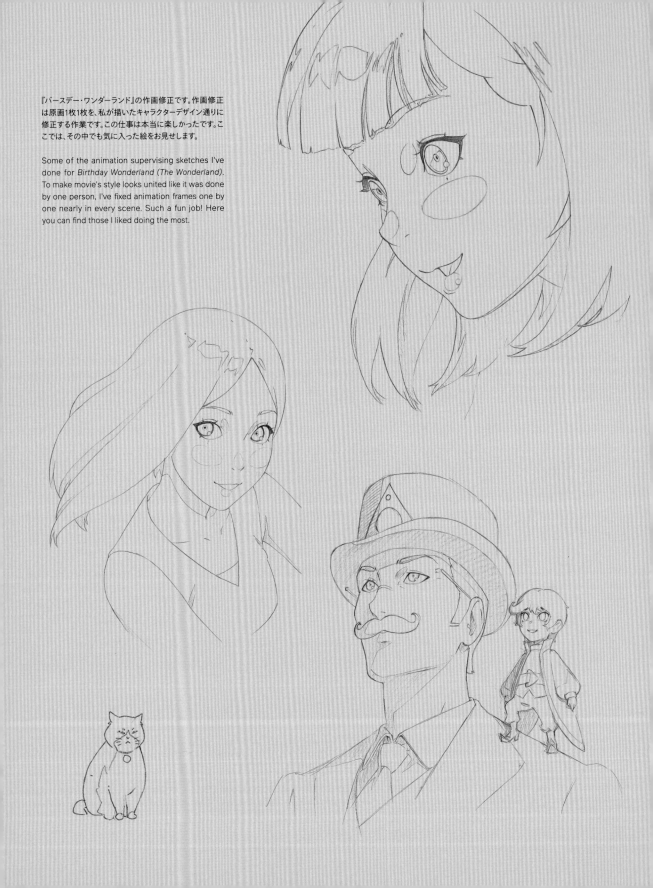

『バースデー・ワンダーランド』の作画修正です。作画修正は原画1枚1枚を、私が描いたキャラクターデザイン通りに修正する作業です。この仕事は本当に楽しかったです。ここでは、その中でも気に入った絵をお見せします。

Some of the animation supervising sketches I've done for *Birthday Wonderland (The Wonderland)*. To make movie's style looks united like it was done by one person, I've fixed animation frames one by one nearly in every scene. Such a fun job! Here you can find those I liked doing the most.

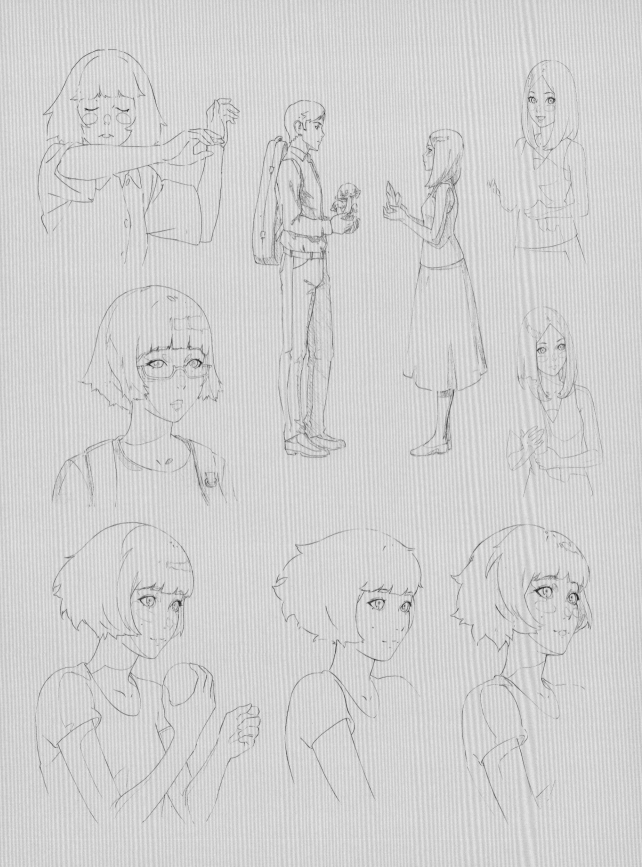

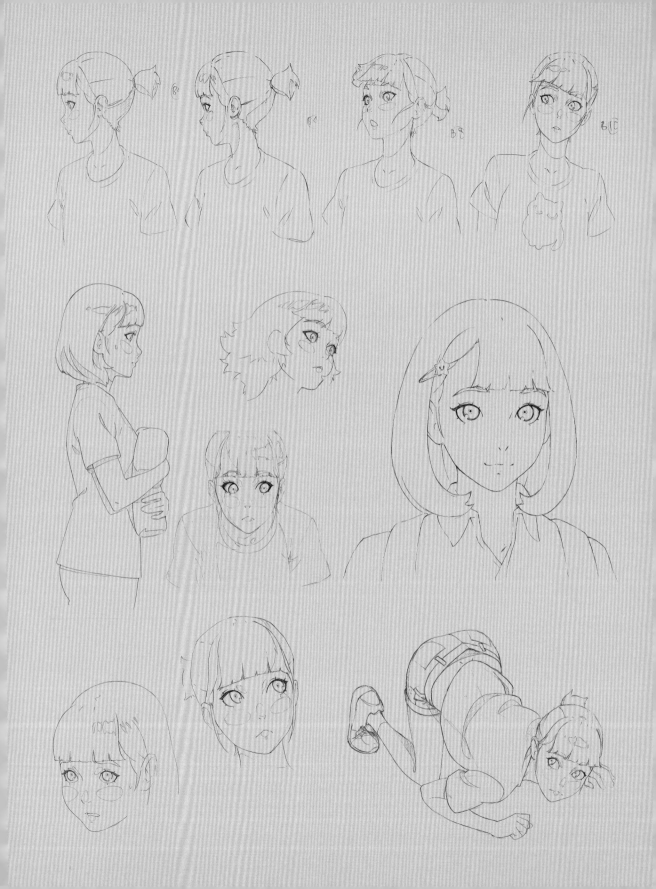

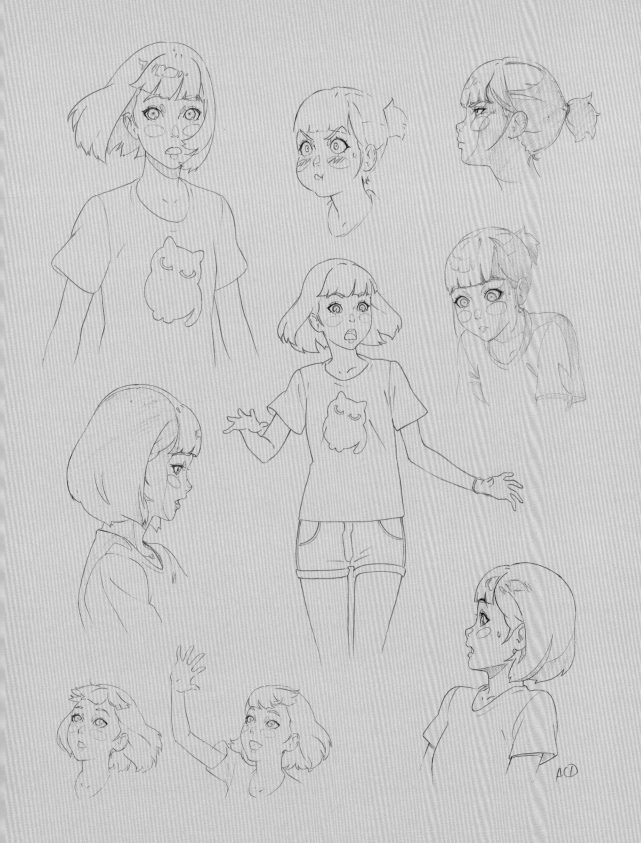

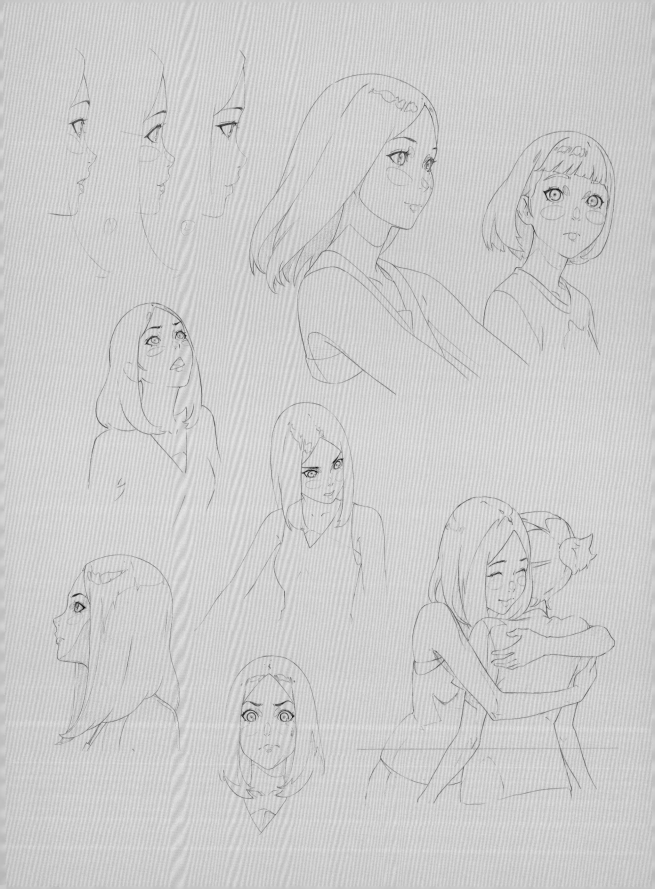

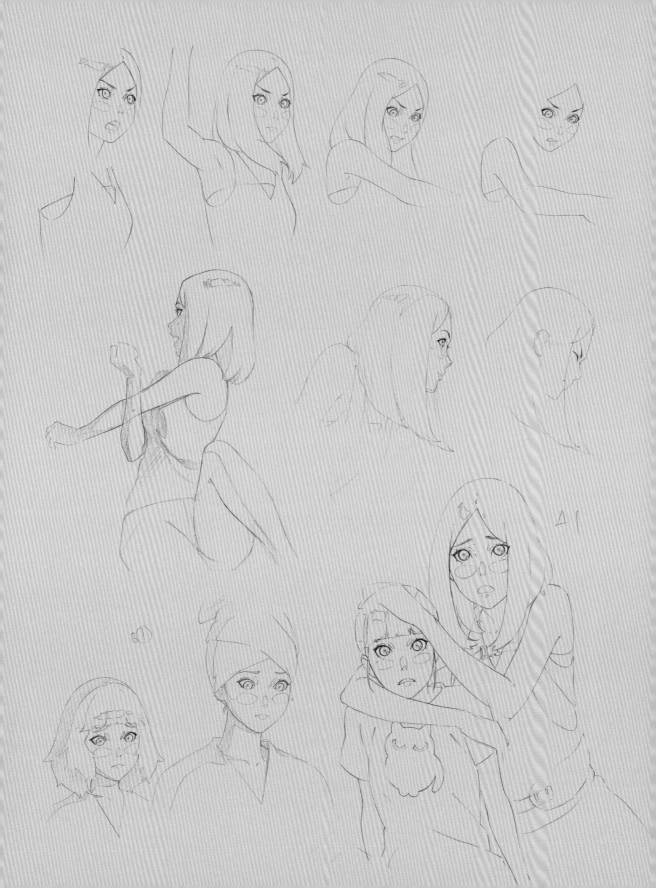

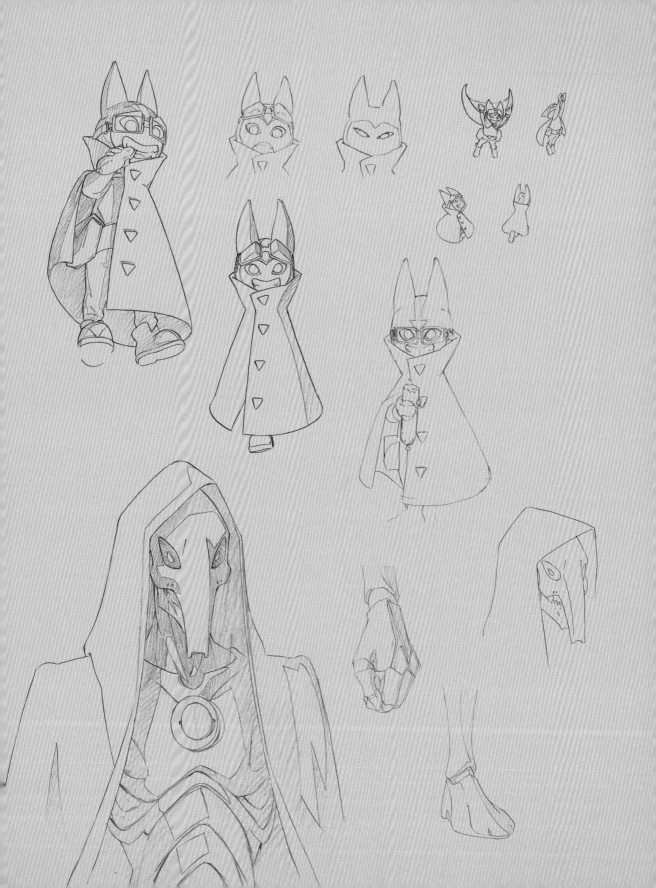

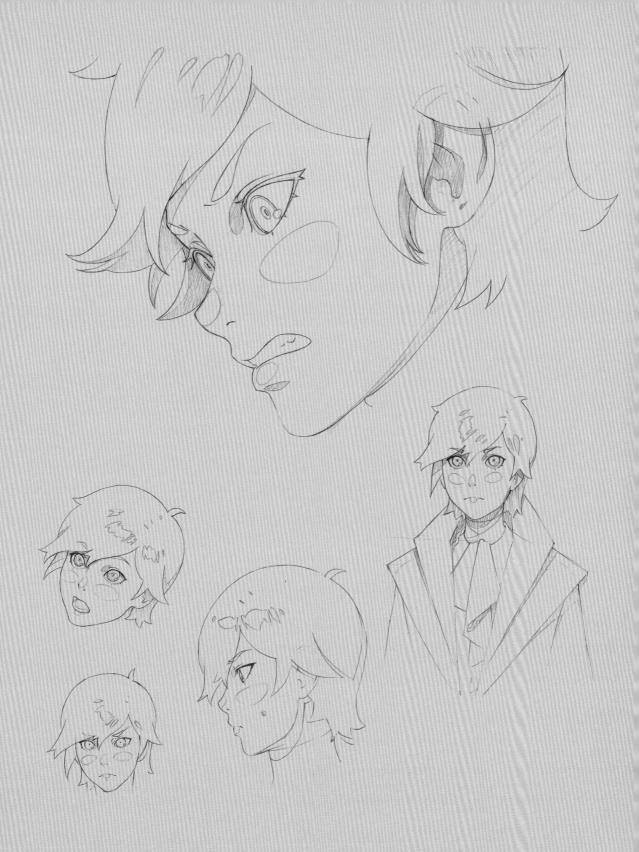

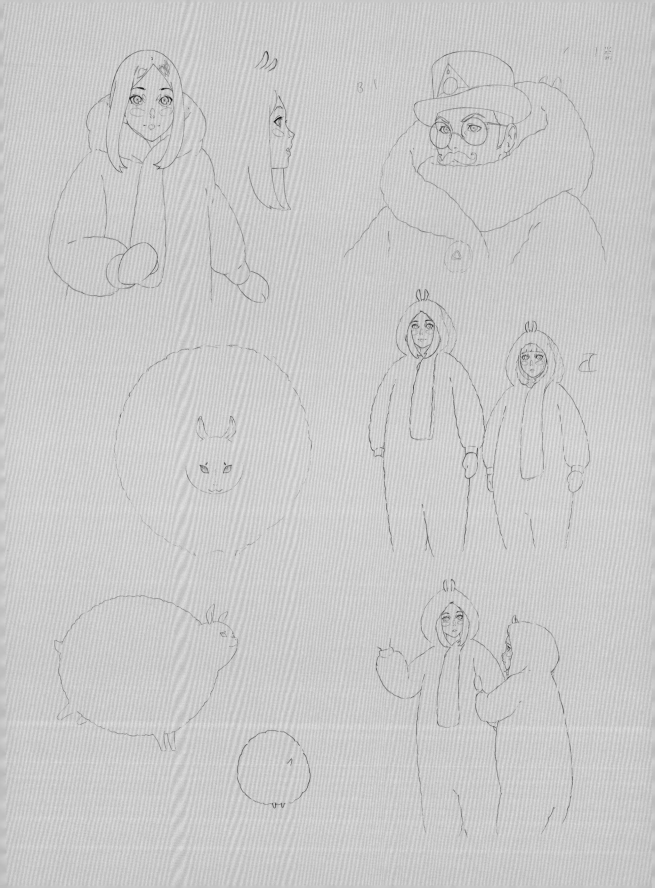

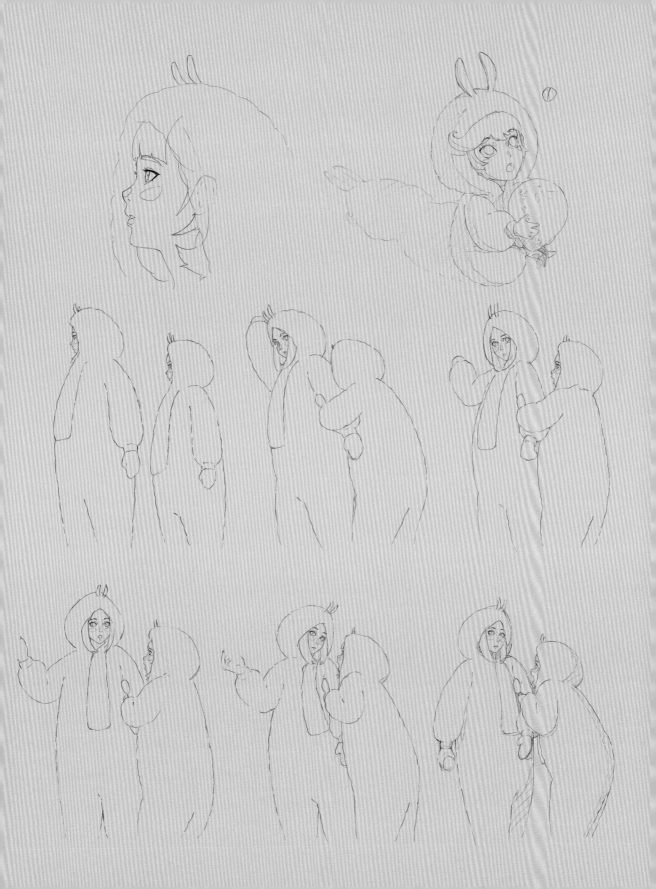

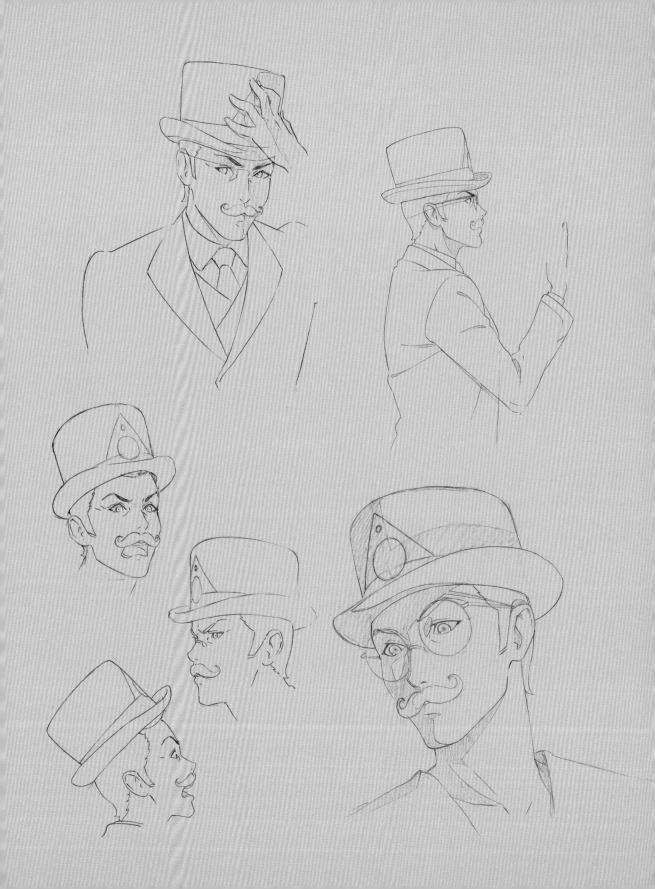

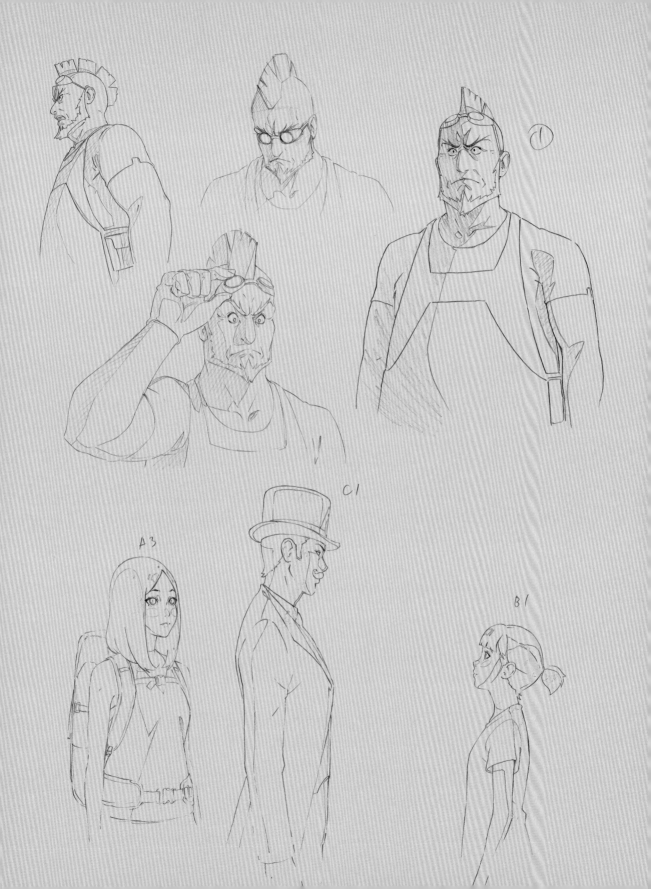

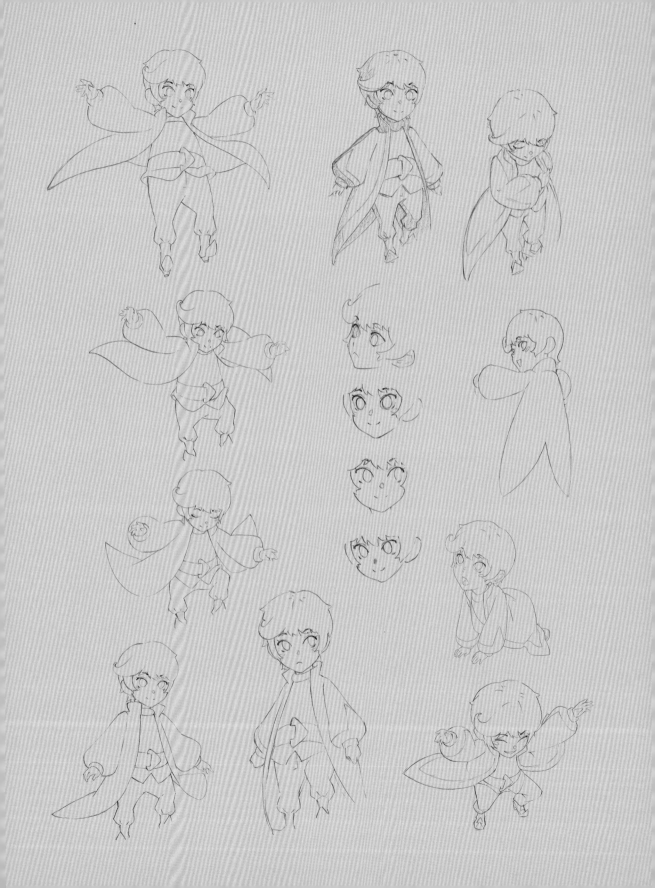

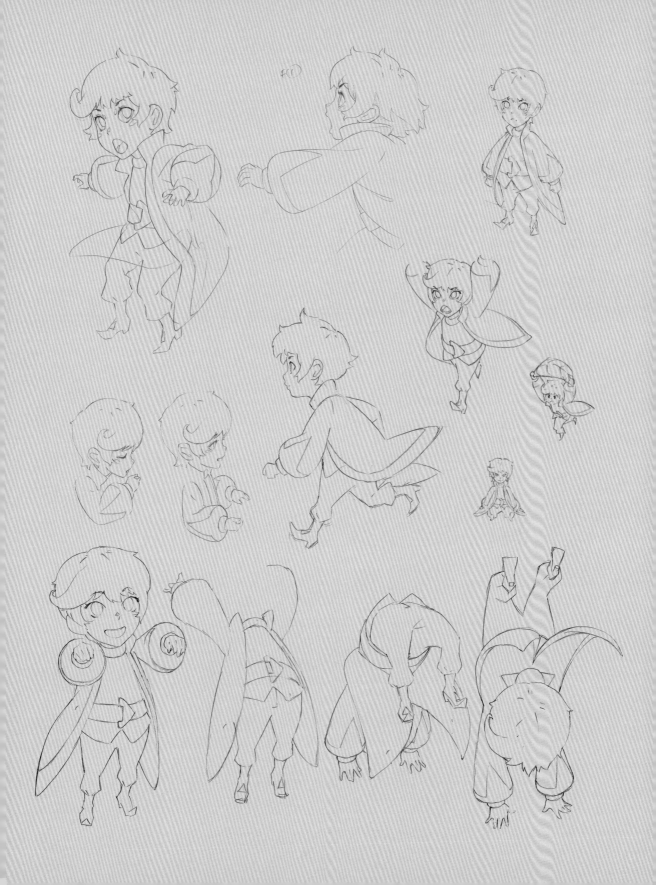

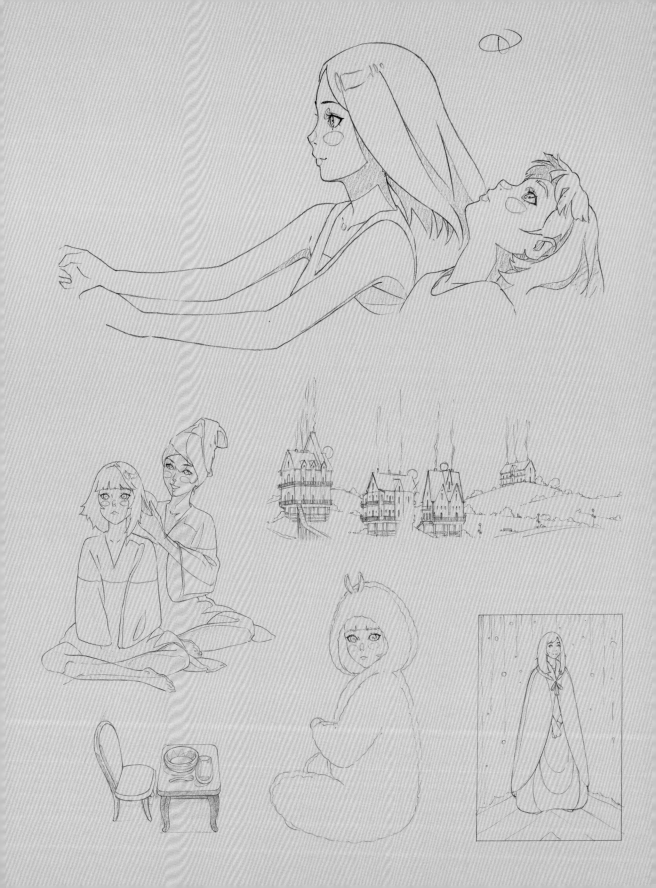

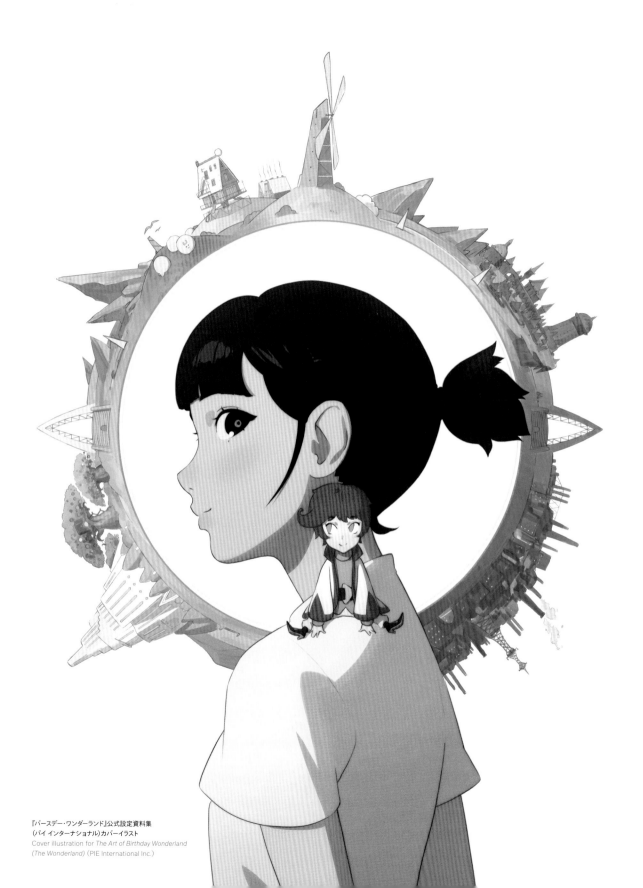

『バースデー・ワンダーランド』公式設定資料集
（パイ インターナショナル）カバーイラスト
Cover illustration for *The Art of Birthday Wonderland*
(*The Wonderland*) (PIE International Inc.)

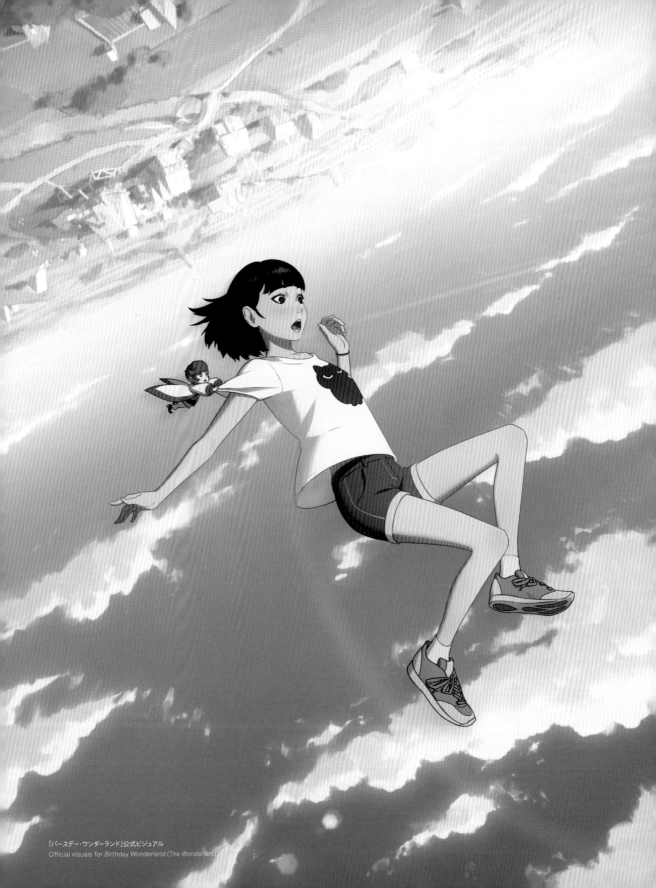

『バースデー・ワンダーランド』公式ビジュアル
Official visuals for *Birthday Wonderland* (*The Wonderland*)

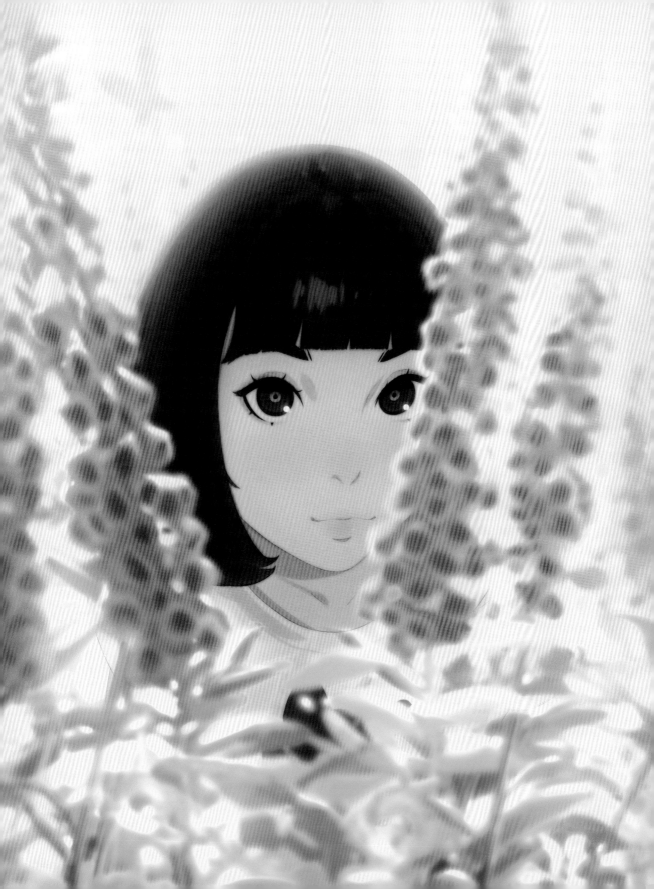

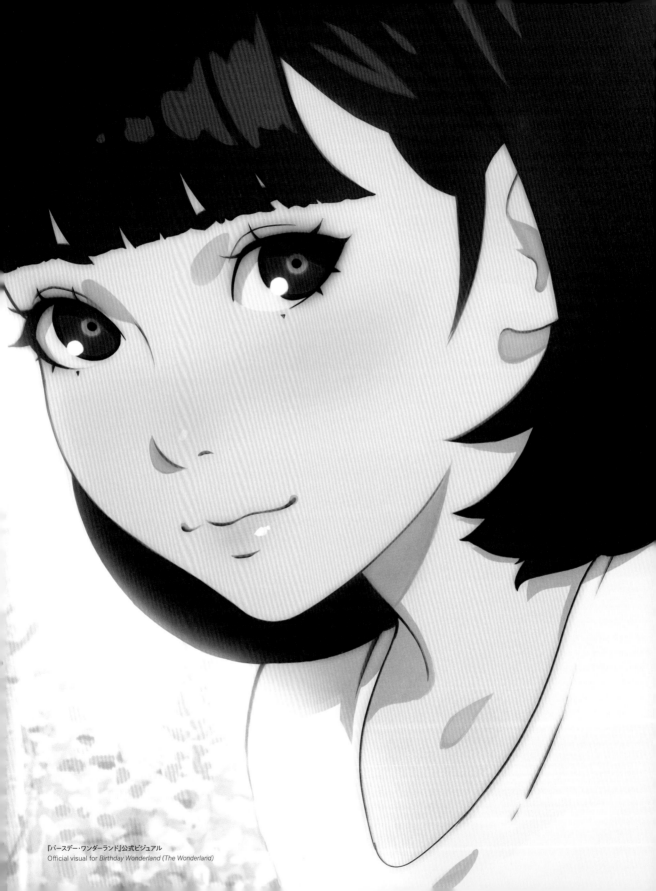

『バースデー・ワンダーランド』公式ビジュアル
Official visual for *Birthday Wonderland (The Wonderland)*

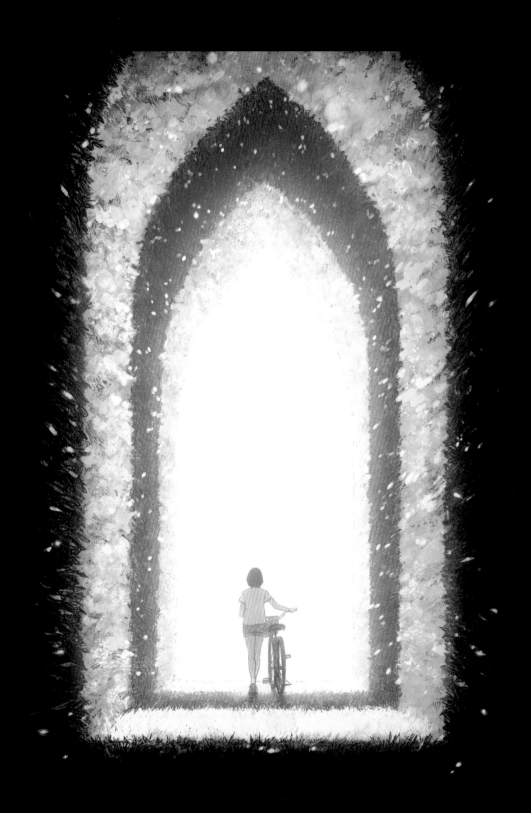

『バースデー・ワンダーランド』イメージビジュアル（第30回東京国際映画祭）
Visual concept for *Birthday Wonderland (The Wonderland)* (30th Tokyo International Film Festival)

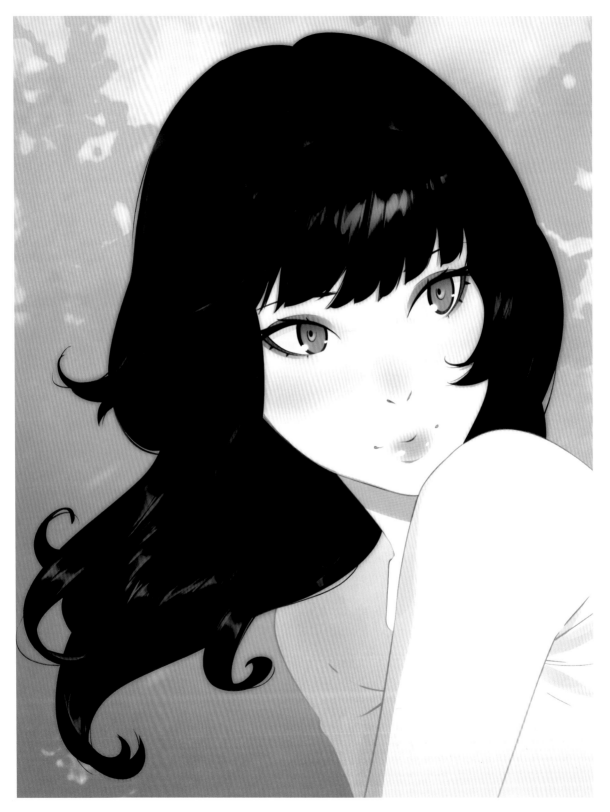

アミュプラザ小倉 広告イラスト
Advertisement illustration for Amu Plaza Kokura

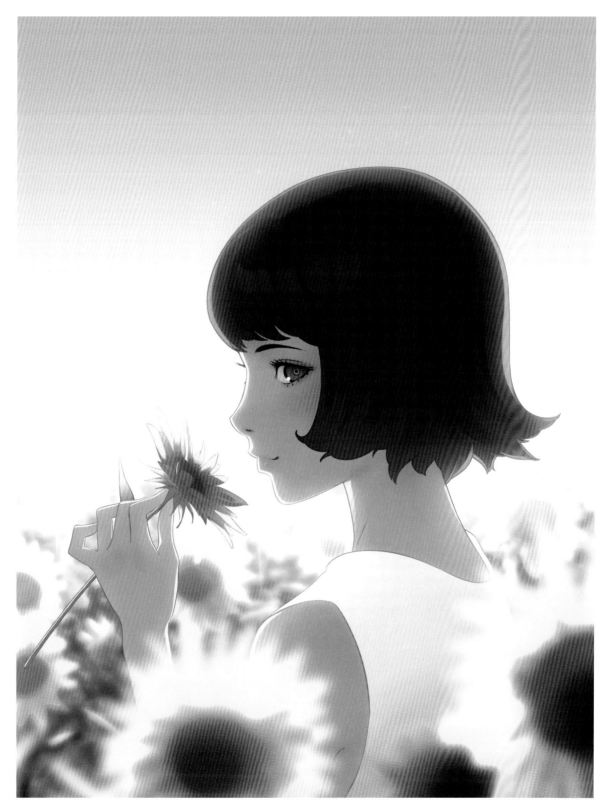

アミュプラザ小倉 広告イラスト
Advertisement illustration for Amu Plaza Kokura

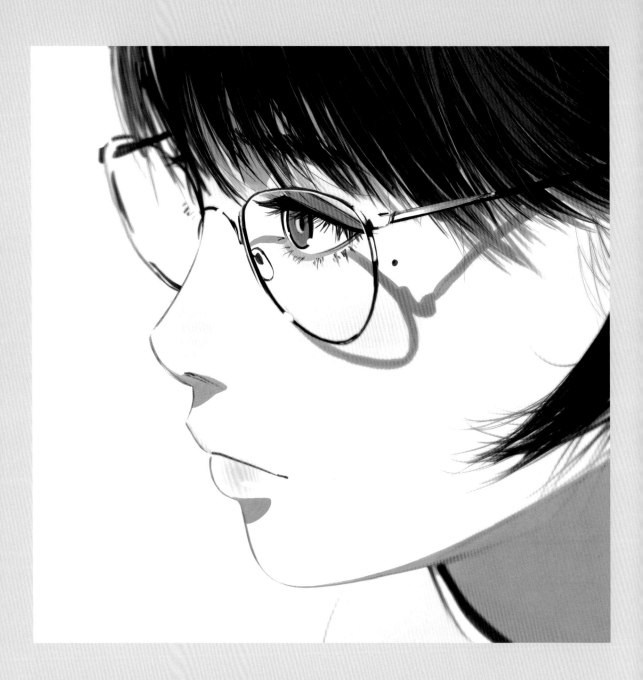

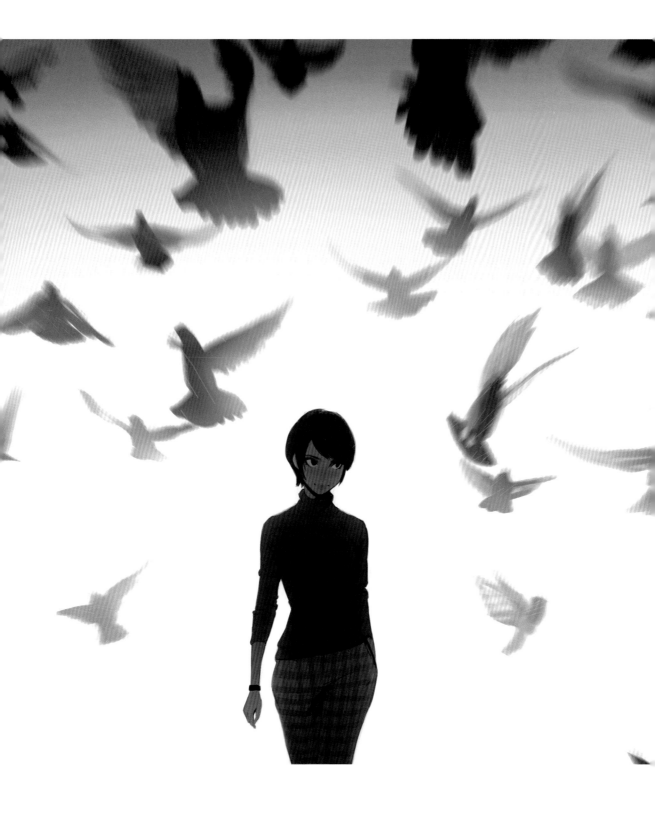

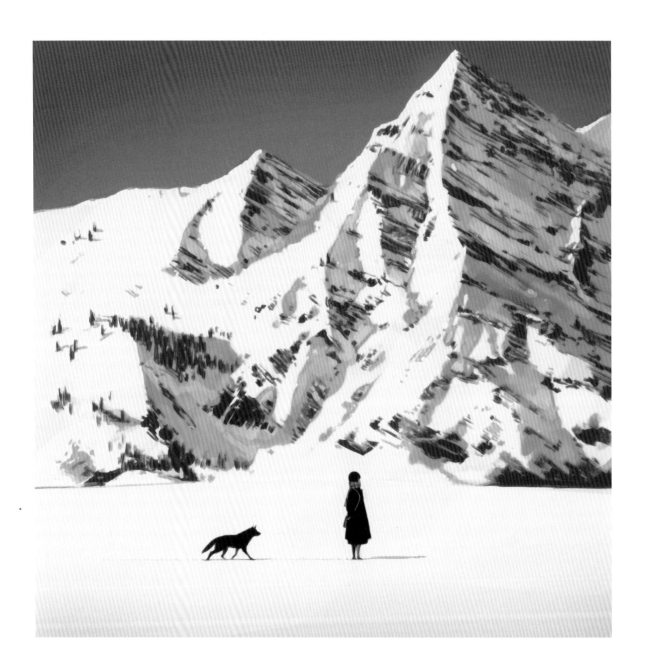

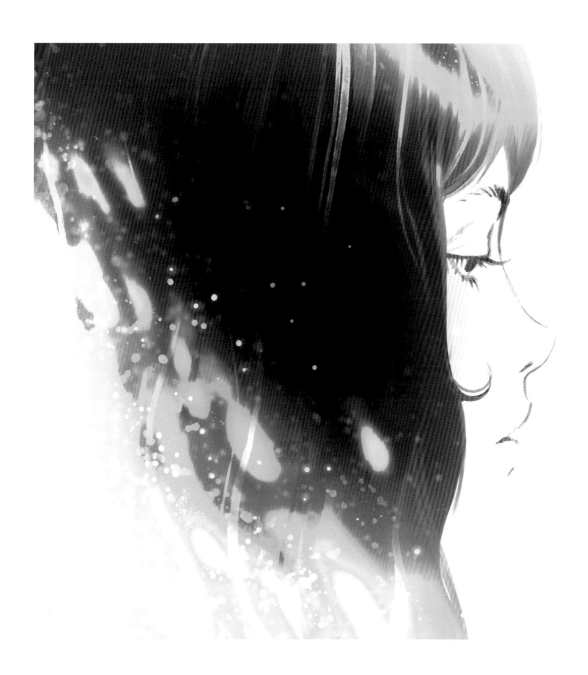

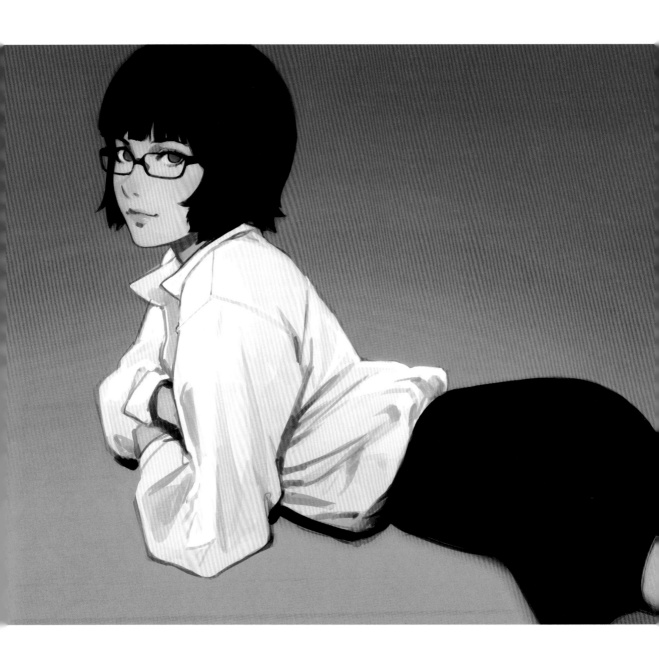

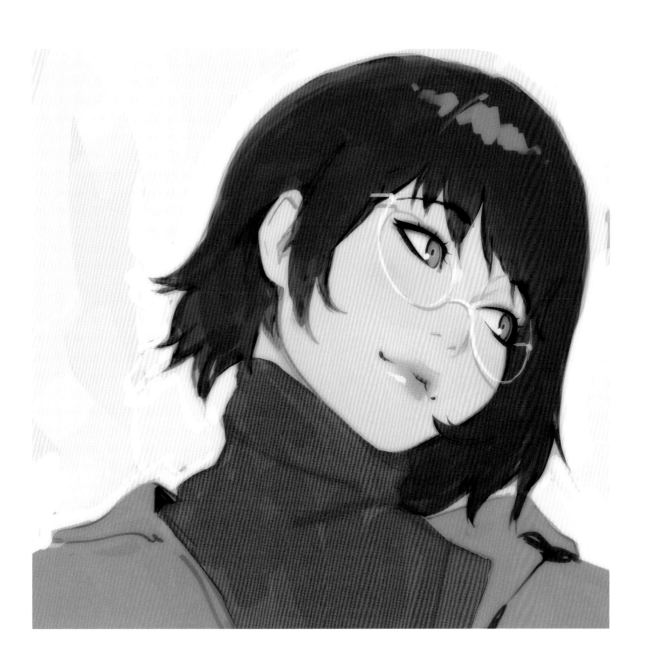

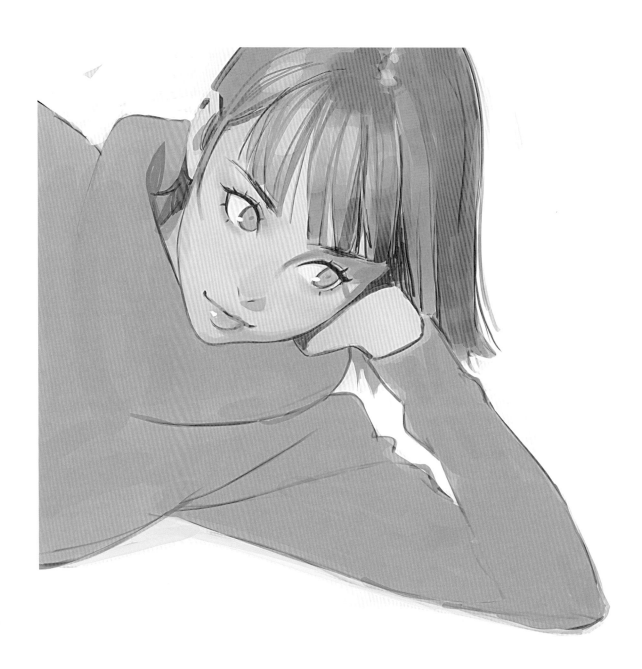

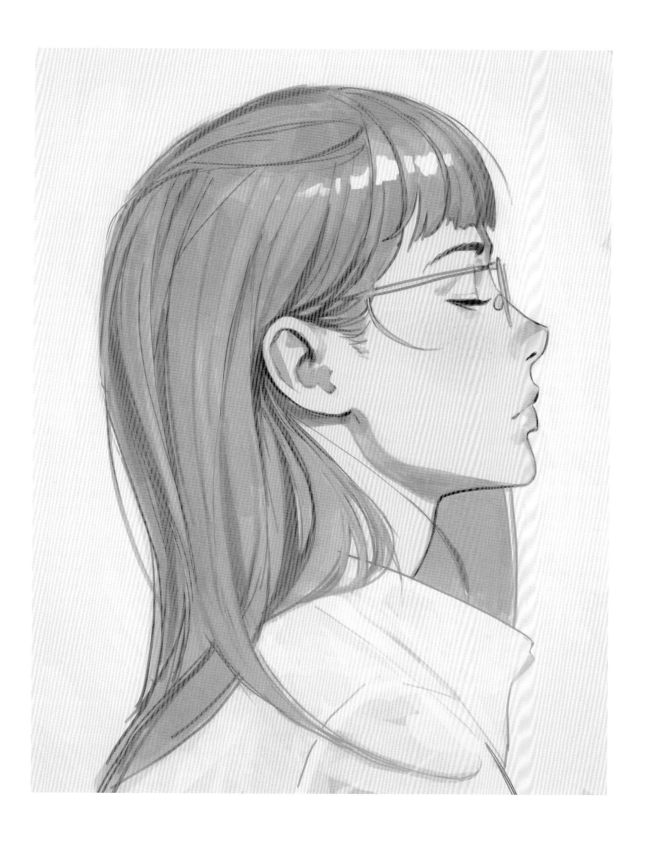

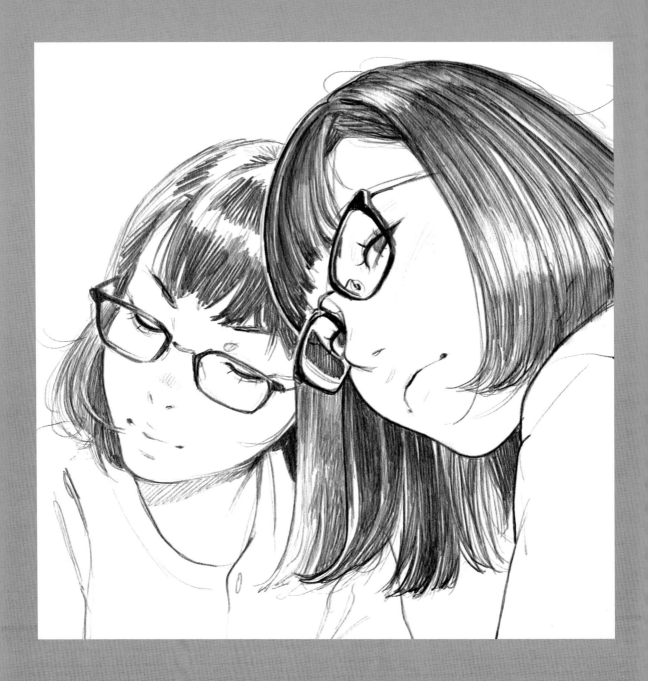

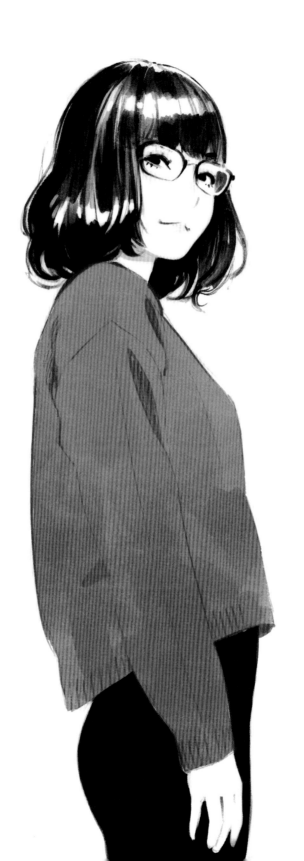

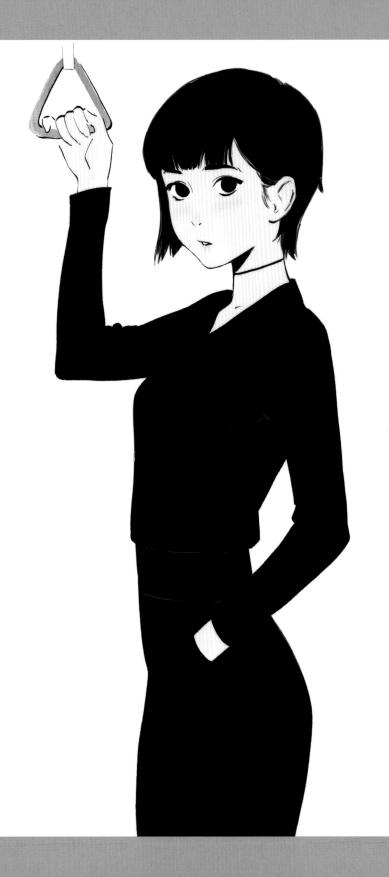

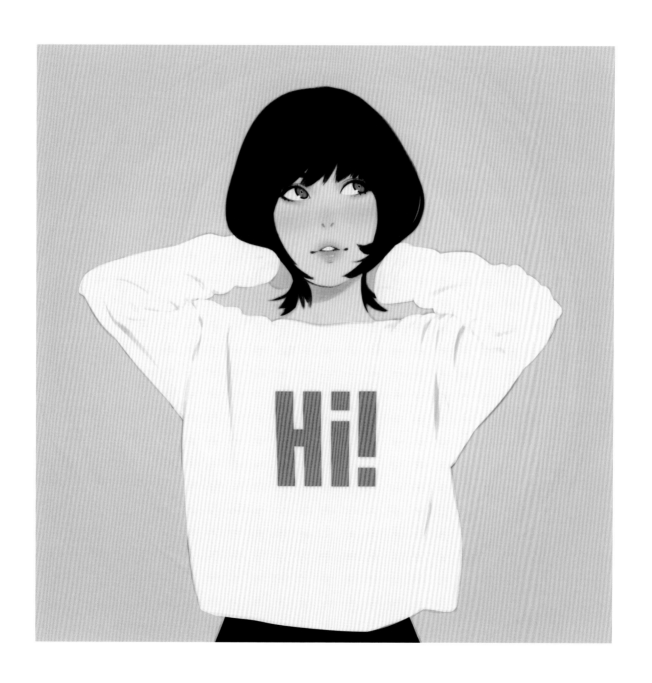

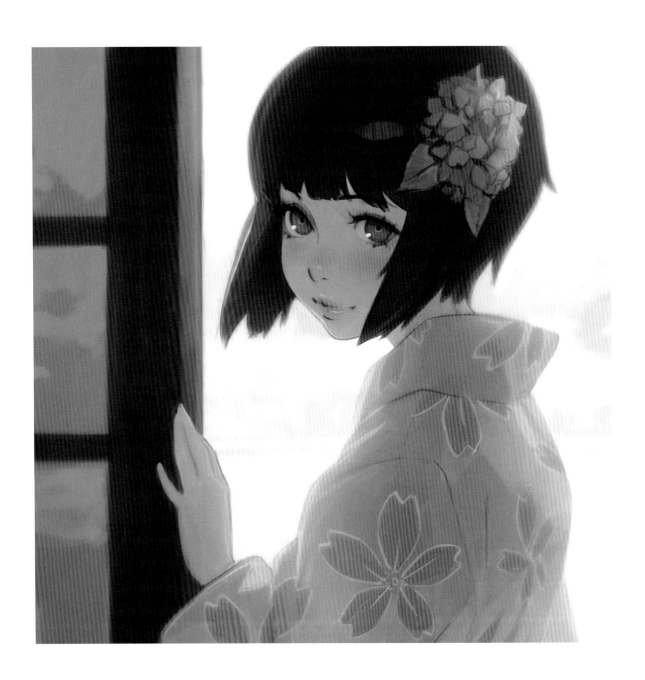

東洋美術学校ライブペイント 描き下ろしイラスト
Illustration drawn for Toyo Institute of Art & Design live art event

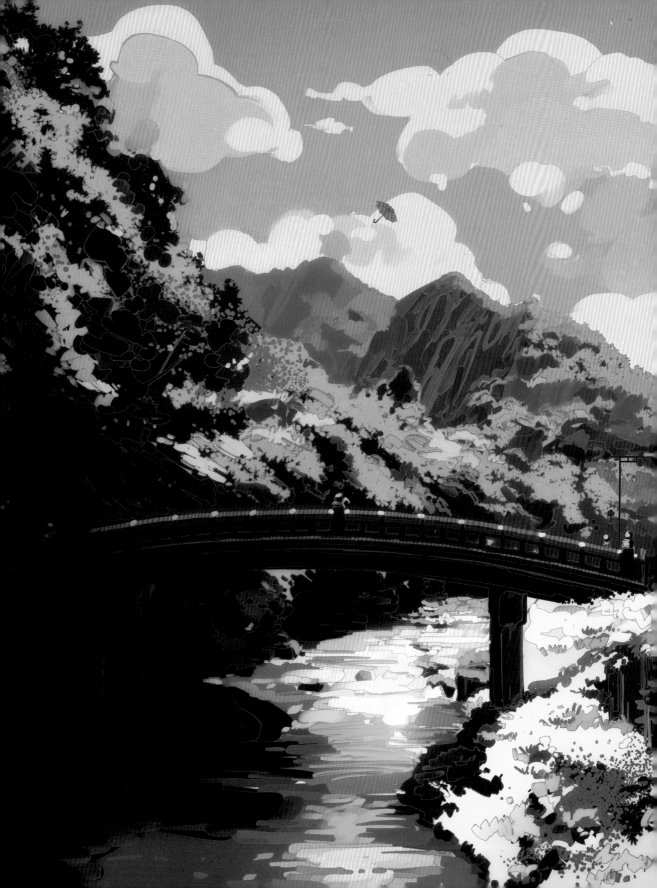

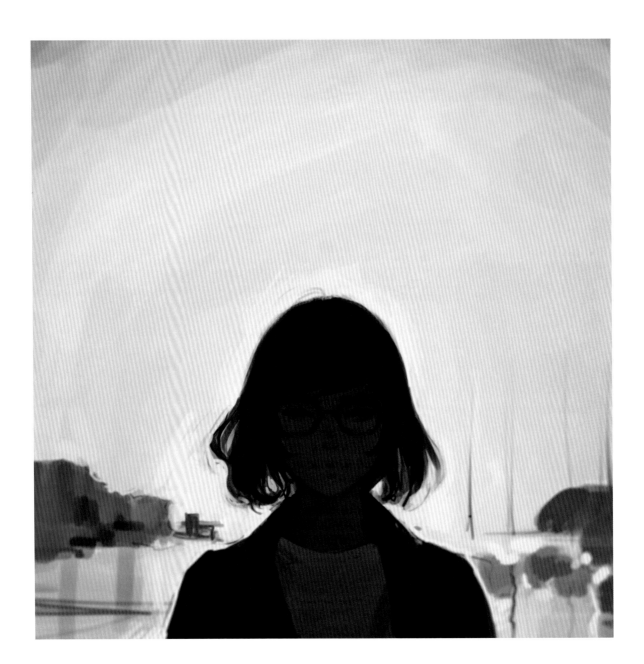

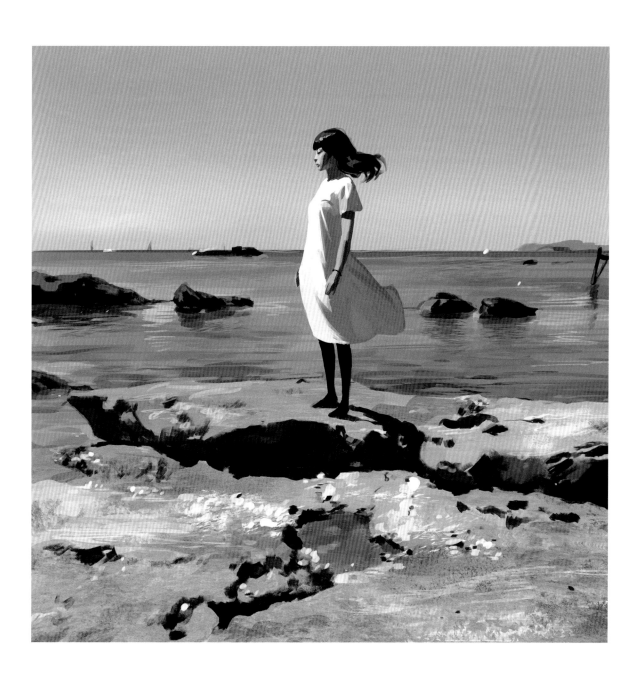

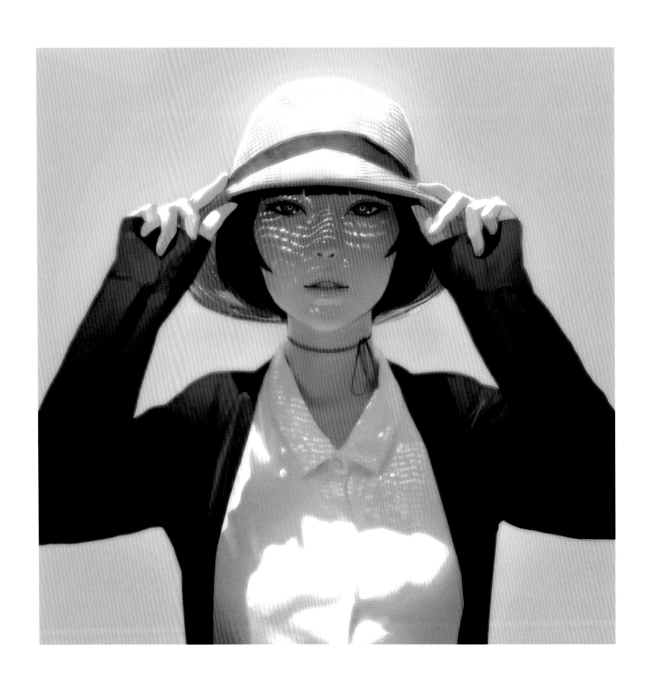

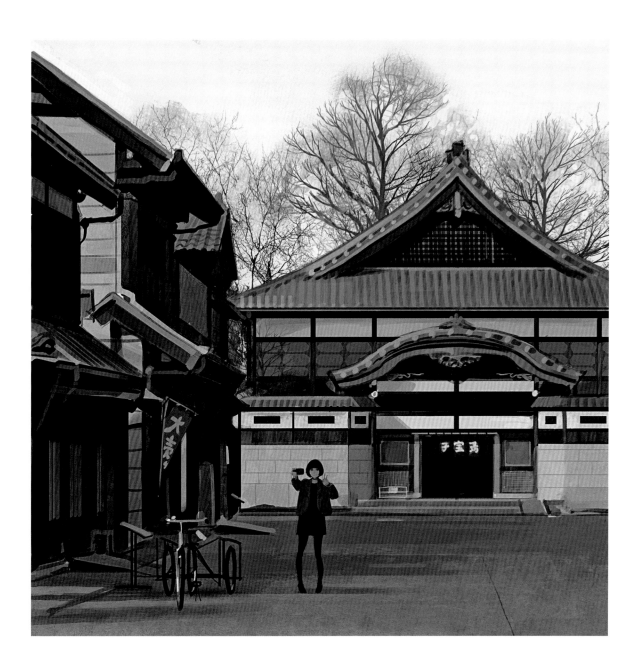

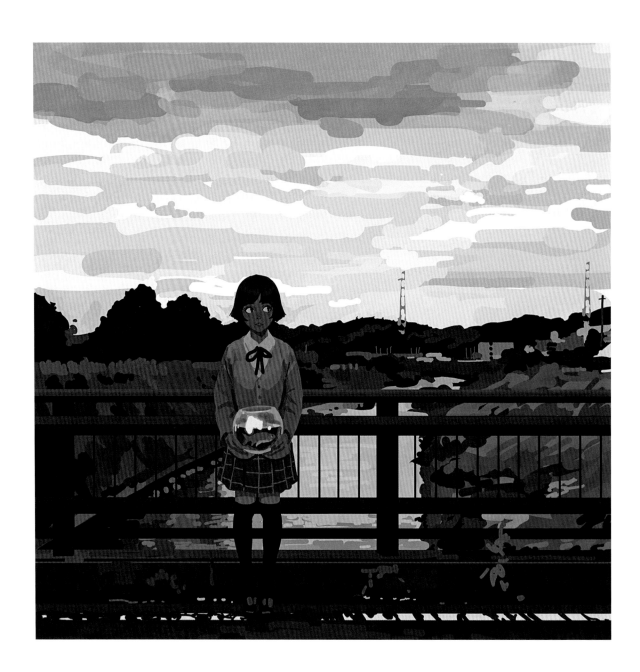

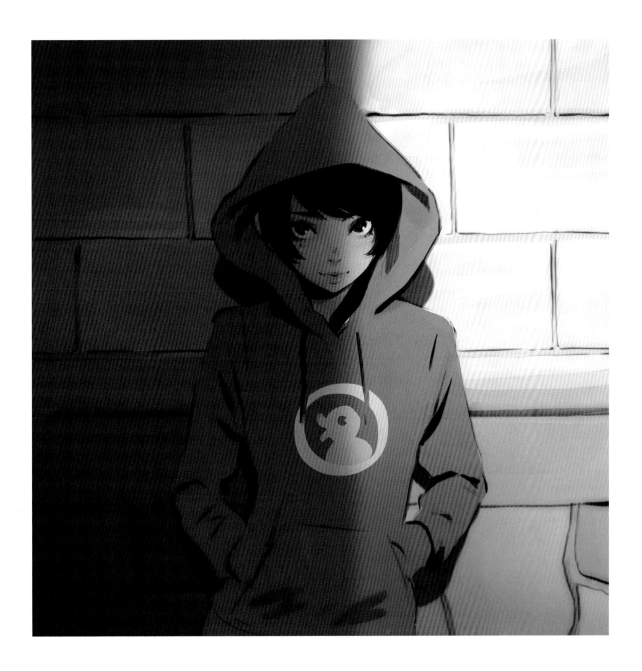

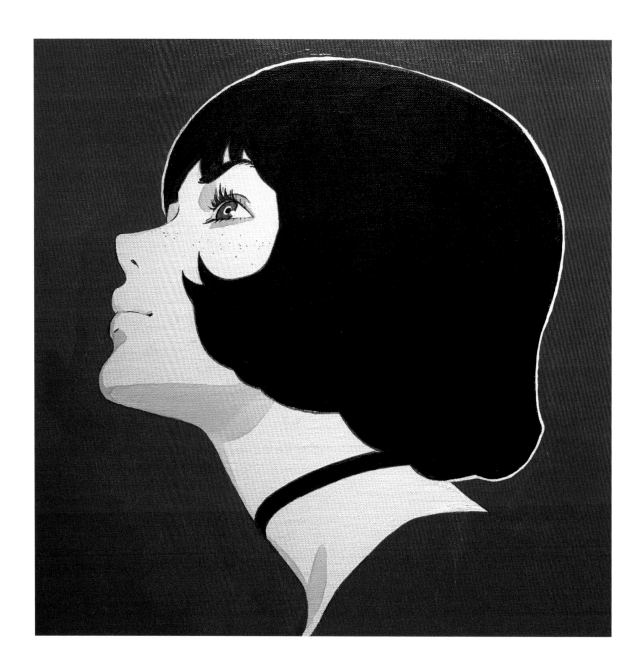

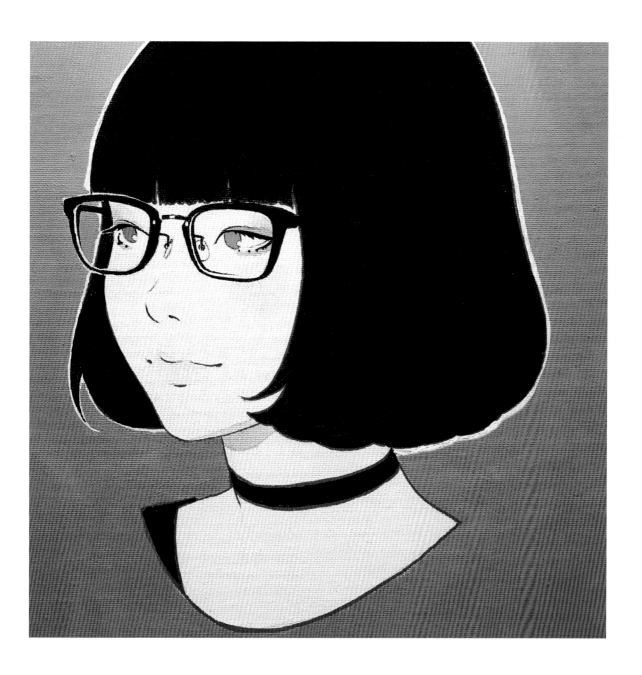

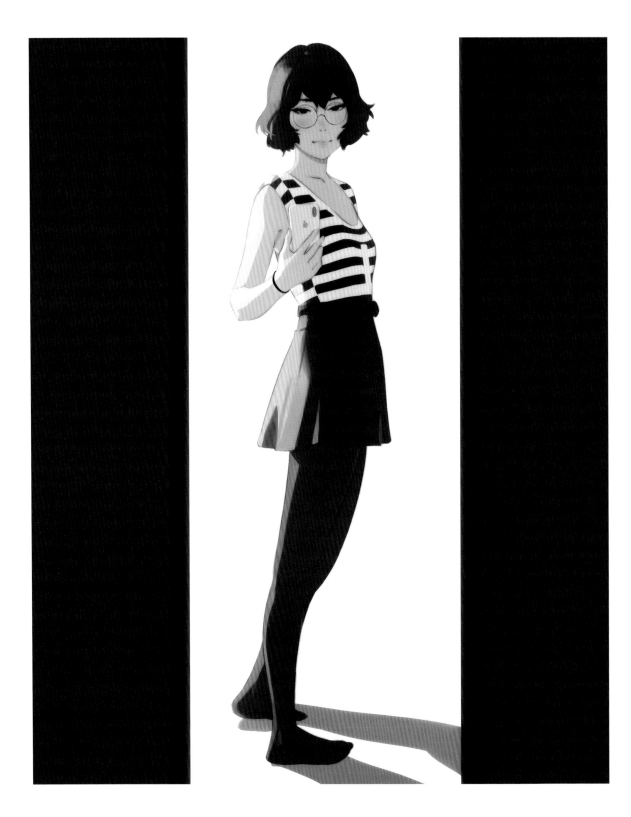

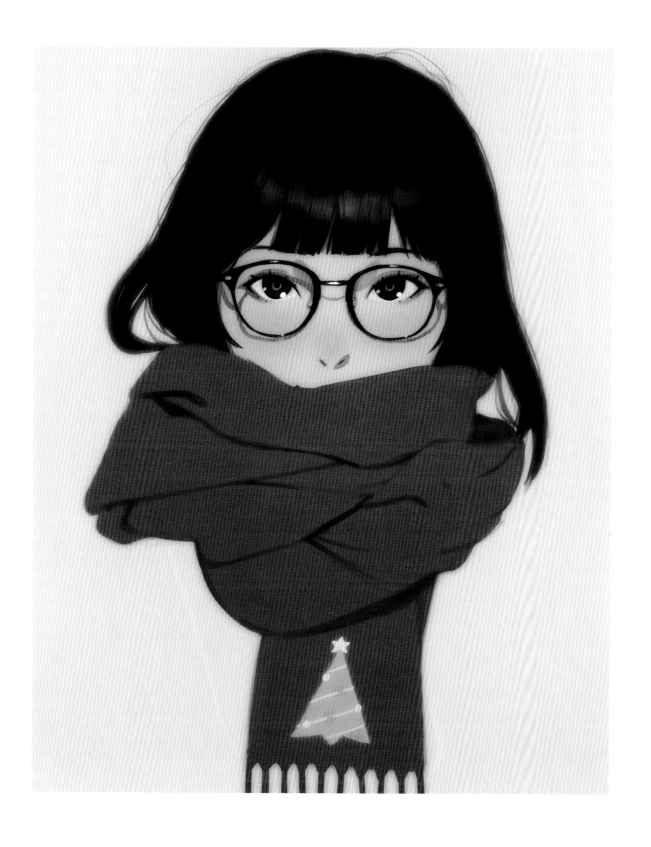

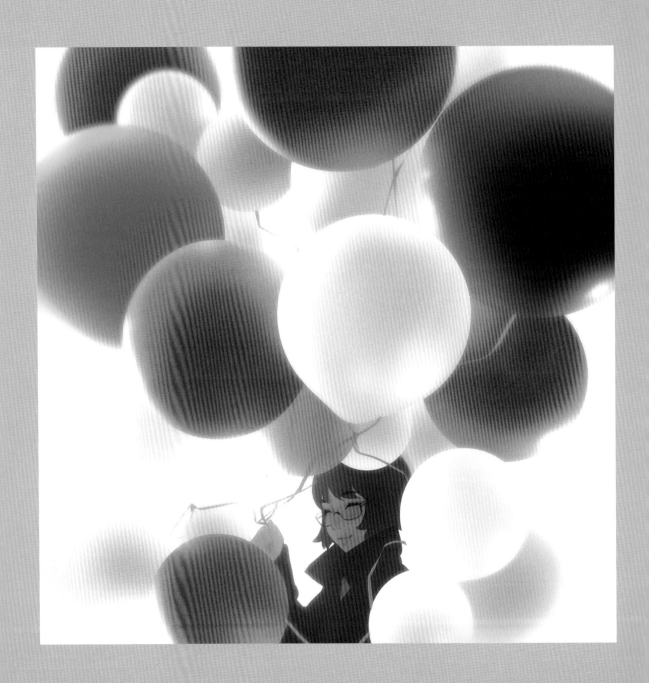

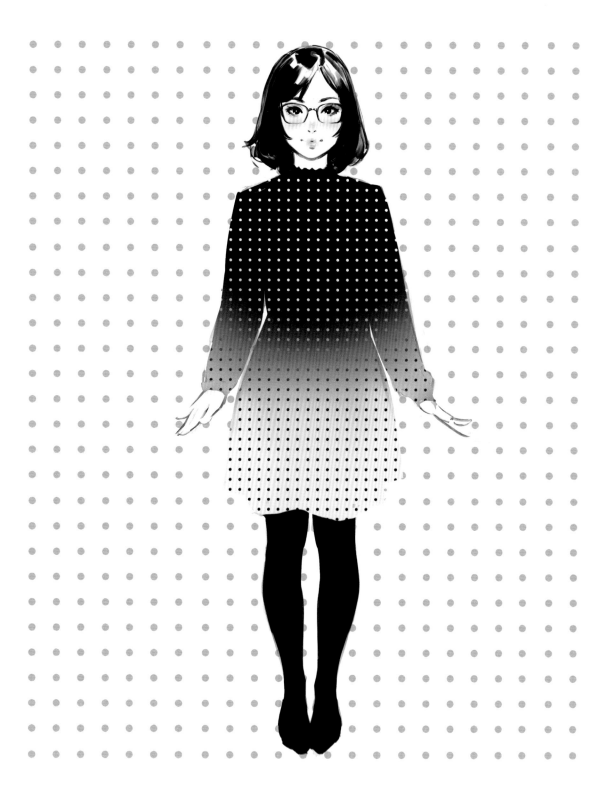

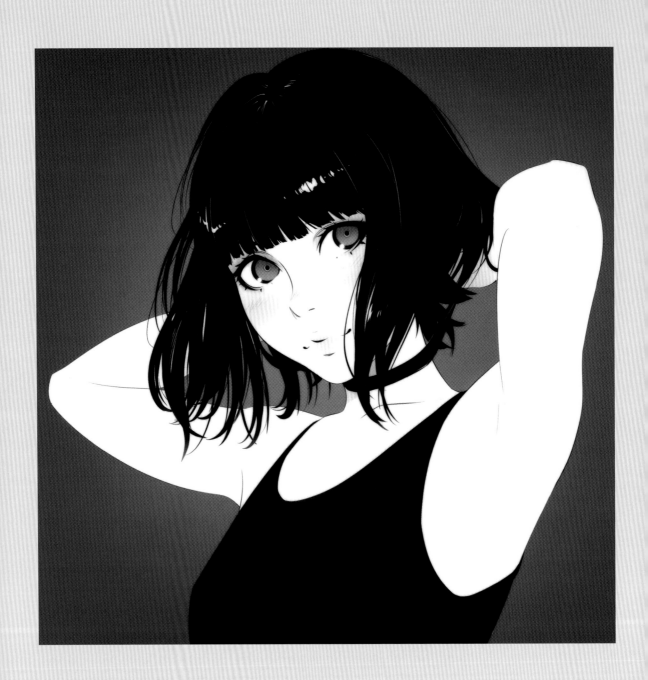

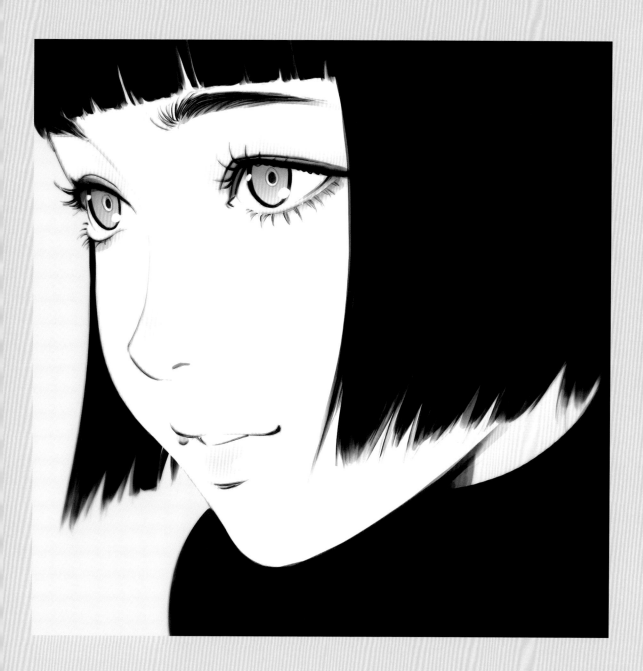

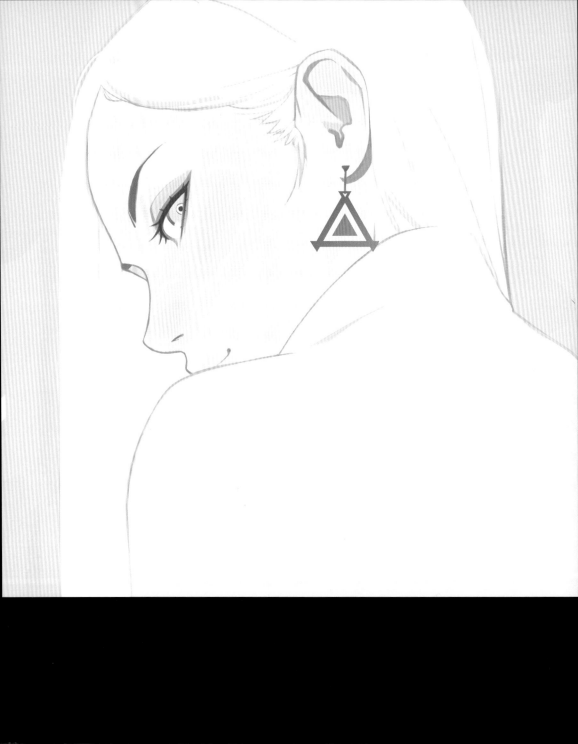

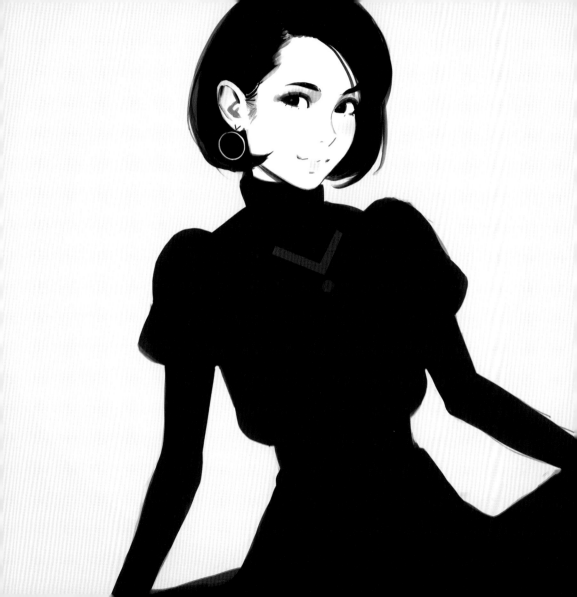

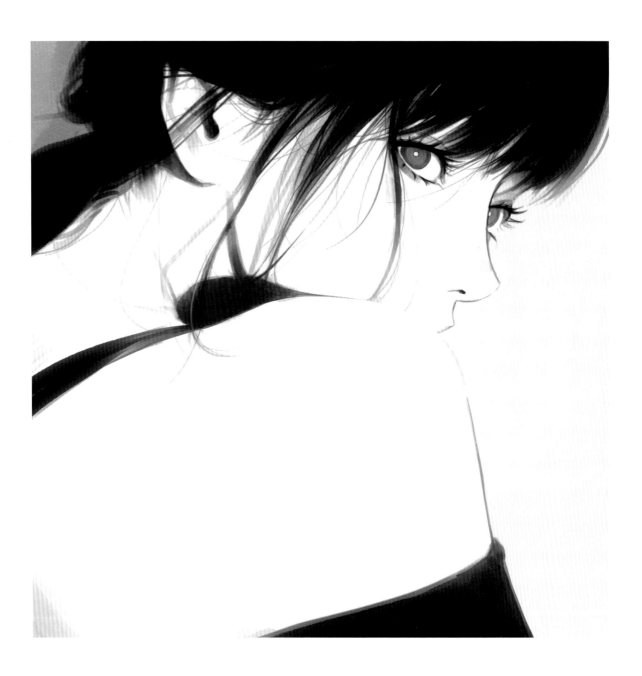

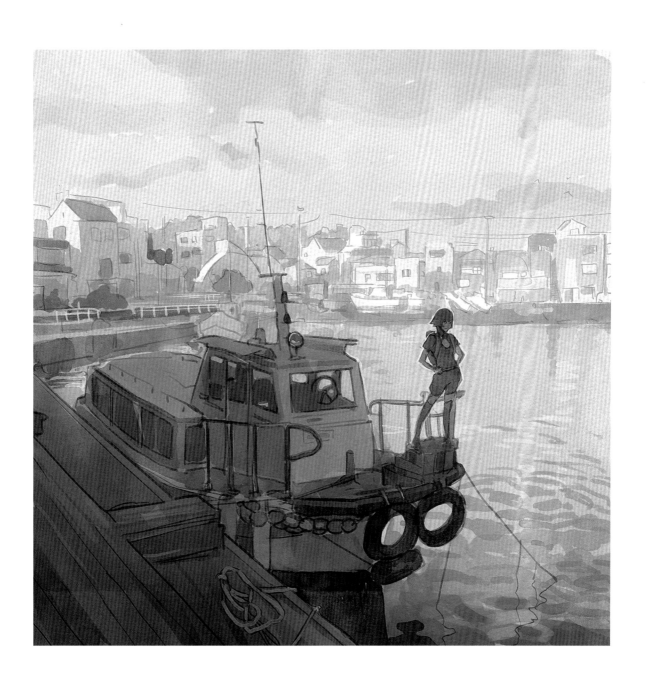

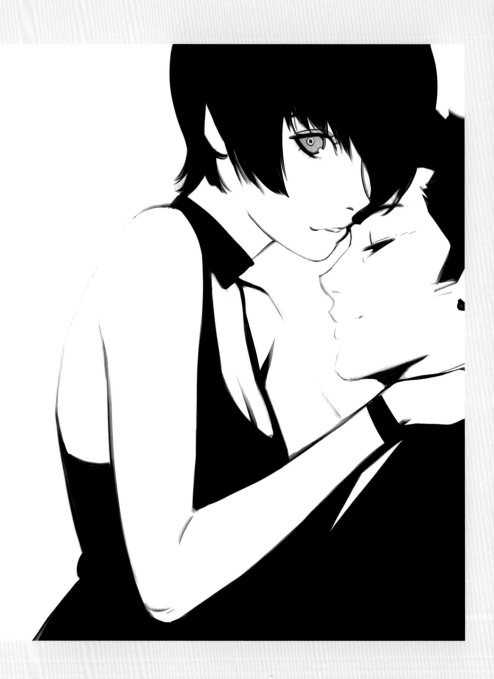

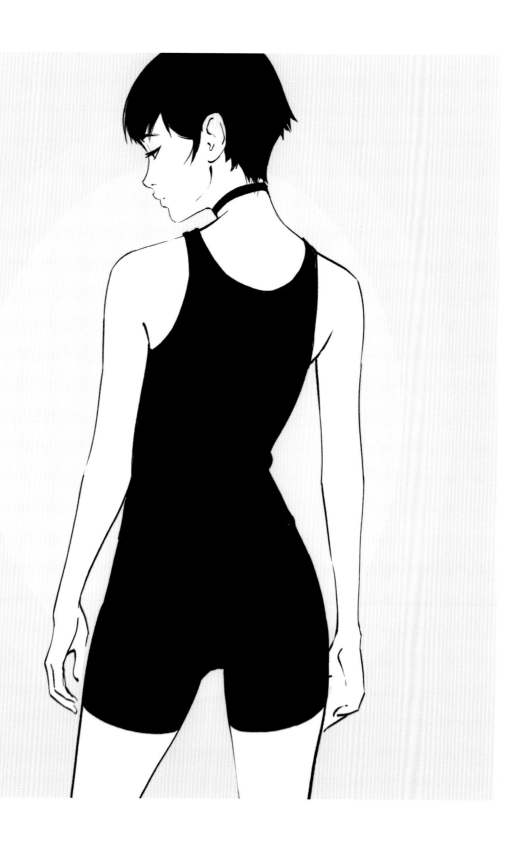

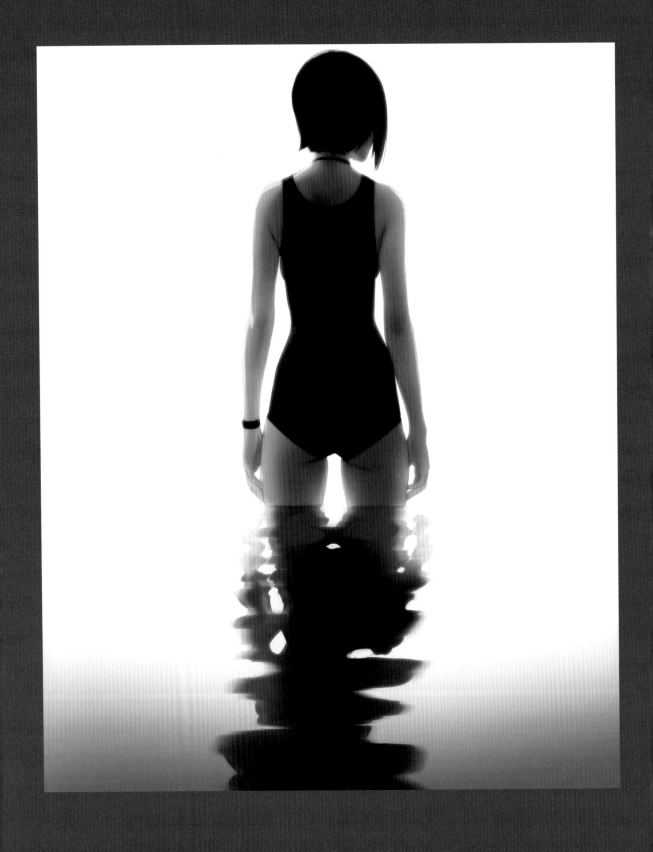

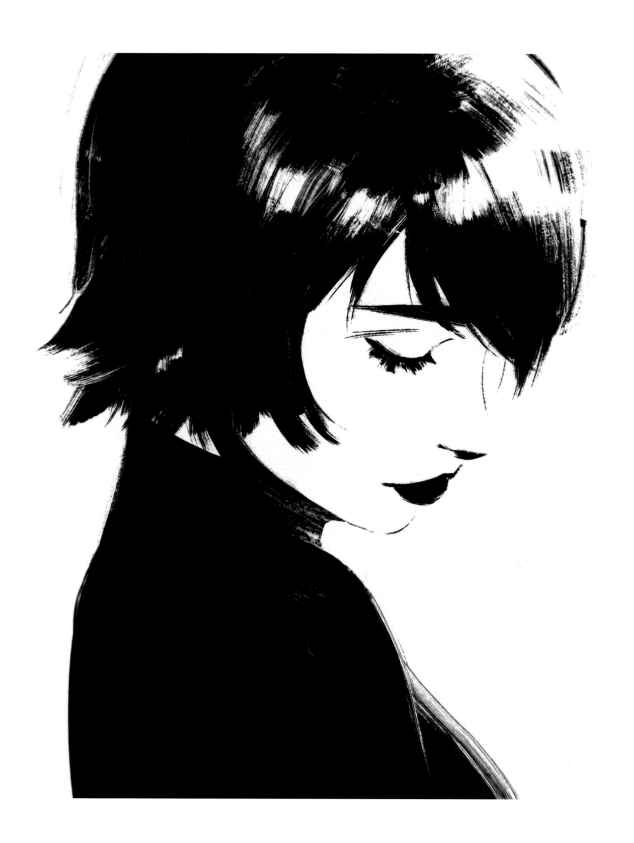

残念ながらページの都合上、この3年間でお世話になった方々すべてに、きちんとお礼を申し上げることはできません。なるべく全員のお名前を挙げるように努めましたが、どなたかをうっかり忘れてしまっていたら、すみません。たとえそんなことがあったとしても、皆さんに心から感謝していることだけは間違いありません。

まずは、いつもそばで私を支えてくれる妻に最大の感謝をささげます。

308PANTSの素晴らしいみんな、Ilya、Sergei、Yura、ありがとう。

Nadia、Pasha、Denechkaも、いつもありがとう。

母や父、祖母、祖父にも感謝します。

そして私をパダワンにしてくれて、私が将来、ダース・ベイダーになることはないと信じてくれている原 恵一監督、ありがとうございます。

長南佳志さん、村田 茜さん、本多史典さん、中村 隆さん、長友孝和さん、田中宏侍さん、浦上貴之さん、霜山朋久さん、新井浩一さん、竹中真吾さん、豊田桂祐さんを含めた『バースデー・ワンダーランド』の制作チーム全員にも感謝しています。皆さんとの仕事を通して、アーティストとしても一人の人間としても成長することができました。チームでの仕事がこれほど楽しかったことは今までありませんでした。

石川光久さん、荒牧伸志さん、神山健治さんには、いつか『攻殻機動隊』シリーズに仕事で携わりたいという夢をかなえてもらった上に、さまざまな面でご指導いただきました。

佐野世奈さん、小林雅之さん、有馬トモユキさん、Vasya、Thomas Romain、d4rkie、Valeriya、Matvey、北林ポールさん、bonezz、Newmilky、Sergi Brosa、Maciej Kuciara、ReJean DuBois、SainaSix、Alexey、Robaato、翰林日本語学院の皆さん、Vitaliy Shushko、nips、Fatima Dominguez、寺田克也さん、cre.o.n、Warren Louw、樋口真嗣さん、Justin Noll、冬目 景さん、小島秀夫さんといった、私が幸運にも巡り合えた素晴らしい方々にも感謝しています。より深く考えるきっかけや希望を与えてくれて、ありがとうございました。「もっと自分を成長させていきたい」と私が思うのも、皆さんがいるおかげです。

Instagram、Twitter、Facebookなどで私をフォローしてくださっている方々全員にもお礼を申し上げます。皆さんから「いいね!」やコメント、フィードバックをいただけるおかげで、「イラストレーターとして自分にできる最高の仕事をしよう」とやる気が出ます。

また、クリエイター応援サイトのPatreonを通して、私を支援してくださっている方々にも改めてお礼を申し上げます。皆さんの支援がなければ、日本で生活することは不可能でした。日本で暮らしていなければ、この本は生まれていなかっただろうし、ここに挙げた方々と出会うことも、そのご縁が素晴らしい機会につながることもなかったでしょう。本当にありがとうございます。皆さんは私にとって最高の存在です!

最後になりましたが、この本を手に取ってくださった読者の皆さんに感謝いたします。この本の真の主人公は皆さんです。今この瞬間に感じていただいていることが、皆さんの人生にいつまでも——ずっと永遠に——残りますように。

イリヤ・クブシノブ

There aren't enough pages to express my deepest gratitude to everyone who's been a part of my journey these last three years. I will try, and I apologize if I've forgotten a name, but please know I truly appreciate you all.

Biggest thanks to my wife for always supporting and being here for me.

To gorgeous guys 308PANTS Ilya, Sergei and Yura

To awesome Nadia, Pasha and Denechka

To my mom, dad and babushkas and granddad

To Keiichi Hara for making me his padawan and believing that I will not become Darth Vader

To Yoshiyuki Chounan, Akane Murata, Fuminori Honda, Takashi Nakamura, Takayoshi Nagatomo, Kouji Tanaka, Takayuki Uragami, Tomohisa Shimoyama, Kouichi Arai, Shingo Takenaka, Keisuke Toyoda and all the awesome *Birthday Wonderland (The Wonderland)* team for making me a better person and artist, while providing the best teamwork experience I ever had.

To Mitsuhisa Ishikawa, Shinji Aramaki and Kenji Kamiyama for making my dream to work on *Ghost in the Shell* come true and being wholesome people overall.

To Seina Sano, Masayuki Kobayashi, Tomoyuki Arima, Vasya, Thomas Romain, d4rkie, Valeriya, Matvey, Paul Kitabayashi, bonezz, Newmilky, Sergi Brosa, Maciej Kuciara, ReJean DuBois, SainaSix, Alexey, Robaato, Kanrin Japanese School, Vitaliy Shushko, nips, Fatima Dominguez, Katsuya Terada, cre.o.n, Warren Louw, Shinji Higuchi, Justin Noll, Kei Toume, Hideo Kojima and all the other awesome people who I am lucky to have in my life. Thank you for helping me think deeper, giving me hope and being a reason for me to change for the better.

Thanks to all my followers on Instagram, Twitter, Facebook and other platforms. Your likes, comments and feedback motivate me to do my best with my personal illustrations.

Thank you to all my patrons, past and present, who support my Patreon page. Without your help I would never be able to afford staying in Japan. Living here has been integral to this book becoming a reality, but I also would never have met most of the people listed above which have led to these great opportunities. You are truly the best.

It goes without saying, but "thank you," my readers. You're the true stars of this book; I hope this moment makes a lasting impression on your life, for eternity and beyond.

ILya Kuvshinov

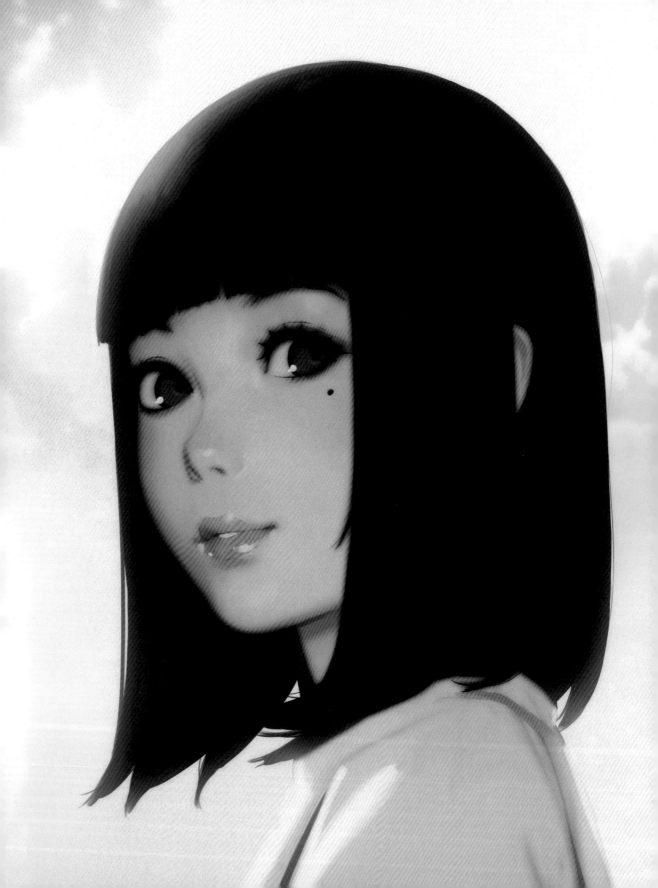

イリヤ・クブシノブ画集 ETERNAL

2019年11月22日　　　初版第1刷発行
2019年12月15日　　　第2刷発行

著者　　　イリヤ・クブシノブ

デザイン　有馬トモユキ（TATSDESIGN）
　　　　　田中千春
翻訳　　　Christian Traylor
　　　　　石井ひろみ
　　　　　ブレインウッズ株式会社
協力　　　Fatima Dominguez
　　　　　ザ・ギャミン・スタジオズ株式会社
編集　　　杵淵恵子

発行人　　三芳寛要
発行元　　株式会社 パイ インターナショナル
　　　　　〒170-0005 東京都豊島区南大塚2-32-4
　　　　　TEL 03-3944-3981 FAX 03-5395-4830
　　　　　sales@pie.co.jp
印刷・製本　図書印刷株式会社